Nature
The End of Art

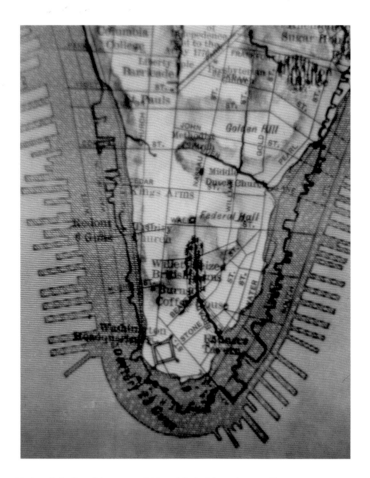

Natural-Cultural Layers of New York City, photocollage,
1965-1976, 24 x 30 in.

Nature
The End of Art

Environmental Landscapes
Alan Sonfist

Introductory Interview with the Artist

Robert Rosenblum
curator, Solomon R. Guggenheim Museum

Essays

Wolfgang Becker
founding director, Ludwig Forum Museum

Jonathan Carpenter
art, archaeology and nature writer

Lawrence Alloway
art critic

Michael Danoff
museum director and writer

John Grande
art and nature writer

Uwe Rüth
director, Skulpturen Museum, Glaskasten Marl, Germany

Publisher: Gli Ori, Florence, Italy
Copyright © 2004 by Alan Sonfist

Editor: C. Field
Copy Editor: Barbara Cavaliere
Editorial Assistants: Allegra Raff, Gilda Meza
Jennifer Tomaiolo, and Bradley Scott

ISBN 0-615-12533-6

Library of Congress Cataloging-in-Publication data available on request

Distributed in the USA by:
D.A.P. / Distributed Art Publishers, Inc.
155 Sixth Avenue
New York, NY 10013-USA
Customer service: 800 338-2665
Fax: 212-627-9484
dap@dapinc.com

Distributed in Europe and Internationally by:
Thames & Hudson Ltd
Registered in England at:
181A High Holborn
London WC1V 7QX
Registered Number 473109
Website: www.thamesandhudson.com

Inquiries can be directed to:
Natural/Cultural Landscapes™ Inc.
205 Mulberry Street
New York, NY 10012-USA
naturalculturalinc@yahoo.com

Printed in Singapore by CS GRAPHICS

Front Cover: *Nature/Culture, photograph, 2001, 30 x 40 in.*

Contents

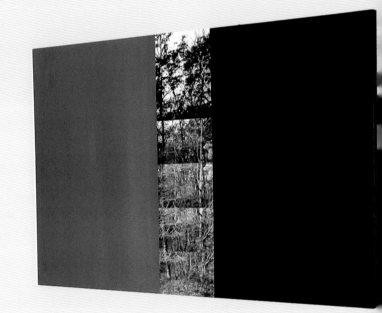

Nature's Colors, Exhibition View, photographs on painting, 1976,
24 x 36 in.

Dedicated to my daughter Rebecca,

my best friend Blythe, my parents

who introduced me to a love of nature, art, and my Red Oak, which taught

me an understanding of life.

Alan Sonfist

Introduction
Interview with the Artist

Robert Rosenblum, New York City

Many earthwork artists have left their marks on the American continent, but none except Sonfist has created artworks that, like any historic monument, have been absorbed into the center of a great city. Measured by Alan Sonfist's sense of geological and botanical time, our chronological slice hardly exists. But measured in terms of the artist's own career, a measure of human life spans and calendars, much has happened. In 1989, Sonfist's *Time Landscape* (still growing on Houston St. and La Guardia Place) was put under the protection of the Parks Department of New York, and in 1998, it was given landmark status as part of the city's Greenstreets Program. Since 1989, when I did the interview reprinted below, Sonfist has continued to expand his domain, not only geographically to European and Asian patrons but also to other relationships between landscape and the work of man. For example, in Florida in 1994, he created a 7 acre natural cultural landscape for the city of Tampa. The archaeological landscape exposes the history of the land from its indigenous roots to its contemporary environment. Moving forward to the 21st century, under the patronage of German Prince Richard of Berleburg, Sonfist has created *The Lost Falcon* near Köln. *The Lost Falcon*, is a recreation of the first forests that existed in Germany 100,000 years ago, cultivated in an open field between a medieval and a contemporary forest. The forest is surrounded by a protective wall; the wall is built in the manner of fortifications created by Celtic civilizations that first inhabited the area. As the Celtic fortifications protected the inhabitants, it will now be used as protection for the endangered habitat of the region. The ancient forest is reintroduced to the environment in the shape of a falcon, a species that is now nearly extinct and has existed as a symbol of Germany since antiquity. Through his innovative, ground breaking use of nature, Sonfist has created a bridge between past and present giving new meaning to the concept of time travel.

R: Alan, since I am primarily an art historian, the first thing I do is to try to situate you in terms of decades, movements, other artists, and learn how you feel about such things. One question I would like to start with has to do with something I read recently. It referred to the present "mood" as "archaeologism." The writer Donald Kuspit thought that the whole spirit of regression, of moving backwards, of exploring layer after layer of our historical past, whether recorded or prehistorical, was part of the mood of the past ten years or so. Does that ring any bells for you?

S: The idea of digging up the past to bring it into the present is exactly what my art is about. I see myself as a visual archaeologist. The research that I do is extensive: the New York City sculpture *Time Landscape*, which I started in 1965, took ten years. I searched through old Dutch records of lumber supplies and read accounts of walks to their favorite streams. From that I was able to get an idea of how the city looked prior to man's interventions. The idea of uncovering the multiple histories of an area and incorporating them into an artwork set in a contemporary environment is integral to my artwork, and has been from the beginning.

R: So, is it really a sort of natural history equivalent to art history? The whole tenor of the past ten, twenty years is to reconstruct the historical past, to dig it out, and make it look as if it were resurrected. You are doing that in terms of what was here before we were. There seems to be a parallel there, don't you think?

S: All my art deals with the primal experience of creation in the land. A good example is the *Circles of Time* at Villa Celle. There, to enter the main part of the sculpture, you must go through a tunnel in the earth, and rediscover our geological past. What I have created is a circle, rippling in waves of rock, each concentric circle representing a layer of time, as with the growth of a hardwood tree. This is a visualization of the upper and lower strata of the hills of Tuscany. As one walks out of this ring, one enters a ring of laurel representing the Greeks, who introduced the tree to Italy. One then goes through an opening which is close to the ground, and there you can feel and smell the Etruscan herbs. Then the passage rises, opening to view bronze castings of endangered and extinct trees, which mimic and represent the Greek and Roman heroes of ancient sculpture. In the center of the circle is the virginal forest of Italy, that which existed before human intervention. Finally, to complete the histories of the land, I have represented its contemporary use by a ring of olive trees and wheat.

R: One of the things that I wonder about, since this includes not only your geological and botanical strata in regression, is your own regression to primitive states of being. How do you fit that in? I mean, the pieces where you were caged in the zoo, and where you ran through the woods imitating an animal?

S: I would say that, as humans, we are all part of the environment. That is a primary revelation in my art. The earth artists, for instance, went out into the desert to work: my art is to rediscover my own part in the city. I grew up in New York. The roots of my caged-animal performance are here, especially in my childhood trips to The Bronx Zoo. Sometimes I would sneak into those environments, right into the cages with the animals.

R: What were the species? I'm trying to think of how you could get in.

S: Mostly I visited the wolves, antelope, and deer. Since I was a child, the animals would walk right up to me. They were very curious. Sometimes I would just jump the fence, go into the trees, and play. So the actual past is where my animal fantasies came from. It relates to archaeology, because it's almost like I'm unearthing my own childhood experiences. When I grew up in the city, I lived next to one of the last original New York forests in the Bronx, which has since been destroyed.

R: It seems like an ideal situation. A combination of both private and personal history, your own regression to our past, and also public history, because your experience is part of a general communal one. I am always curious about the proportion of science to poetry, if they can be separated. That is, how much actual work do you do in terms of research in order to find the truth about geological, botanical developments wherever you are working. Is it imaginary? I mean, what is the proportion of fact to fiction?

S: In New York City, I have created several forests. Each one has its own unique vegetation which I get from a history of each sculpture site. In Dallas, I have traced the history of the Trinity River, so that it could be reconstructed into a functional waterway. The city is using this environmental sculpture as part of its master plan. I have also traced the historical streams of New York and proposed that a bronze line be set in the concrete, marking the courses they once traversed. During Earth Day in 1970, I marked off the natural boundary of New York to show where the island naturally ended before its boundary was expanded by humans.

R: Have any of the official historians of New York, whether involved in social history or natural history, been concerned with your work?

S: Yes. After the sculpture in New York was created, several historians from around the city called to compliment me on the site. In the natural forests, I am not creating a true ecological model but a romantic one. My goal is to uncover the primary struggle of nature: between life and death. The human interaction is also a part of the historical time forest. It is like a palette. I see it as a layering out of the facts, be they natural cycles, ecological or scientific models, or pure history; then I make the aesthetic decisions.

R: It is like reconstructing Darwin. Have you ever thought of doing environments with animals?

S: When plans to reconstruct the Central Park Zoo were taking shape, I proposed to New York City officials that they create an environment with animals indigenous to Manhattan, such as deer, foxes, and raccoons. It would be different from a typical zoo that has exotic animals. This is another

concept of archaeological layering of the city environment. In Dallas, I proposed to create islands that would present primal forests, each with animals indigenous to the unique vegetation of that island. With contemporary evolution, the animals native to the city have become unfamiliar. Can you imagine walking down Spring Street and seeing a fox? Yet there are five ocelots in the Central Park Zoo.

R: It is the most thrilling irony to turn the least natural of cities to its natural origins. It almost seems impossible to get from the present to the past. But obviously you work between the layers, and New York is the perfect place. The perfect city to do it in.

S: As an art center, New York is unique. But actually, all cities have obliterated their natural past. They have built layers and layers of human habitation on top of it. It is only in the last twenty years that New York has rediscovered its historical buildings. In my work the city's historical nature can also become a functional monument to the fabric of the community.

R: I know. I remember that there was a point when suddenly all of the 1930s buildings of New York, the Art Deco buildings, looked like ancient architecture, and they were thrilling because they suddenly loomed as historical strata upon which the present is built. So we are all interested in layers. I am curious. We have been talking about New York and Dallas, but obviously you have worked all over the West. The East, too? Have you ever done anything in the East?

S: Recently, in Japan, I received a commission near Tokyo to create a *Time Landscape* in the lobby of a new building. This environment will show the layerings of time and the land under the building. I will combine my concept of constant change to the Zen garden concept of a fixed moment in time.

R: How do you adjust internationally? That is, so much of your work is involved with your personal history, in New York, and what that means to you, personally as a human being, and what it means to you as your own environment. But when you go abroad, to Europe especially, where you have done so much work, how do you plug into their history, natural and unnatural?

S: At a new site, immediately upon approval, I start sensing the land by walking, smelling, and feeling. As I absorb the atmosphere and associate with my past experiences, the process begins. I start by creating a series of drawings, bringing my own history to my immediate observations of the site. In the case of *Circles of Time* at Villa Celle, I began with hundreds of sketches of the environment and history of Tuscany. I always start by collecting historical and botanical traces of the site; these eventually become the larger project connecting myself to the land and the forces that shape it. Circles became a landscape of concentric circles covering a three acre site. Each ring represent-

ed another layer or dimension of Florence's human and natural history: in the center is the pristine forest; surrounding it are ever broadening layers of herbs, bronze casts, stone shards, and new forests, each representing another era of human and environmental time: Etruscan gardens, Greco-Roman urban culture, modern Italy. The circle's motif and structure represent not only my sense of historical and spiritual time - like the rings of a tree's personal history or the circle spirals of the galaxy - but also my own history, from my childhood images of primal forests right up to my present thinking.

R: Incidentally, just as an aside, did you spend a lot of time as a child in the Museum of Natural History?

S: Yes, I spent a lot of time in all of the museums in New York. To me there was no difference between the Museum of Modern Art and the Museum of Natural History. Both added magic to my existence.

R: It's interesting to think here about historical connections, because recent research on the Abstract Expressionists has turned up that the Museum of Natural History was one of the major locales of inspiration for them, not only in terms of ethnological displays, but also in terms of geological and botanical displays of the forties. But to get back to Europe, do you find a difference in the response to your work there from the response here? Are the Europeans more attuned to your viewpoint?

S: I think it's interesting that the Abstract Expressionists went to the Museum of Natural History. Most of my early drawings and photographs were created from the exhibitions there, as well as from the direct observations of nature. The museum showed the multiple histories of the land, while the art museums showed me the history of the human mind. To this day I still go back there to connect with those experiences. In Europe there is a clearer understanding of the multiple histories of the land, probably because it has been inhabited for a longer period of time. And Western art history has more meaning for them since it is easier for Europeans to see the logical connection of my environmental sculptures in relationship to the history of art.

R: In how many countries have you worked in Europe?

S: Most of my European art is in Germany, Italy and France. Right now I am working on a sculpture park for a manufacturer in Austria. The concept for this park will be to trace the history of the original primeval forest that once stood there. There was a castle on the land in the Renaissance, which is now a ruin. I plan to reconstruct the castle to be the protector of the forest that I will plant. Eventually, the parklands will become the grounds of an international sculpture park.

R: Do you have any connections with England? I always think of Britain as being the most earth-oriented of European countries.

S: In the early seventies, I had a one-man exhibit at the Institute of Contemporary Art in London. I was later invited to create a historical forest surrounding the ruins of a family castle. The trees that I planted were under three feet so that the ruins would eventually disappear into the forest, thus becoming another lost fragment of history to be rediscovered in the future. This inspired me later to create the centennial commission for the Kansas City Art Institute. In this sculpture, a young forest and prairie surround a thirty foot bronze column of intertwining branches cast from fallen limbs of endangered species. Again, the bronze sculpture will disappear into the forest over the next century.

R: That's fascinating. Being a historian, I always connect things with tradition. In England especially, there is the whole concept of romantic ruins which were built abundantly in the 18th century, looking as though they had been there all along, but were really mock ruins. The idea of reconstructing something that is in the process of growth, but will decay or even has decayed, that is something that has its roots in the Romantic tradition. So in a funny way you are resurrecting that tradition.

S: I have always been fascinated with the concept of reconstructive ruins, and how they become created viewings of time. There is a recurring theme in my sculptures of human histories of land. For example, in St. Louis, I collaged the Native American mounds of indigenous plants in relation to the formal, Versailles-like, French gardens of the later European settlers.

R: I am interested in your ideas of painting and commerce. That is, the kind of art you do, or were doing in the seventies, was always thought of as being heroic because it was against the grain of commerce. You were no longer making commodities that could be bought and sold. They were site specific, or just unpossessible by individuals. But that whole mood has changed so drastically in the 1980s whether is has to do with the revival of the commerce of art or the revival of painting and sculpture as commodities. But in any case, I am just wondering how you felt about all of this, and also the practical reality of making a living doing what you do. Do you have to depend on private and public commissions?

S: Yes, I do. The vast majority of my art is done through public, private, and academic commissions. It takes years to create the sculptures and complete the remuneration process, though some collectors are interested in buying the drawings, sketches, and plans for the environments I create. But I don't believe in the 19th–century romantic image of the starving artist.

R: Neither do I. I'm all against it.

S: It's good that younger artists have brought up the issue of money in relation to their art. The danger is that they can forget that art is above monetary value and that the artists' primary concern should be with the work itself, and with the philosophical issues that they are trying to express, not with its potential salability. Young artists should try to escape that win-lose attitude, that either-or situation. Remember, even Andy Warhol sold his first silkscreens for next to nothing.

R: That's true. It's just a question of something being tangible enough to sell.

S: Duchamp's original artworks were destroyed because no one would purchase them. Later, when they became art with a capital "A", he reconstructed them for sale by creating a suitcase of his artworks.

R: Well, that's archaeology. He was doing the same thing you are, reconstructing his earlier work and putting it into a tiny package, like a vitrine in a museum. How do you feel about your connection with performance art? Earlier you were, yourself, very much part of the ecological fantasy you constructed. Sometimes even dangerously so, or at least in extremes, as with the zoo.

S: In the zoo I occupied a cage next to apes and chimpanzees. I was the resident Homo Sapiens. I engaged in typical human activities, paralleling the typical activities of the other animals at the zoo. I read, listened to the radio. I used my body as a sculptural material to demonstrate that man is not so far removed from an animal. I think it is very important that we do not separate ourselves from our environment.

R: That brings up something that I have found to be a tough question for artists, that is to what degree they feel like a loner, or the degree to which you feel of a community in spirit with other artists. One could obviously connect you with all sorts of earthwork artists, like Smithson or Heizer or connect you with artists who are interested in art and botany and geology, like Nancy Graves. How do you yourself feel? Do you feel that you want to be part of a group, or do you feel as though you are distinct from others? I am wondering how you would classify yourself.

S: The artwork of Long, Heizer, and Smithson came from the minimalist tradition. They imposed this aesthetic on the earthworks in such remote places as the deserts and the mountains, and documented it to exhibit in galleries. In contrast, my art comes from my personal experiences with the land in, around, and under New York City. Since I grew up in a dense and crowded city, all my art concerns the human interaction with nature. My early work paralleled the earth artists, but it was done in urban and suburban centers, places where nature had been already reworked by humans, as opposed to the remote locations used by the others. In terms of gallery art, when Richard Long was initially only showing photographs of nature, I brought natural fragments into the gallery: rocks,

leaves, branches, and so on. I brought the organic into the gallery and directly mapped the land, respecting the actual land configurations of the original. Then I began to feel myself a visual and ecological archaeologist.

R: It means that it is accessible to the real world. Most people's knowledge of Smithson and Heizer has been through reproductions, including my own experience.

S: My commitment has always been to show a direct natural event as opposed to giving only secondary information. Also, my gallery installations of the natural elements are composed with an aesthetic derived from natural orderings, not the geometric shapes imposed on nature by the more minimalist artists.

R: I guess Walter DeMaria must have been a pioneer when he brought earth into a gallery in Germany.

S: Exactly. But he is more involved in the I-Ching, and his other artworks follow those concepts. In my art, I trace my own European roots of paying homage to nature as a basis for religion. I feel that it's important that we should get back to our own heritage to create a clearer symbol of our own environment. When I was in Japan, I became very aware of the contrast between the Zen tradition and the European tradition. In both there are repetitive symbols concerning trees, a part of the spiritus mundi, I guess. This inspired me to create an artwork juxtaposing the Japanese culture and ours.

R: There is a long enough tradition, just in terms of Western art of this kind of archaeology of nature, especially in the 18th and 19th centuries. You should have seen southern England after the hurricane last October. I was unfortunate enough to arrive there just the night before. But it would have been something for you, in terms of ecological disaster. It really looked like dinosaur territory, with all those trees uprooted and just strewn all over the streets and the parks. It was terrible, a real natural disaster.

S: Nature is not a gentle force. It's because we have very little contact with natural elements that we have created the myth of its docility. Nature can be cruel in its indifference to life and death. In the forests I create, I will always place dead trees within the living forests to represent the complete cycle. Like a hurricane, death is horrible, but it is a reality.

R: I must say that what you are saying now rings true. There was, of course, something terrible about this hurricane but also something very real about the death and destruction in this prehuman, subhuman world that had been so carefully cultivated by civilization, a sort of brutal truth about what things were like before the cities took over. When you saw the signs of it, you realized that trees lived

and died, the way you seldom do in the reality of urban centers. It was shocking on that level.

S: Without death the natural cycle is incomplete. Since in my art I am trying to create a complete picture of the cycle, I must represent both sides. This is an important issue: most people want only to see one side. It's sad to see the hurricane in England, but it does give an awareness of the power of the elements.

R: It's almost as bad as human events.

S: In the 20th century we tend to separate ourselves from our natural past. My art visualizes the human effects on land. So the Tuscan historical forest, once again, maps the primal core of the land, surrounded by so many layers of contemporary uses of it. The Greeks introduced the olive tree to Italy, so I replanted the olive grove as the outermost ring, olives and olive oil being so central to contemporary Italian identity. We are part of nature; we have to include ourselves within the natural system.

R: It is true that it is a fantasy that human beings can be unnatural. Human beings are just as much a part of nature as anything else, and anything they do, even what seems to be a violation of nature, is a part of nature. The whole idea of inorganic or organic, of natural or unnatural, is somehow predicated on a false assumption that we can be outside of nature.

S: Right. We feel that we are above the environment but in reality we are in a relationship with it. Like every other thing, living or dead, we are a part of the natural ecosystem. Cities are but one type of landscape. The similarities among the New York City subway system, the burrows of a fox hole, and an ant hill are, I think, more profound than their differences. Once I exhibited the cast of a labyrinthine animal burrow within the grid of city streets. It is through my art that I can create an awareness of the archaeology of these natural systems. I can see us in the future, living in little space satellites orbiting the earth, visiting the historic cities.

R: Just think, in the future you will be able to reconstruct the moon the way it was before man came.

Endangered Animal Drawing Series, graphite on paper, 1999, 22 x 30 in.

"In the center is the endangered animal. The rings represent the past present and future proportional survival of the species."

Alan Sonfist: A Portrait of the Artist as a Child

Wolfgang Becker, Aachen, Germany

Paul Klee is one of the first artists who considered the drawings and paintings that he made as a child to be the first items of his artistic inventory. It was a revolutionary gesture; the parameters of the art school would from now on be regarded as necessary obstacles in the maturation of a creative personality. The artist´s work would begin long before his academic education ends, and the artistic practice would no more be respected as a specific profession. Paul Klee inscribed traces of his childhood drawings into his paintings until the end of his career. Consequently, a new species of artist was born.

When I invited Alan Sonfist to exhibit in the Neue Galerie-Sammlung Ludwig in Aachen in 1976, he, like several American and European artists around 1968, abandoned the academic disciplines when he began his career and joined the movement of those who focused on "The Land", "The Great Outdoors", and "Earth Art". The problem of this large group of American and European artists was then: how could they return to the museums and galleries after having left the tight structure to which others had continued to adhere?

Sonfist did not belong to the formalist, minimalist sculptors who worked in deserts nor to the "farmers" and "Robinson Crusoes", neither to the botanists nor to the mineralogists. He did not undergo experiences of nature as a modern human observer, mixing aesthetic and scientific interests in an emotional pattern. He was, when I met him 30 years ago, engaged in a mimesis of natural processes—embracing trees and rubbing off the pattern of their barks, replacing monkeys in their cages in zoological gardens, and following the labyrinthine caverns of wild animals in the forests.

In most of his works he referred to experiences of childhood; his memories of loneliness, sadness, and happiness form a strong emotional foundation for his artistic work. Observing the destruction of natural environments in New York City (his environments, as he felt in his childhood) and information about the horrible consequences of civilization's "progress" created a deep feeling of loss. He gathered a strong will to belong to those pioneers of the century who had begun to re–create what had been covered or abolished by steady growth of the world's human population.

The search for identity in one's own childhood and the nature of which it is a part implies notions of innocence and virginity as paradigms of beauty. Never would Sonfist follow those who regard nature as uncontrollable, a cruel enemy of man victimizing him with epidemics and catastrophes. His forests are not jungles but parks. His re-creations do contain contemporary ecological arguments, but what

he essentially wishes to express is the happiness of a union with nature which he felt 40 years ago, when he hid between the twigs of a tree in the middle of New York City.

It was the retrospective element in his works which brought him from the forests back to the museums in the cities; he utilized them as places where the present is melted into past, and history is part of contemporariness. Maybe that is why he was welcomed in Europe after his first appearance in Aachen, the city of Charlemagne, in 1977, and Duisburg, the harbour city of the Ruhr District, in 1984/85, as well as Florence, the Medici city, in 1986 to 1989. He continues to work, in Paris, Northern France, Denmark, and again in Germany. In most of these places he was invited to build outdoor sculptures, transforming natural environments into meaningful installations.

The huge span of Sonfist's work is a cornucopia of statements, citations, and inventions using every media he could get hold of. Many of them belong to the natural sciences and have appeared in museums of nature before, where they returned in modernized forms. This means that they were regarded as artworks for a short time, readymades which could be used again, or proposals which could be easily exploited by following artists or adapted to contexts other than art.

He regarded the thousands of photographs he made as essential aesthetic statements. Now, after the experience of new group styles of landscape photography, a new evaluation will start of these early testimonies as revealing a growing awareness of nature. His big outdoor sculptures will be regarded in different ways, now and in the future. After the attention they got when they were first realized, they will unfold the complete vision of their author as they grow into their natural environment – and some of them will risk disappearing as they become integrated into their larger environment. And again, like his indoor work, they developed at the beginning of an international movement of new landscape gardening and architecture which is happy to follow his traces.

Sonfist takes his chance with this book showing the full scale of his work rather late, which means that after its appearance, several chapters of the history of environmental art will need to be corrected.

Alan Sonfist's Public Sculpture

Jonathan Carpenter, London

To review the public sculptures of Alan Sonfist since the 1960s is to witness the reemergence of the socially aware artist. His sculptures reassert the historical role of the artist as an active initiator of ideas within society. Each of his artworks fundamentally redefine what sculpture is, who the artist is, and how art should function for its public.

Sonfist's artworks establish new relationships between public sculpture and its site. In *Atlanta Earth Wall*, a relief sculpture that encompasses the entire wall of a building, layers of earth from beneath the site are the media: the red topsoil, the buried old city, the sand, the granite bedrock. In the exhibition catalogue for the project *Atlanta Earth Wall*, the critic Carter Ratcliff discussed that artwork in terms that also apply more generally to Sonfist's art:

"Alan Sonfist's *Atlanta Earth Wall* is a public monument of a new kind. Briefly, it takes its form and its meaning from a direct reference to its site. Most public artworks are large abstract sculptures in styles that have found approval within the world of avant-garde art and art criticism. Their appearance is thus a displacement of very specialized tastes and values from the art world into the public realm. In other words, what makes sense to an aesthetic elite is suddenly offered to the general public in a way that doesn't permit much recourse... In order to make sense out of the usual public monument one must take an imaginative leap out of its setting. That is because the work's meanings have been developed elsewhere, not at the center of contemporary life but in the art-world periphery. By contrast, the meanings of Sonfist's *Atlanta Earth Wall* derive from the site itself. It gives the individual a very strong sense of being precisely where he or she is here and now. This is an artwork that leaps over the boundaries of art-world specialization to become part of the environment. In doing so, it reveals the environment to us at a time when such revelations are essential for survival on the imaginative plane and also on the plane of the absolutely real - on earth itself."

Sonfist's concept of public sculpture can be clarified by contrasting his *Earth Monument* (1971) with Walter De Maria's *Broken Kilometer* (1979). Both artworks are based on measure. Sonfist's sculpture, exhibited in 1972 at the Akron Art Institute in Ohio, laid out in the gallery rods from a land coring 100 feet long. Encoded in the variations of color and texture of the rock were events in the history of that land during millions of years. Length was equal to time; material changes were equal to events on that site. De Maria's sculpture, also of rods lying on a gallery floor, was made of bronze fabricated in uniform lengths. Together they equaled an abstract unit of measurement, one kilometer. When De Maria utilized the idea of drilling in the earth for *Vertical Earth Kilometer* (1977) in Kassel, Germany, the distinction between his art and Sonfist's is again clear. Whereas Sonfist's sculpture emphasized every visual detail of the local earth, De Maria discarded the earth displaced by his drilling of the site and inserted a brass rod.

Sonfist described the way he thinks artwork should function as public sculpture:
"Public monuments traditionally have celebrated events in human history - acts or humans of importance to the whole community. In the twentieth century, as we perceive our dependence on nature, the concept of community expands to include nonhuman elements, and civic monuments should honor and celebrate life and acts of another part of the community: natural phenomena. Within the city, public monuments should recapture and revitalize the history of the environment natural to that location."

The art critic Lawrence Alloway summarized the innovation of Sonfist's sculpture, its unique revelation of its site and the social implications of his vision: "Sonfist's interest in monumental art rests on a revision of the idea of public sculpture, carrying it in the direction of both topicality and ethics." *Rock Monument of Buffalo*, the largest version of Sonfist's *Element Selections* artworks of the 1960s, was installed at the Albright-Knox Art Gallery in 1978. It is a sculpture that takes its materials and composition from the site, thereby enhancing the individual's relationship to the land he inhabits.

In an article in a Buffalo newspaper, Sonfist explained the objective of the artwork and asked people to seek rocks in their area. Each rock was selected by Sonfist for aesthetic power and verified for historical significance by a local geologist. Sonfist's composition of selected rocks embedded to scale in a 25-foot area on the museum lawn compressed a 50-mile area of the city. In his words, "The actual geology is like a book unfolding itself below the city; my art deals with creating and revealing aesthetic experiences that are normally inaccessible to people, either hidden under the ground or under roads and buildings, or inaccessible because the relationships exist in such large scale that they cannot be perceived or coherently related. My sculpture reveals what is below the surface and by collapsing the scale makes clear in one experience the geology of the entire area. The public monument for Buffalo can never be duplicated because it takes its form from the specific characteristics of its location."

Sonfist selected a site to bring together different times: the twentieth century museum, its Greek-inspired portico, evoking the art styles of thousands of years, and the rocks formed during millions of years. Each rock's contrasting color and texture reveal its individual history. The tilt, reflecting its original position in the ground, gives each rock the sensation of reach, as if it were emerging from its past into the present moment. Although faithful to the nature of the material, Sonfist's work is, in the end, evocative and poetic.

This vision becomes clearer through comparison with other recent sculpture built with boulders. In Michael Heizer's sculpture *Adjacent, Against, Upon* (1976) huge boulders are stacked to illustrate prepositional alternatives. In Carl Andre's *Stone Field Sculpture* (1977), Hartford, Connecticut, boulders are lined up in rows increasing in size, while decreasing in number and spacing within a triangular site. Sonfist's sculpture does not refer the viewer's awareness to language or numerical relations. *Rock Monument of Buffalo* refers to the immediate context of the viewer, placing people in space and time and in relationship with nature.

Each artist who began to build art with nature in the 1960s approached its use from a different philosophical basis. Hans Haacke's interest in systems led him to present natural systems, such as water, and later led him into examining the social system in which art exists. Robert Smithson's interest in myths, in ideas of order and entropy, led to his building natural materials into symbolic shapes, such as the spiral, and his intention to let them decay eventually. Sonfist's aesthetic philosophy is the positive interdependence of humans and nature. His youthful experience in a natural city park shaped his attitude toward nature as an isolated realm within an industrialized environment. When he made *Element Selections* from this threatened natural forest and transported part of it to a safer environment in 1965, he was establishing the basic theme of his art. This personal image has proved to have wider validity as a metaphor for the new relationship of society and the natural world that is unique to the twentieth century. Sonfist's art represents the meeting of personal myth and cultural need.

Up to the present time, the Earth could be pictured as a vast natural system with tiny isolated areas of human culture. However, human activity has been altering the globe as radically as have the Ice Ages or continental drift. Now, cultural areas have spread so much that the Earth has become a broad field of cultivated lands and chemically altered air and sea within which exist only a few patches of untouched nature. Sonfist's awareness of this vast change, which defines the modern condition, has led him to rethink what art should be.

Art and other products of human culture used to be rare items in a natural world. Now, objects of human creation are the norm, and products of unadulterated natural production are rare. The scarcity of nature makes it occupy the position that culture once did. It is becoming something of a rare collectible. This radically revised relationship of art and nature has inspired Sonfist's art.

In the 1960s, Sonfist made sculptures enclosing colonies of micro-organisms. People looked down on the red, green, black, and yellow shapes of these creatures spreading over the surface as they would later look at themselves on Earth from the moon. Sonfist brought from Panama a colony of army ants that lived in a gallery space. The winding paths in which they followed each other created a graceful drawing showing the patterns and structures of an entire society functioning within and sometimes mirroring a complex urban society. These artworks embody the vast perspective that characterizes Sonfist's work. He sees the Earth as a whole and the human being's place in it. He sees society as a whole and the artist's place in it. He sees time in its vast scale and the human being's place in it.

His largest work in actual scale is *Time Landscape* (l965-1978). Historical nature from past centuries is the medium for a series of sculptures on sites dotting the entire city of New York.

Time Landscape is built of trees and shrubs and grasses. The species chosen were present in the vast time before human intervention. As each area had a different natural past, Sonfist utilized distinct materials and compositions in each *Time Landscape*. In the Bronx he used the dense verticality of native hemlocks. In Brooklyn his sculptural materials were free-flowing sand and vines and grasses. In Manhattan his materials were the contrast of cedars in a low grass meadow and the sparse mass of a young oak forest. In Wave Hill a 10-acre site will have sculptures constructed of material from a succession of uses of the land over a 300-year period.

Another large-scale project is the *Monument to Texas* being developed with the Museum of Fine Arts in Dallas. On a series of islands isolated by the Trinity River, which runs through Dallas, Sonfist has designed sculptures using the elements of each of the natural ecologies of Texas. As the critic Ron Onorato has said, "Sonfist is an artist-historian, not of past civilizations, but of the earth itself."

Sonfist designs these sculptures through study, selection, and reintegration. Many observations are recorded; together these observations form a new totality while retaining their exact reference to the original site. Like the nineteenth-century Hudson River painter Asher B. Durand, whom he admires, Sonfist journeys to remaining untouched forests to study the visual relationships of a real natural forest. Thousands of observations are collected (he calls them "*Element Selections*") in the forms of drawings, photographs, and actual elements taken from the site. Nuances of difference in the position of rock to twig, of tree trunk to bush, are studied. Together, exhibited in museums and galleries, they describe the formal visual vocabulary of a natural forest. To create each *Time Landscape*, Sonfist combines these studies into his own composition.

Sonfist's method is clarified by comparison with Richard Long. Sonfist's movements through nature are not predetermined in shape or length; when recorded after a trip, they have an irregular shape formed by his own response to the forest: "As I followed the surface of the pine needles, it led me to observe a whitish hue. " In a museum, Long's collected rocks are arranged in geometric configurations, their particular order unspecified. Retaining no visual clues of their relationship to the environment, Long's shaped paths and rocks refer the viewer away from the site. In contrast Sonfist's artistic transformation of materials is a visual, contextual one; the act of pulling relationships out of the field of the forest floor isolates them, allowing new relationships among these collected perceptions to occur. An elegant calligraphy is created that was present but unseen because of other dominant relationships in the original environment. From a material standpoint the site has been faithfully recorded; from a visual standpoint a new entity has been created. Sonfist has simultaneously recorded and transformed the site.

Since the 1960s many artists have dealt with the land. Because the land has a potent meaning in America, carrying the myth of the frontier and the fruitful promised land, one cannot avoid the issue of the meaning of that use. Most of the artists who worked with the land continued the historic American push to the natural frontier. They claimed land much as settlers did: their sculpture was like territorial markings on land inaccessible to or remote from human contact. Seen in this way, these monoliths and markings appear as nostalgic references to a long-vanished era in American history. Sonfist's art deals with the present reality in which the unexplored frontier is only a myth: the reality is industrialized America from coast to coast. Sonfist's daring move has been to reverse the movement and bring the American frontier back to claim the urban context. When Sonfist uses natural materials from the site itself to make his public sculpture, he brings the city into a complex interaction with his art. The natural materials contrast vividly with the fabricated environment, yet are not alien to it. They actually preceded the structures on their own sites. Sonfist's sculptures act like a perspective point that allows people to see the present as part of a larger, vaster stretch of time. Natural monuments like *Time Landscape* become identifiable symbols for the city; an awareness of natural origins becomes part of the population's everyday consciousness. In Sonfist's work nature is given a new identity. It is not a competitor to be fought: humans against nature. It is not a backdrop for human recreation: humans using nature. Nature asserts itself as itself. It exists alongside people, occupying space with the same legal status as they do: humans and nature together equally.

People's response to *Time Landscape* has been enthusiastic. One segment of *Time Landscape*, considered by the board of The Metropolitan Museum of Art in 1969 as an outdoor work within the museum complex, was finally completed in 1978 on a 9,000-square-foot lot in Greenwich Village.

An editorial in *The Villager* newspaper expressed the reaction of the community to the new sculpture:
"Here in New York . . . many of our residents never have the chance to hear the message in the murmuring of pines and hemlocks. It is for this reason we are delighted that artist Alan Sonfist's proposal to create a "forest" in a 200 foot by 45 foot strip of land . . . is about to become a reality. That it would be filled with the types of trees and vegetation that existed here before the area was colonized 300 years ago is a great idea, especially to show those of our number who seldom see or hear a forest that New York was not always concrete and steel."

The reaction of public officials was also positive. Mayor Edward Koch wrote on April 18, 1978:

"I am delighted that the long-awaited "Time Landscape" project is being dedicated this morning in La Guardia Place. The concept of a year-round, natural microcosmic forest which would contain plants and trees indigenous to pre-colonial New York is fresh and intriguing."

Benjamin Paterson, New York City's Assistant Director of Cultural Affairs, noted that "the fragility and vulnerability of this living and exposed site cannot help but magnify for the public at large the urban ecological concerns of the 1970s, 1980s, and 1990s."

Immaterial forces of nature such as light, heat, wind, and growth have also been the subject of Sonfist's art. In attempting to visualize these processes, Sonfist has redefined the use of fabricated materials in public art. Bronze or steel is commonly used to create a form that is then placed in a natural site. Such sculptures are regarded as environmental, but in reality these sculptures have nothing to do with the environment. Nature functions as if it were a traditional pedestal: it is used to isolate the artistic object from other objects, to create a context of different materials in order to enhance the impact and drama of the composed form. Any spatial extension of materials different from the sculpture would serve the same function.

Sonfist's attitude toward fabricated materials is different: his materials exist to make visible the natural elements of the site. The form of steel is decided not in reference to artistic styles, but for its appropriateness in interpreting natural forces. Nature is the subject of his work, not merely used as its context. He has used steel, copper, bronze, and glass - all to focus attention on some aspect of natural elements. *Crystal Monument* (1966-1972), for example, consisted of a transparent column that contained natural crystals ranging in size from microscopic to one foot. Installed in Dayton, Ohio, in 1972, the crystals regroup and shift position continually, responding to the surrounding temperature, illumination, and air currents. The column isolates and frames the crystals, providing a field on which to visualize patterns of changes in the environment. Jack Burnham, writing about *Crystal Monument* in the *Britannica Yearbook of Science and the Future* in 1973, said of Sonfist, "He sees 'sculpture' in the ecological exchanges that occur every day and believes that man-nature stability will come only when we have become acutely sensitive to the natural changes around us."

Selected Critical Excerpts

"Once upon a time it was a function of art to mirror nature but in the new ecological era, art is more likely to be nature."
Grace Glueck, New York Times

"To complete the Time Landscape on the La Guardia Place site, Sonfist had to weave his way through community groups, local politicians, real estate interests, several arms of city government, art patrons, and their lawyers."
Jeffrey Deitch, The New Economics of Environmental Art

"His art exposes the dichotomy of art-life as the myth that it has always been, and we are finally made to realize that his main concern, that of time, is in fact only a thin veil between the hemispheres of one single, experiential world."
Ronald J. Onorato, ARTFORUM

"The Earth itself has become a part of the artist's imaginative calculations. On the other hand … Alan Sonfist… has reacted to a cosmic consciousness by returning to specific nature in its smallest detail."
Joshua C. Taylor, A Land for Landscapes, Smithsonian Institute

" …Sonfist cultivates a garden...and symbolizes the ecological servant of nature."
Mark Rosenthal, Some Attitudes of Earth Art

"The impetus behind Sonfist's art is an acute fascination with living things and their processes of survival."
Michael Auping, Earth Art: A Study in Ecological Politics

"Sonfist, providing the least to see, has the most to impart. His artworks relate to real time, as a process of the growth cycle, and as a subject in the alignment with nature. Neither a horticulturist nor a social reformer, Sonfist, nonetheless, aims, in the midst of bustling urban environments, to alert perceptions to the slow and sure rhythms of nature. His sensibilities and concerns are precisely those that moved our 19th-century Hudson River School artists to paint vistas of yet-unspoiled nature."
Helen Kohen, Miami Herald

Few artists have had such an unswerving, or generative, interest in the landscape (physical, social, historical) that surrounds us. Alan Sonfist is that rare species of artist – not just a pioneer in a particular form or approach, but a real trailblazer whose ideas have remained consistent, and consistently interesting, over the course of an entire career. No history of post-war art would be complete without an acknowledgment of his achievement."
Jeffrey Kastner, Cabinet Magazine

"After making art of quiet distinction for over 30 years, Alan Sonfist suddenly finds himself close to the spotlight. His concern for the fragility of nature, rather than for its sublimeness or monumentality, makes him a forerunner of the new ecological sensibility. "

Michael Brenson, New York Times

"At the time when more and more gardeners are recognizing the value of using native plants, pioneer landscape artist Alan Sonfist draws upon such plants in the context of the area's natural history. He tells the stories of cultures and natural habitats. And awakens our responsibilities to the conservation of our environment."

C.S. Johnson, Horticulture Magazine

"To review the environmental sculptures of Alan Sonfist since the 1960's is to witness the reemergence of a socially aware artist. The sculptures reassert the historic role of the artist as an active innovator of ideas within society."

Jonathan Carpenter, Public Sculptures

"Alan Sonfist's *Earthwall* is a public monument of a new kind. It takes its form and meaning from direct reference to the site."

Carter Ratcliff, Art in America

"The concept of a year-round natural microcosmic forest which would contain plants and trees indigenous to pre-colonial New York is fresh and intriguing and is desperately needed for our city."

Ed Koch, former mayor of New York City

"Sonfist is the premier landscaper of urban forest restoration bringing us a unique view of what is below our concrete existence. He's been in the vanguard of those profoundly devoted to the understanding, protection and preservation of our natural surroundings."

Stephen Prokopoff, Director, Museum of Art, Iowa

"Sonfist himself is a pioneer. Today, reforestation is an urgent issue worldwide, but back in the mid-1970s he was creating landscape sculptures of endangered species of trees. Native seeds, a trend now among gardeners and landscapers, have been planted in his projects since the mid- 1960s. His working ground is particularly compelling for Americans. His is an uncompromising, tough-to-classify art, part sculpture, part landscape design, which plays on the forces of nature and time."

Michael McDonough, Metropolitan Home

CHILDHOOD

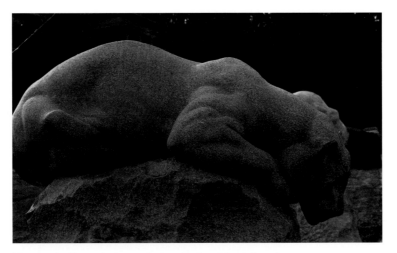

Lioness in Zoo, photograph, age 7, 2 x 4 in. (above)

Within My Tree, crayon, age 6, 9 x 12 in. (left)

"My sanctuary was my wise red oak, which I would become part of."

As a child, Sonfist watched the annihilation of a forest in which he had played every day. The native Hemlock forests of the South Bronx that he loved disappeared almost instantly. The town paved over them, declaring them dangerous. Sonfist tasted loss for the first time, and it spurred him to create. Loss and time's passage became the most prevalent themes of his art.

The haunting images in this chapter are childhood drawings, that Sonfist saved. They instantly remind the viewer of primordial cave paintings. Sonfist did not know it at the time, but the major concerns of his life's work were already in place. Unlike many of the environmental artists who later joined the movement and became contemporaries, Sonfist was reconciling the relationship of Humans vs. Nature even during his childhood.

"We are made from Mother Earth, and we shall all go back to Mother Earth."
 Shenandoah belief

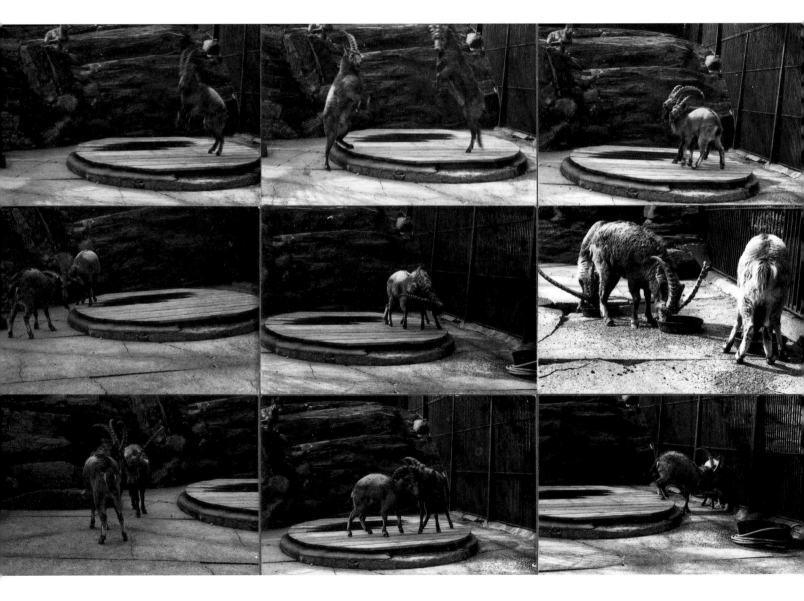

Animals Running and Fighting, crayon, age 3, 8 x 16 in. (above)
Photographic Series, age 7, 6 x 9 in. (left)

"From my birth, my parents would take me to the Metropolitan Museum of Art, the Museum of Natural History,
and the Bronx Zoo. It became a ritual. My parents always gave me a tool to record my observations."

Animal Collection, drawings, age 7, 16 x 20 in.

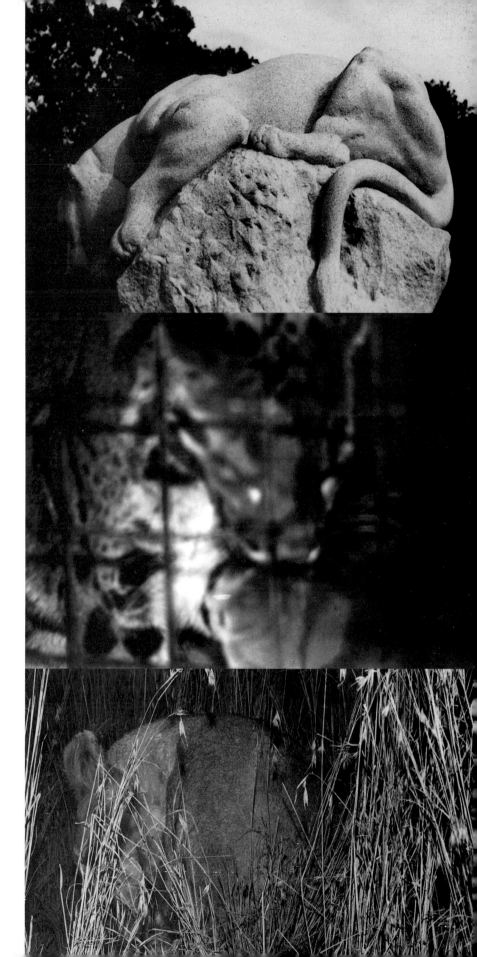

Caged Lion, crayon, age 8, 8 x 10 in.(left)

*Sleeping Lioness, photograph, age 8,
4 x 5 in., photograph of lioness statue
in Bronx Zoo*

*Tiger Rhythm Captured,
photograph, age 8, 4 x 5 in.,
photograph of live tiger in Bronx Zoo*

*Lioness Waiting, photograph, age 8, 4 x 5 in.,
photograph of stuffed lioness in Museum of
Natural History*

*"As a child, I didn't make a distinction between live
and inanimate animals. They were all part of my
dreams. I would photograph and draw all forms of
animals that I encountered."*

Hiding within My Trees, crayon, age 7, 9 x 12 in.

"Hiding in the womb of the wise oak covering myself with the fallen foliage, I view the world through the transparencies of a leaf."

Bird Flying, crayon, age 8, 8 x 10 in.

"I would fantasize about becoming the animals that I experienced."

"My life began in the teeming jungles of the South Bronx. On the way to school I passed smoldering fires and packs of dogs eating garbage. There were no trees anywhere - the few that had existed were long dead - there were only concrete streets and brick buildings. The streets were divided between local gangs and each gang controlled a section. Each day my walk to school was a passage through terror and my survival depended on my urban instincts. This was my first experience with nature.

Several blocks away there was an isolated forest where no one played. It was deep in a ravine of the Bronx River near an abandoned icehouse where they used to make ice from the river water. There were cliffs and a bridge across the river so I played on both sides of the ravine. The smells of the freshness of the earth were in direct contrast to the smells of the overcrowding and urban decay. Instead of gang members there were turtles and snakes. Instead of wild dogs that could sense my fear and who would attack if I entered their territory, there were deer and fox that were curious and gentle and would let me enter their world. The forest became my sanctuary. My wise oak always answered the questions that I had.

My fascination with the living animal spirit was overwhelming. I tended to imitate them by recreating their markings and movements in my play and artwork. Photographs and drawings in this section are my first documentations of flora and fauna from early childhood. I was especially interested in the human transformations of living animals into sculpture. We carve them out of stone, cast them in bronze and concrete and even stuff their once living hides. I spent many hours in the Museum of Natural History, the Metropolitan Museum of Art, and the Bronx Zoo.

My parents were constantly expanding my understanding of the world, beginning with the parks of the Bronx and then the museums of New York City. I created maps of my travels. My parents gave me my first camera when I was seven years old. Immediately, I went to photograph my wise oak in all it's magnificent beauty from top to it bottom.

As I grew older, more people from the neighborhood spent time in the forest. Little by little the undergrowth was trampled down, garbage was everywhere and fires were set. Later, when someone drowned in the river, the city decided the forest was a dangerous place. So they cut down the trees and poured concrete over the roots. The bedrock cliff was buried under the gray monotonous carpet of our city. My forest had disappeared."

Alan Sonfist

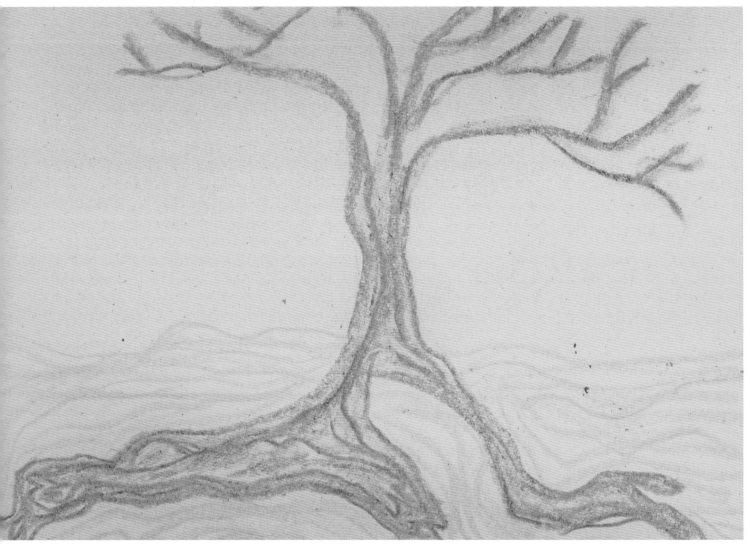

Hiding in the Oak Roots, crayon, age 7, 8 x 10 in.

Releasing Moon, crayon, age 7, 9 x 12 in. (above)
Releasing Bird, crayon, age 7, 9 x 12 in. (below)

"I would twist my body into the hollow of the oak as my hands became the leaves."

Traveling Safari within the City, photographic series, age 9, 8 x 8 in.(above)

Changing Observations of New York in Comparison to Changing Observations of Childhood, personal statements and parental statements, pencil (age 7), historical engravings of New York, size variable, Autobiography Exhibition at 112 Greene Street, 1979 (right)

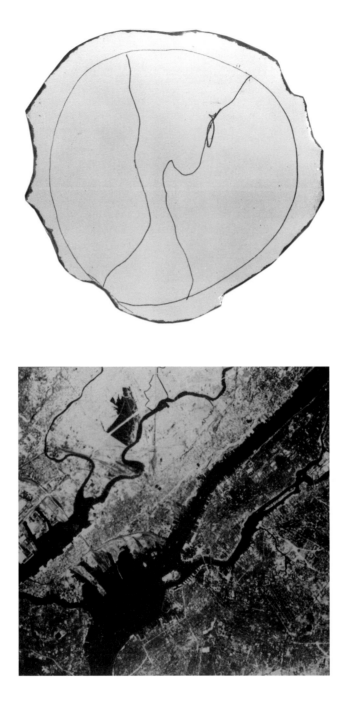

Comparisons of Maps, pencil (age 8), satellite photograph of New York, courtesy of NASA, each image: 6 x 9 in. From Autobiography Exhibition, 1979

"The life of a man is a circle from childhood to childhood, and so it is in everything where power moves."
Black Elk, Oglala Sioux

Autobiography of Dreams, 1974, 24 x 24 in.

"The box encloses dreams past, present, and future. The owner of the dreambox is the only one who can open it. Dreams were discussed with the collector for placement suitability."

"One cannot afford to be naïve in dealing with dreams. They originate in a spirit that is not quite human, but is rather a breath of nature."

 Carl G. Jung

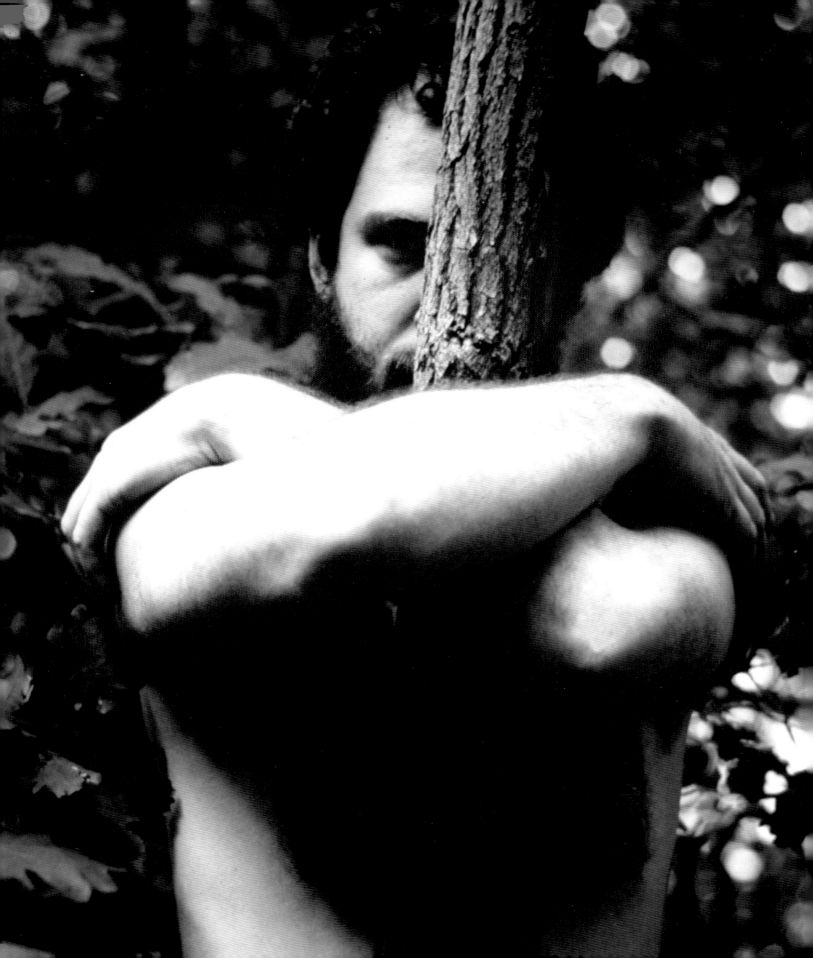

ANCIENT TREE

Tree Rubbing, resin and canvas, 1969, 6 x 10 ft. (above)

Tree Rubbing process documented in above photograph. CF

*Myself Becoming One with the Tree, photographic series, 1969,
8 x 10 in. (left)*

When he was a child, Sonfist's fantasy world existed in the Hemlock forest near his childhood home. He would talk with the trees, seeking the secrets at the heart of Nature.

Growing up caused his disconnection from this childhood empathy with nature. Only through hypnosis did the spirits of the trees resurface, inspiring a period of fertile creativity.

"One touch of nature makes the whole world kin."
 William Shakespeare

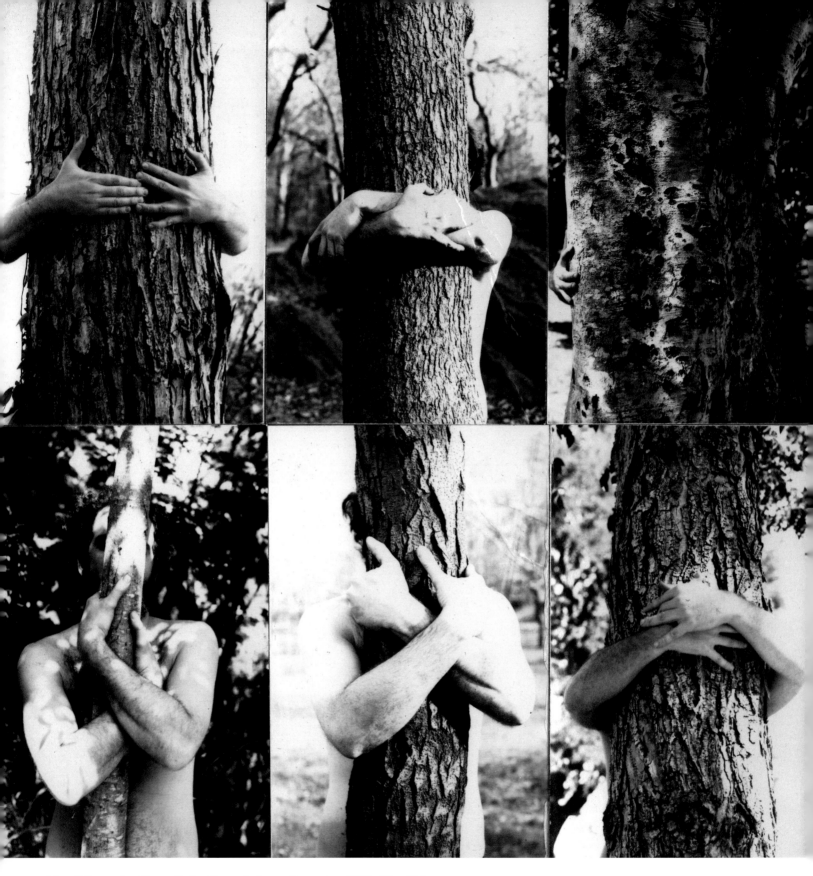

Myself Becoming One with the Tree, photographic series, 1969, 16 x 60 in.

"Revisiting my childhood trees, I immediately caressed the White Oak."

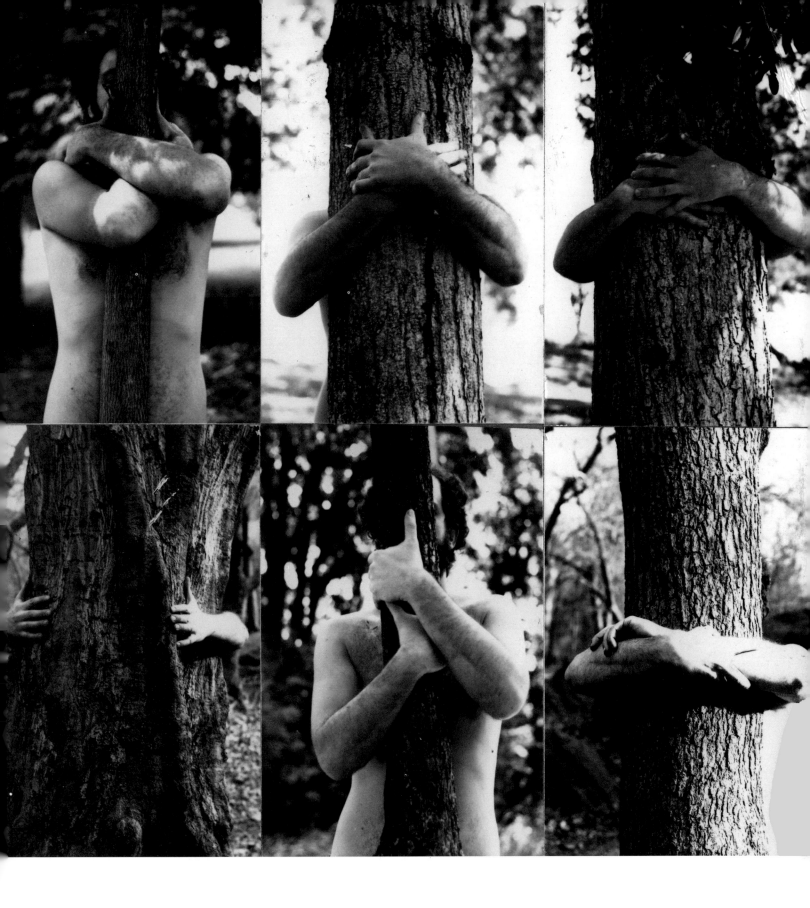

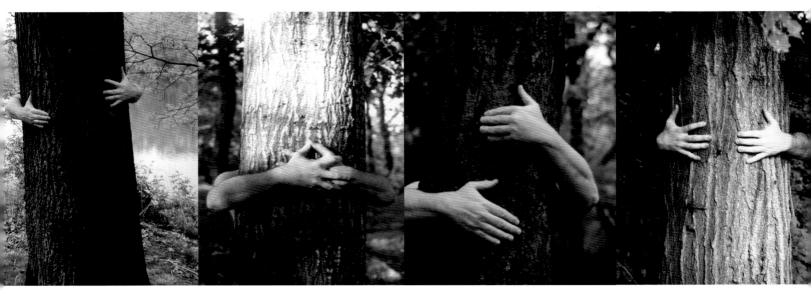

Myself Becoming One with the Tree #2, photographic series, 1969, 16 x 60 in.

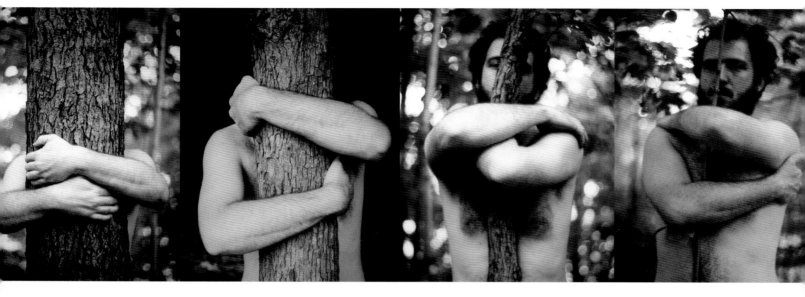

"I never saw a discontented tree. They grip the ground as though they liked it, and though fast rooted they travel about as far as we do. They go wandering forth in all directions with every wind, going and coming like ourselves, traveling with us around the sun two million miles a day, and through space heaven knows how fast and far!"
John Muir

Circumference of Beech Tree, photographic series, 1969, 8 x 40 in.

Circumference of Oak Tree #1, photographic series, 1969, 8 x 40 in.

Circumference of Oak Tree #2, photographic series, 1969, 8 x 40 in.

"As my own skin ages, so does the skin of the tree."

Circumference of Ancient Trees, resin and canvas, 1967, 6 x 15 ft. (above)

Oak meeting the Beech, resin and canvas, 1969, 6 x 10 ft. (right)

"As I caressed the trees, I saw their skin become mine."

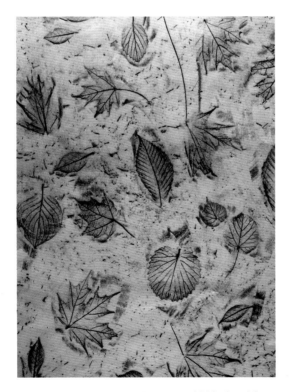

Earth Rubbing, resin and canvas, 1969, 6 x 4 ft.

Autobiography of Hemlock Forest, mixed media, 1969 - 75, 2 x 4 ft. (left)

Installation View, Dokumenta VI, Kassel, Germany, 1978 (below)

The photographs visualized the four seasons in the forest, creating a time landscape of the historical forest of New York. CF

Dreams with Asher B. Durand, mixed media, 1975, 2 x 4 ft.

"In my childhood I became fascinated with the Hudson River School painters, especially Asher B. Durand. In these prints I traced through historical records, travelling to the places where Durand's paintings were made and recorded my observations in comparison to his observations about the sites."

"In his youth, Sonfist made routine visits to the New York Historical Society and witnessed early topological maps of the region. These maps showed the magical streams and native wetlands, which had long since been covered by concrete. This in turn inspired childhood photographs; the cracks within the concrete were recorded, exposing the earth that had been hidden since those maps of long ago. In 1967, Sonfist was able to re-visit the memories of his childhood by exploring and photographing the forests in the New York City area. Throughout the four seasons, he collected rocks and fragments of endangered species, including twigs, seeds and leaves. Placed on pedestals, these natural elements became an art piece entitled Direct>Living>Museum Landscapes. He also separated them into more formal patterns, in works such as Leaf Gradation, Rock Gradation, and Twig Gradation."

Jonathan Carpenter

"I was exploring the various sizes and forms of what a landscape could be, from the microscopic landscape to the landscape of the universe. In each one of my artworks, I explored the unique qualities of each landscape through an art media that will enhance their visual representation."

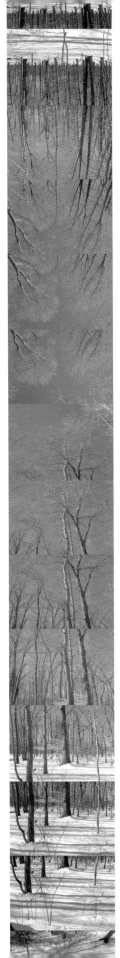
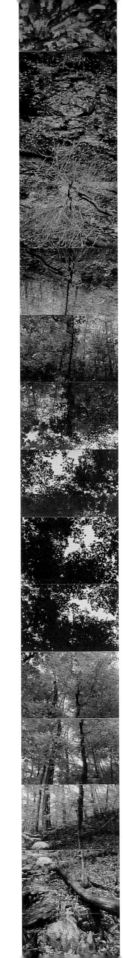
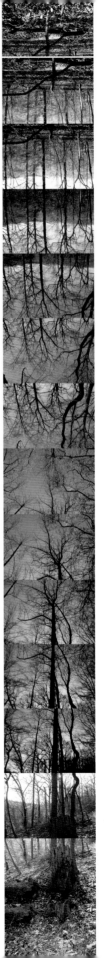

Forest Reflections,
photocollage,
1983, 120 x 10 in.

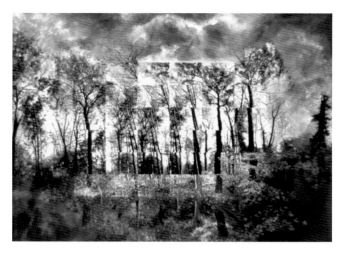

Endangered Forest of the East, Fall, mixed media, 1990, 42 x 60 in.

Endangered Forest of the East, Summer/Fall, mixed media, 1991, 42 x 60 in.

Endangered Forest of the East, Winter, mixed media, 1990, 42 x 60 in.

Endangered Forest of the South, Summer, mixed media, 1992, 42 x 60 in.

Endangered Forest of the East, Spring, mixed media, 1991, 42 x 60 in.

Endangered Forest of the East, Summer, mixed media, 1989, 42 x 60 in.

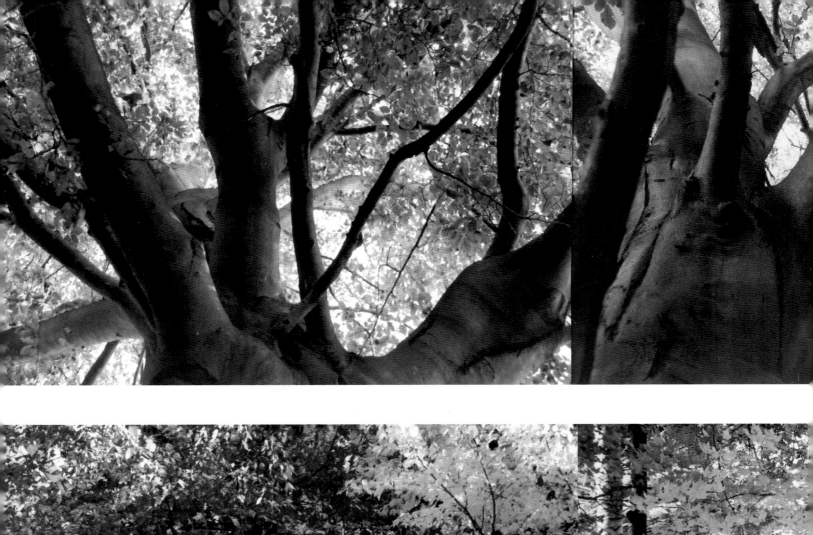

Cubist View of the Great Beech, photocollage, 1992, 11 x 42 in.

Cubist View of the Sugar Maple, photocollage, 1992, 11 x 42 in.

"I was inspired by Cezanne's landscapes to create a series of cubist landscapes."

56

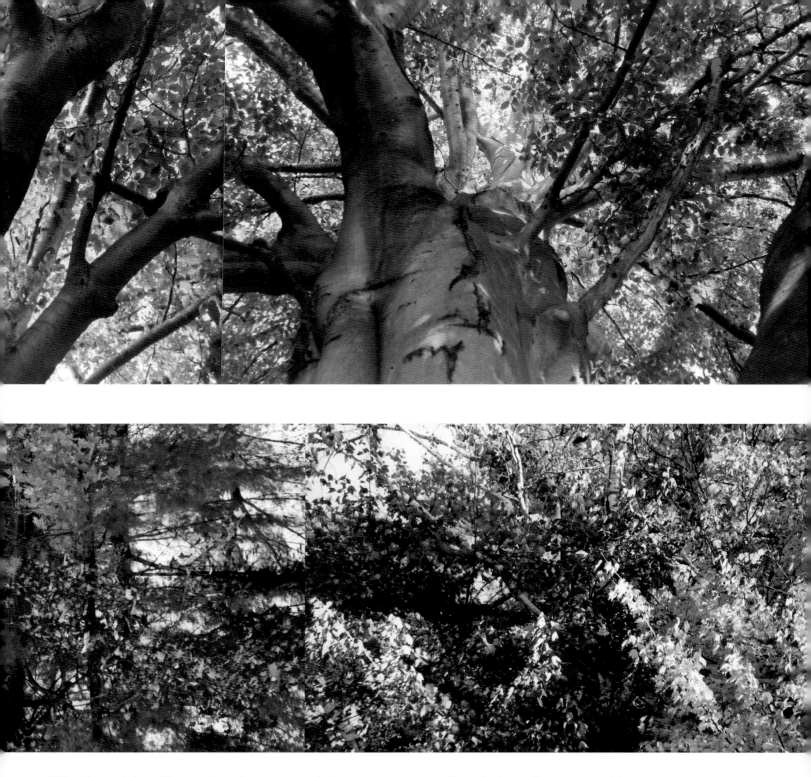

"We all travel the milky way together, trees and men... trees are travellers, in the ordinary sense. They make journeys, not very extensive ones, it is true: but our own little comes and goes are only little more than tree-wavings—many of them not so much."
 John Muir

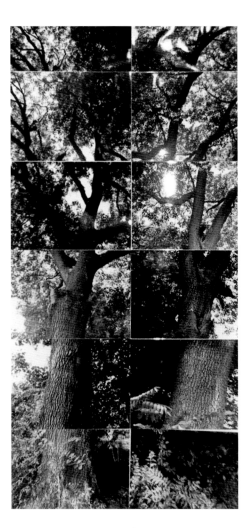

Cubist View of the Oak, photocollage, 1992,
20 x 48 in.

"The leaves danced in the wind, and the yellow came
forward as the sun shined through the skeleton of the tree."

Sugar Maple 180 degree Turn, photocollage, 1974, 40 x 70 in.

Nature/City, photocollage, 2000, 48 x 60 in.

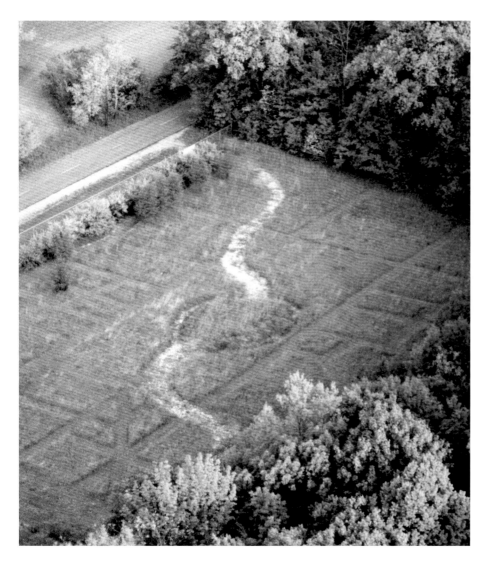

Labyrinth of South Bend, Indiana, 1986, 1 acre (complete)

"On each section of the city's grid, I planted its indigenous plants from ancient time."

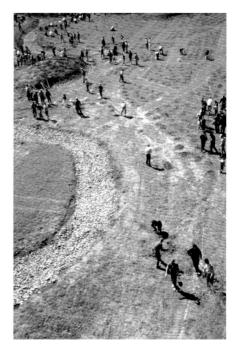

Labyrinth of South Bend (construction)

The members of the community came out to replant their section of the city. CF

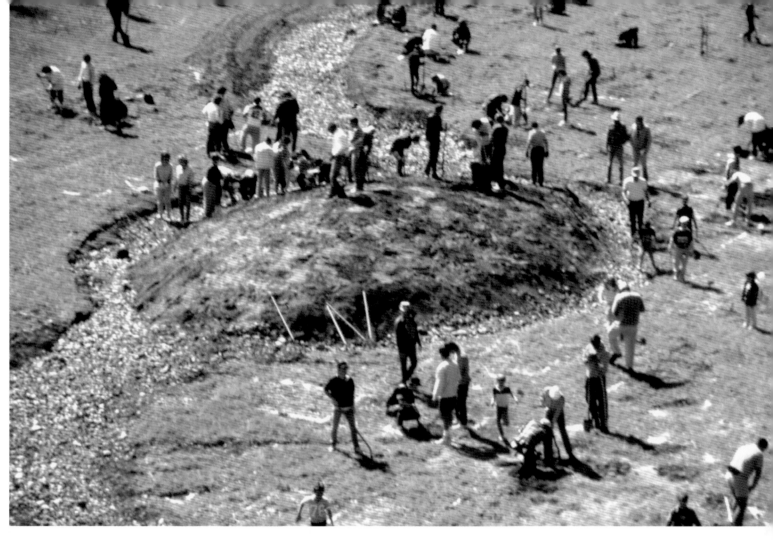

Labyrinth of South Bend (construction above, drawing below 24 x 24 in.)

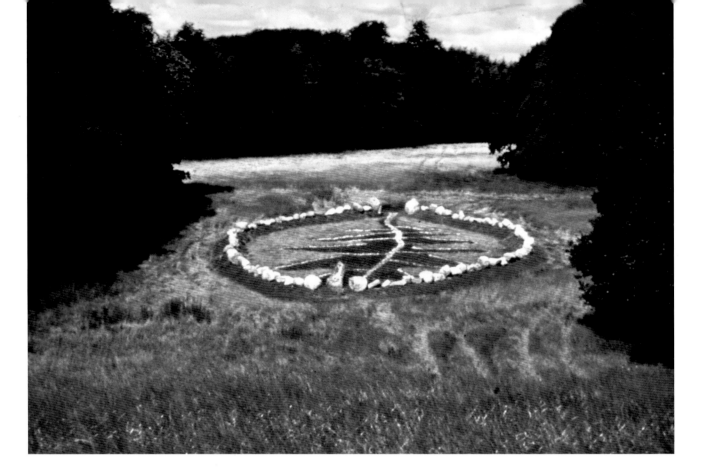

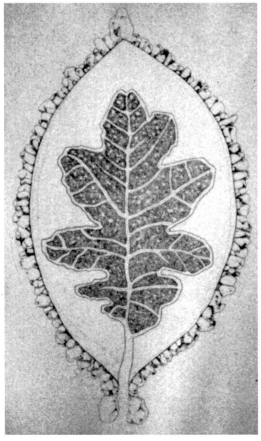

Labyrinth of 1,001 Endangered Oak Trees within a Stone Ship, 1994, 2 acres, Denmark (site above and right, drawing left)

"Stone ships in Denmark were created during the Viking period to protect the dead. Oak trees were used historically to make the Viking ships. The historical Oak forests are gone. I have taken the symbology of the stones and used them to protect the life of the future Oak forest in Denmark."

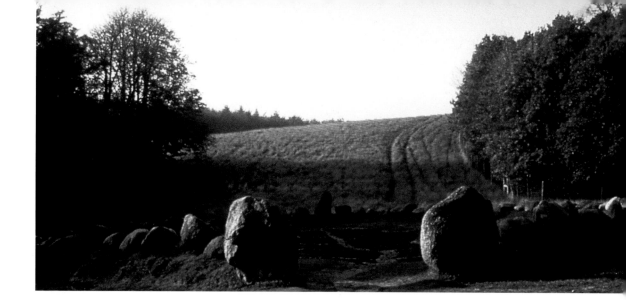

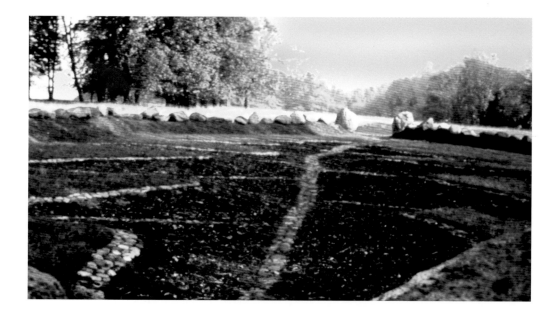

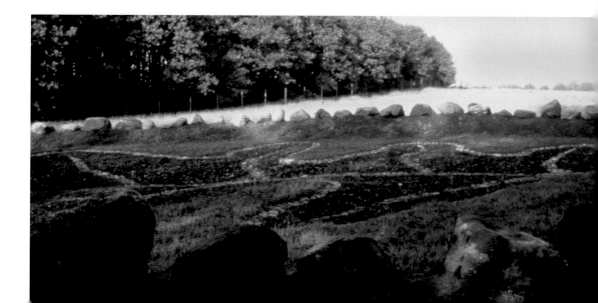

Burning Earth of California, encaustic, burnt trees and leaves, 2003, 48 x 48 in.

Myself as a Tree, photograph, 1969, 18 x 24 in.
Myself as a Leaf, photograph, 1969, 18 x 24 in.
(following spread)

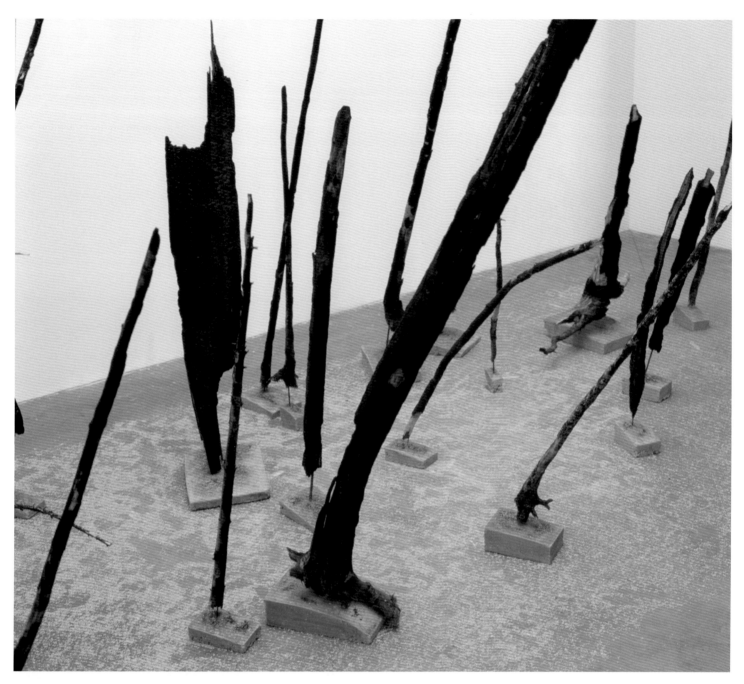

The Burning Forest, 1,000,000 seeds, concrete, steel, burnt wood, 2002, size variable,
Sponsored by Santa Fe Art Institute

The burnt-out sections of trees are relics from a forest fire in the southwestern United States. CF

"The tree which moves some to tears of joy is in the eyes of others only a green thing that stands in the way. Some see nature all ridicule and deformity… and some scarcely see nature at all. But to the eyes of the man of imagination, nature is imagination itself."
　　　William Blake

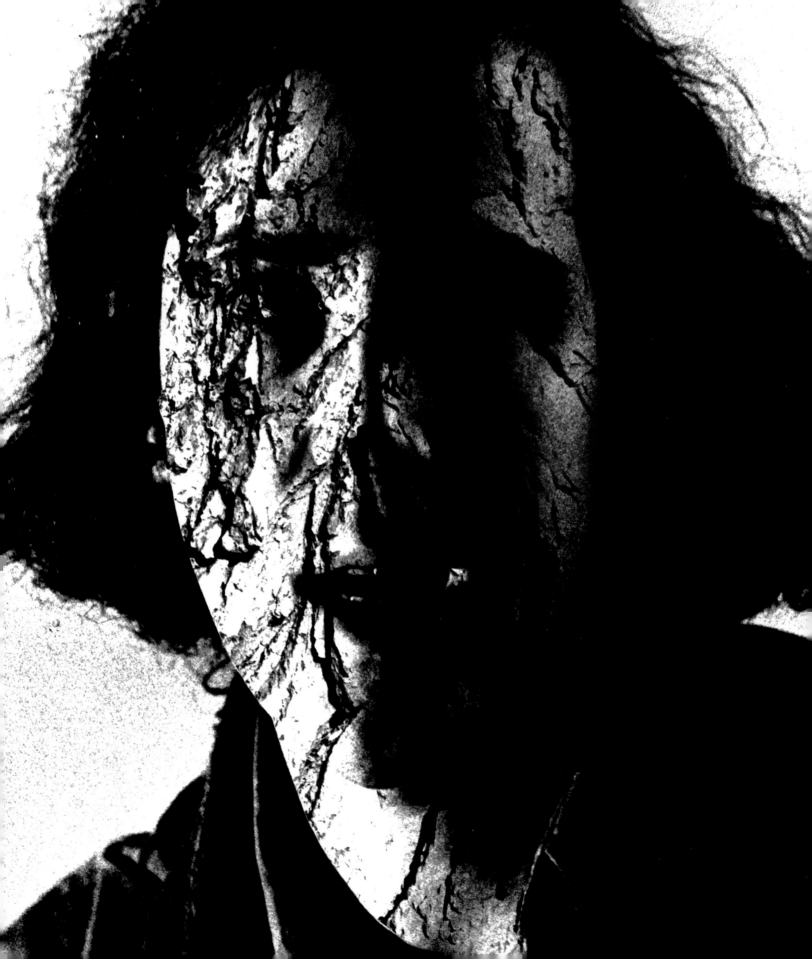

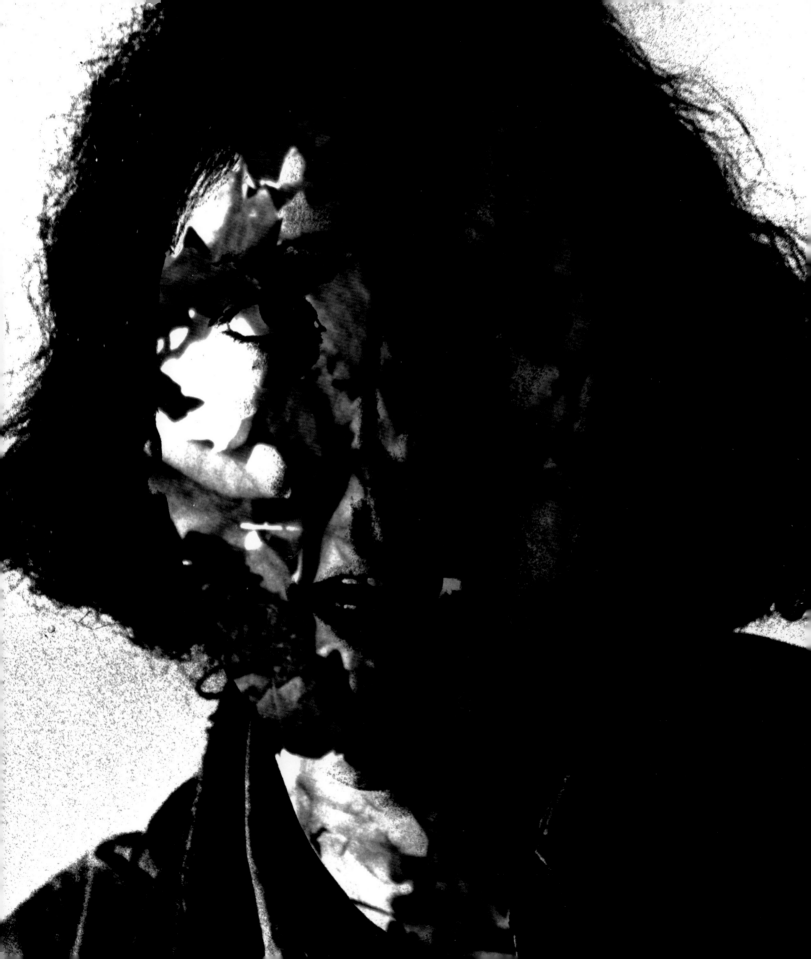

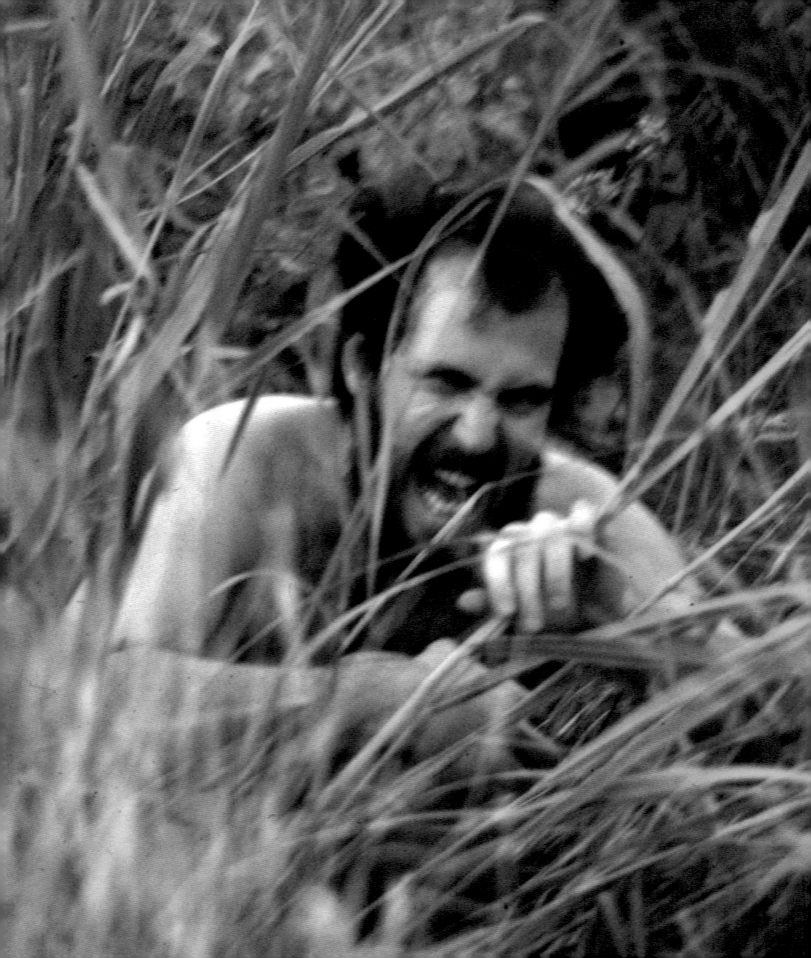

ANIMAL FANTASY

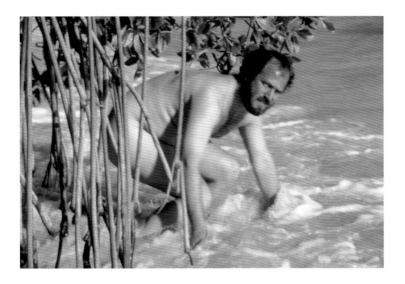

Alligator Attack, photograph, 1972-73, 8 x 10 in. (above)

Tiger Waiting, photograph, 1972-73, 8 x 10 in. (left)

Sonfist breaks through to the primordial and becomes animal. Every culture has identified with the animal within. Hidden in all of us lies the animal, crouched, waiting. The artist taps that savage energy. His body becomes the universe as he explores the animal within.

"There is a pleasure in the pathless woods,
There is a rapture on the lonely shore,
There is society, where none intrudes,
By the deep sea, and music in its roar:
I love not man the less, but Nature more."
 Lord Byron

Turtle Returning Home, photographic series, 1972-73, 32 x 40 in. (following 2 spreads)

"The edge of life brought out the animal within, I became the turtle who searched for water."

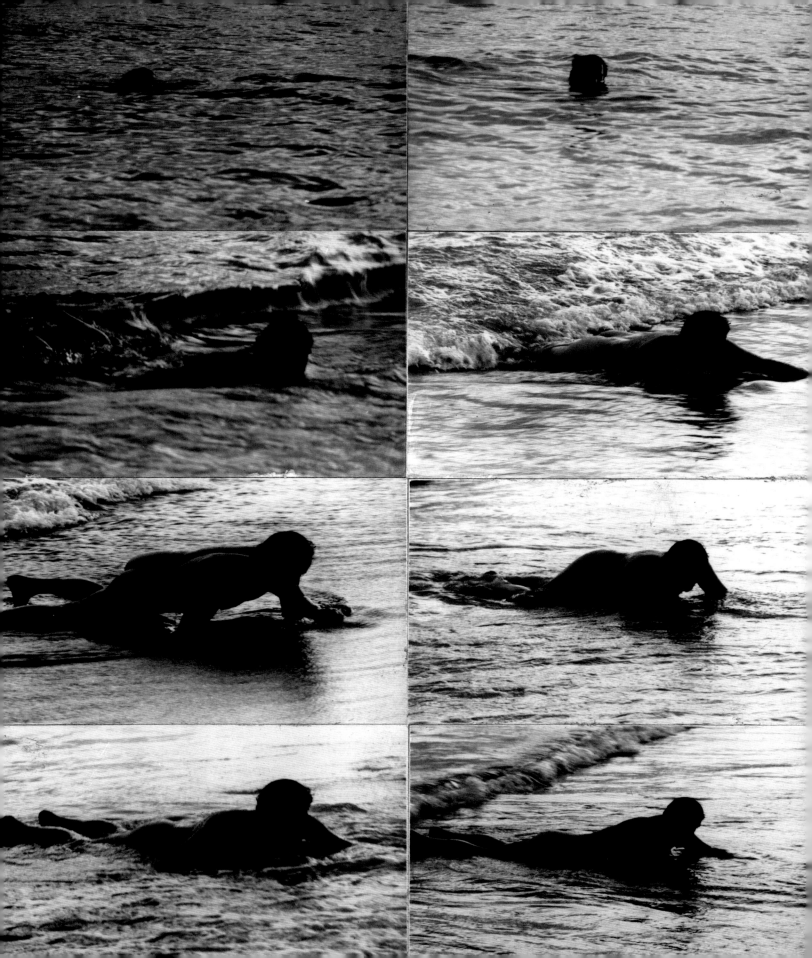

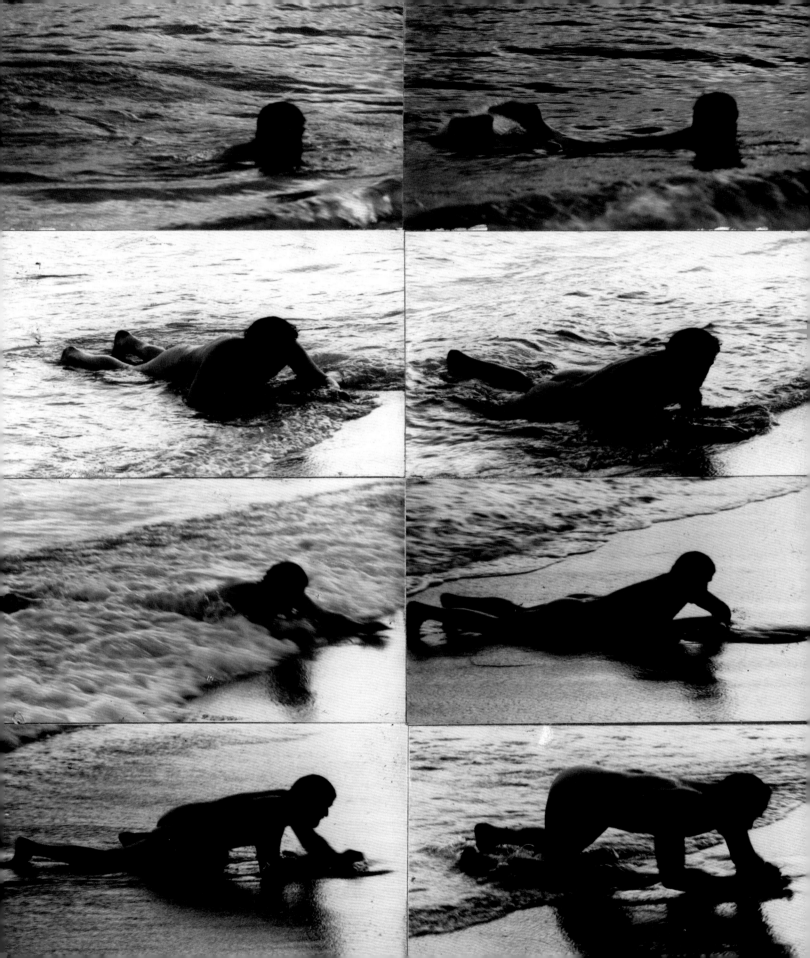

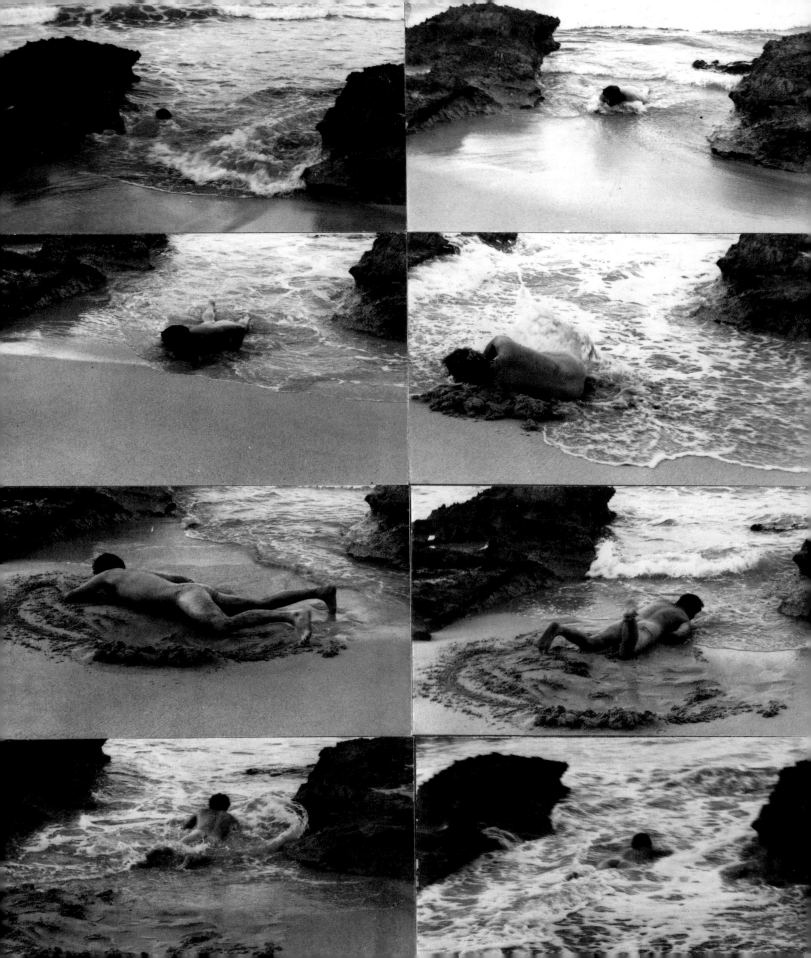

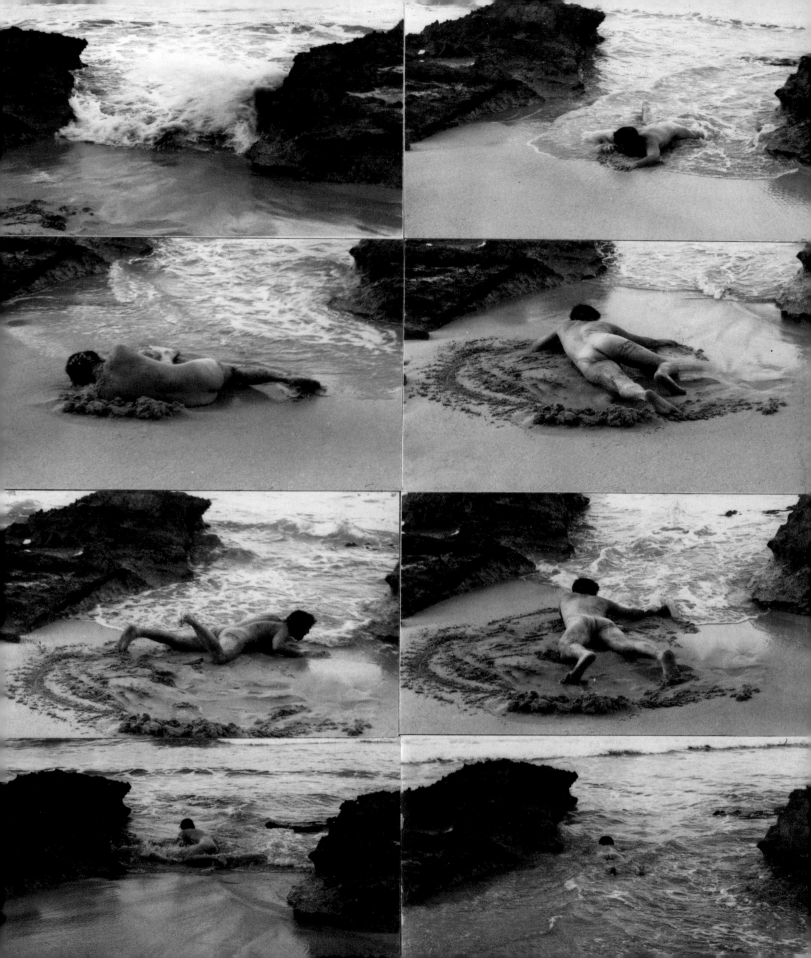

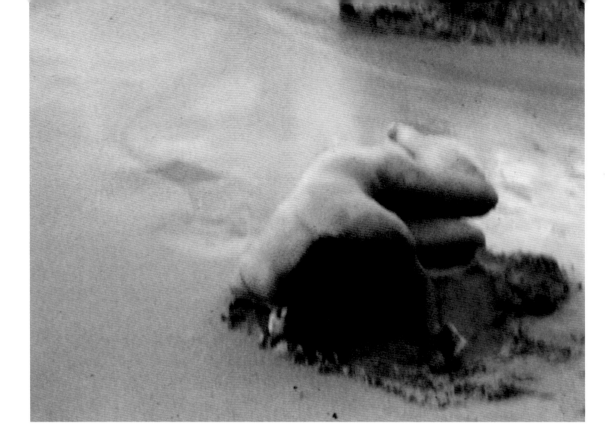

Seal Returning Home, photographic series, 1972-73, 8 x 10 in.

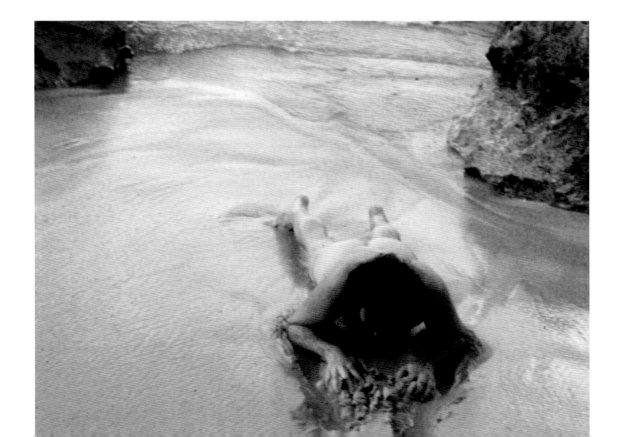

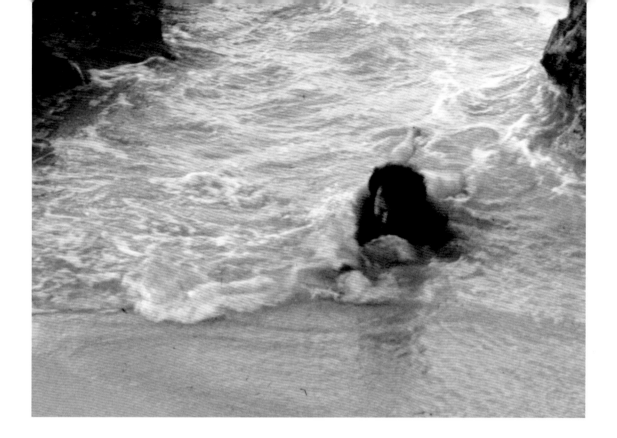

Seal Returning Home, photographic series, 1972-73, 8 x 10 in.

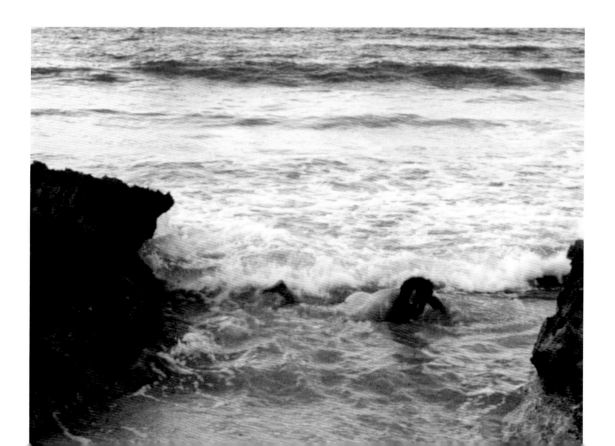

Crab Seeking Shelter, photographic series, 1973, 24 x 40 in.
"The crabs would dart in and out of the earth womb as I would bury myself within the sand."

"An artist, under pain of oblivion, must have confidence in himself, and listen to his real master: Nature."
Auguste Rodin

Territorial Gorilla Invasion, photographic series, 1972-73, 16 x 60 in.

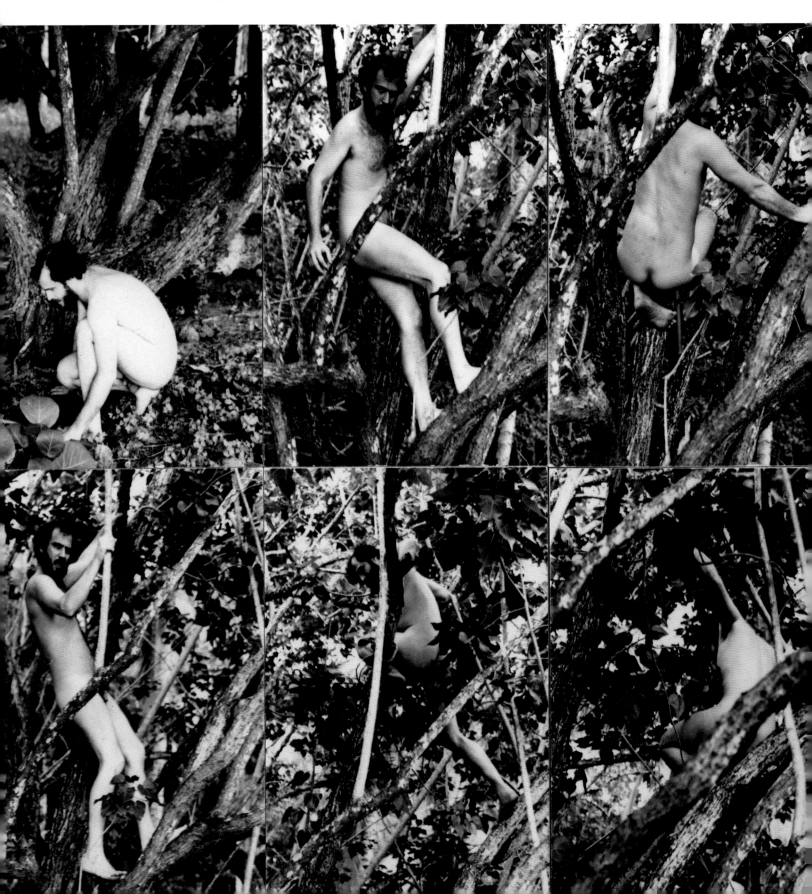

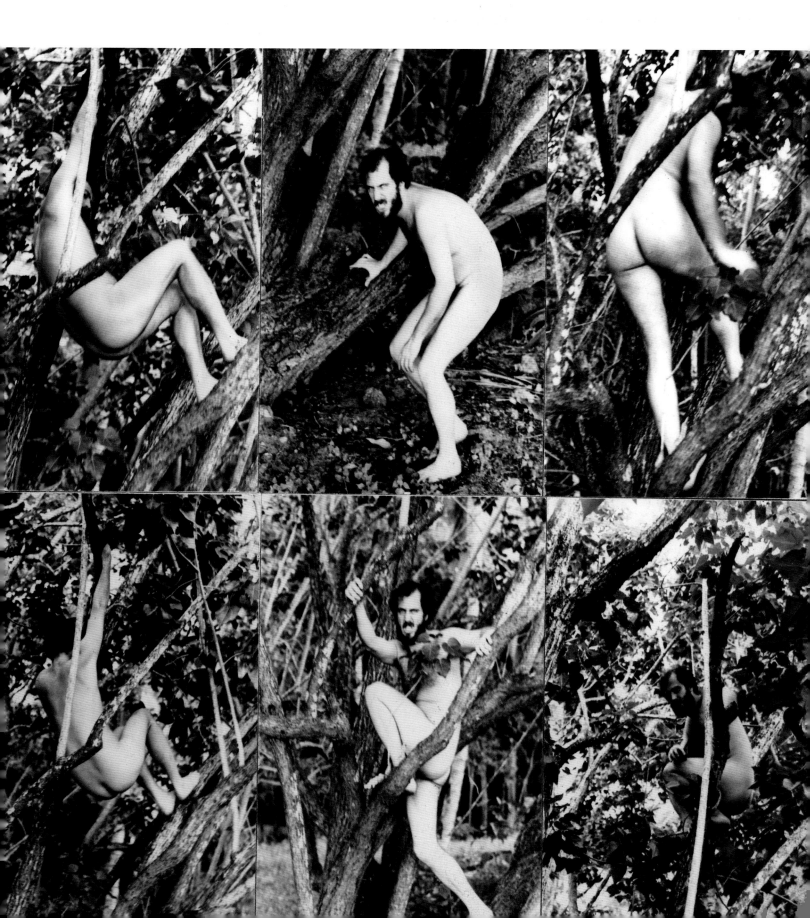

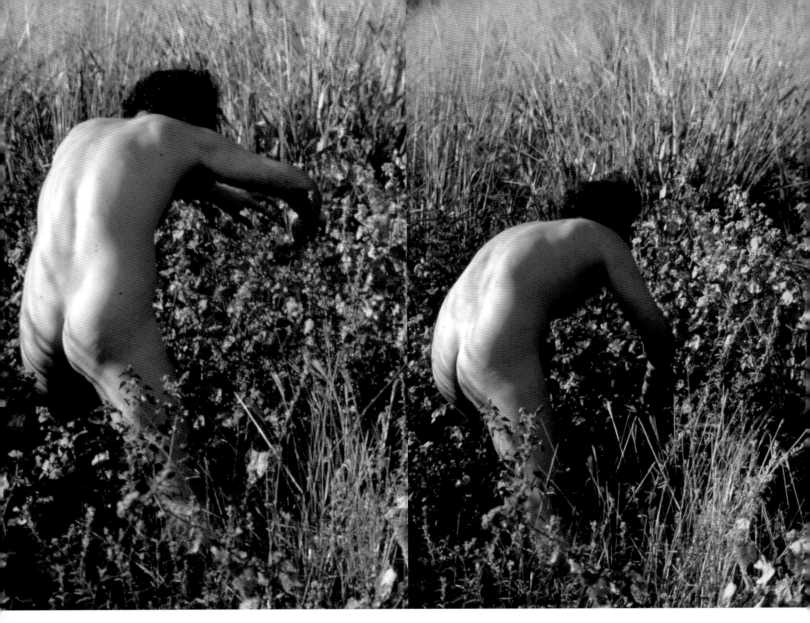

Tiger Attack, photographic series, 1972-73, 11 x 42 in. (above and following spread)

"I went into the grass to become one with myself. I knew someone was coming to photograph but I didn't know when. Gradually I began to think less and less of them and more of the animal. I became a tiger – waiting. I sensed the approach and my feelings were of anger. It was my territory not theirs. I leaped to test their judgement, but they kept coming so I held my ground and positioned for the final chance-kill. The tall grass opened and I saw as I had sensed before. They growled. I growled back. We stood and faced. They ran and I knew and I turned."

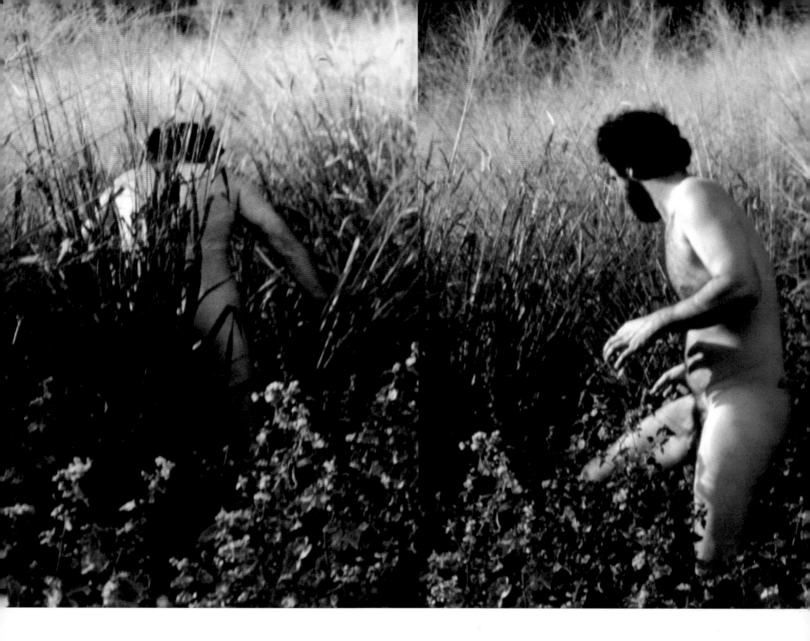

"All nature is but art, unknown to thee; All chance, direction, which thou canst not see; All discord, harmony not understood; All partial evil, universal good; And spite of pride, in erring reason's spite, One truth is clear, Whatever is, is right."
Alexander Pope

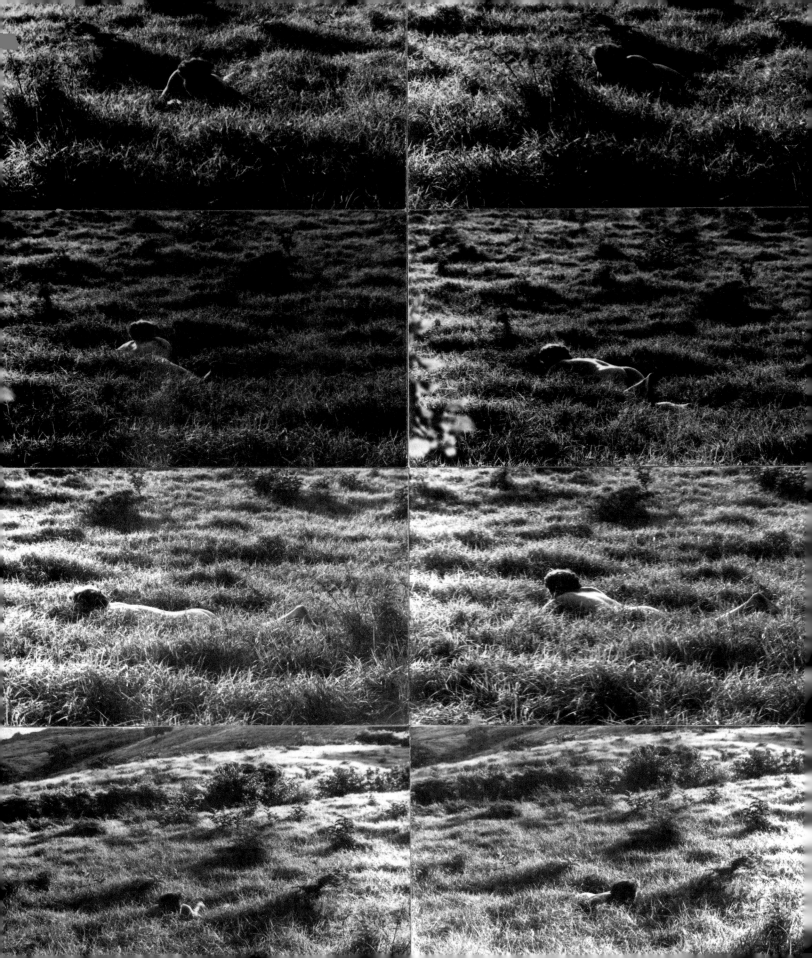

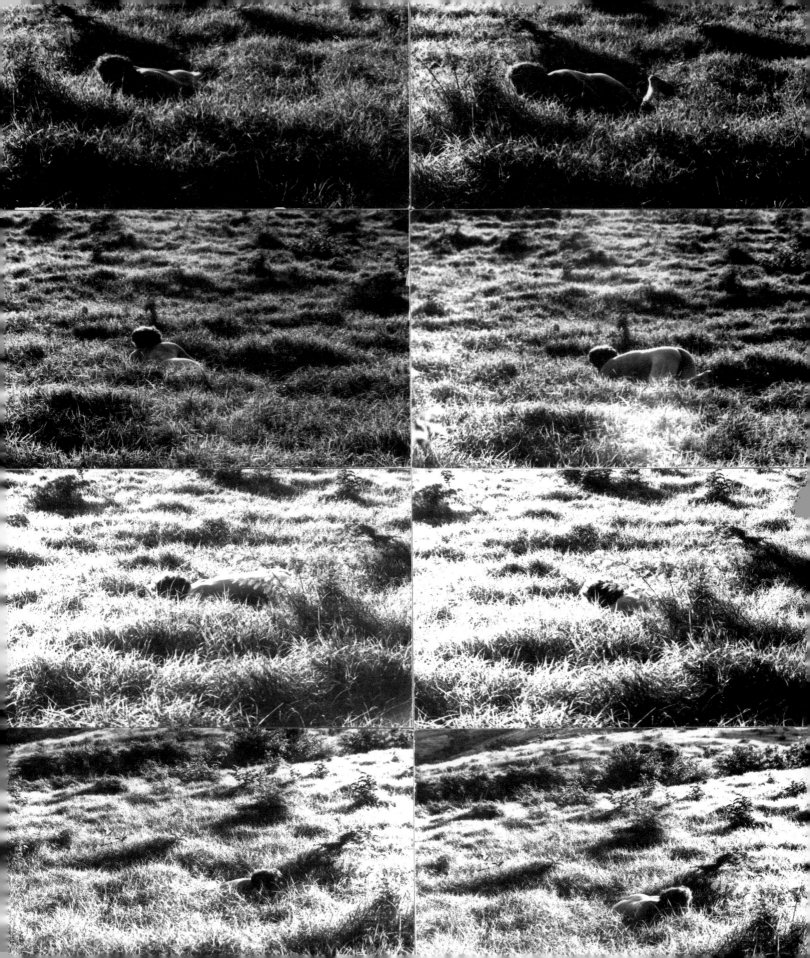

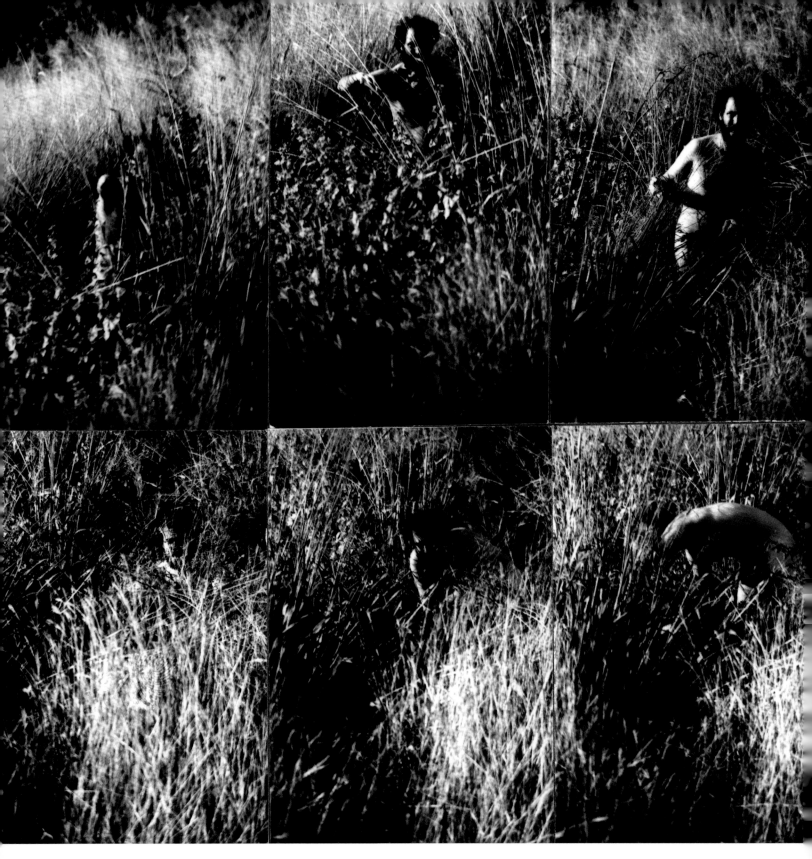

Tiger Chance Kill, photographic series, 1972-73, 16 x 60 in.

84

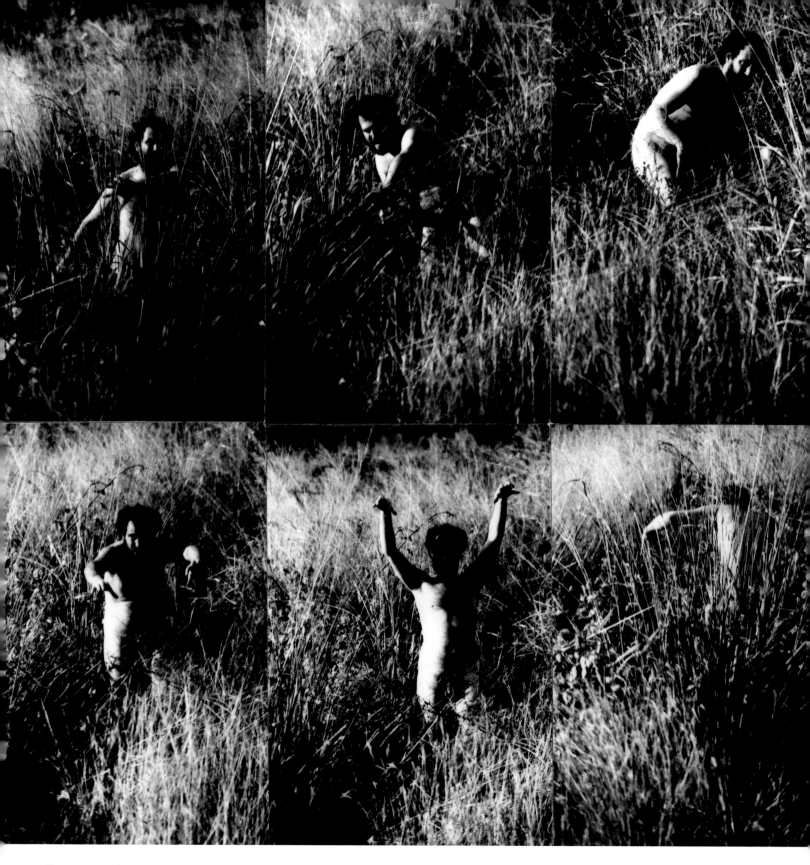

"I can sense the presence. My ears open through the sound of cracked twig. My smell
of the crushed blossom. My eyes to the movement of grass and I knew it was the time."

Animal Markings, My Markings, paint and earth, 1972-73, 24 x 36 in. (above and right)

Becoming the Animal Within, photographic series, 1972-73, 24 x 10 in.

"After a near-death experience I suffered in Central America, I left my body to the Museum of Modern Art, since they were the first museum to acquire my art. A year has passed and my body gradually began to rediscover itself as I regained a physical connection to the universe."

Last Artwork, will and body, 1972-3, 7 x 4 x 4 ft.

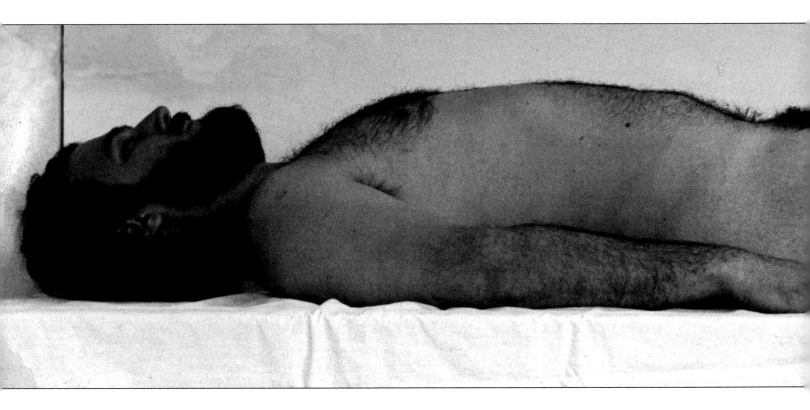

"Whereas, my body is my museum, it's my history. It collects and absorbs observations – interactions. It is the deciphering of these recordings that I project into the outside world. My boundaries define the world of art. I clarify my own common boundaries in relationship to the outside, whether it be the room I exist in, the country I exist in, the universe I exist in. By adding other awarenesses, I am constantly redefining my boundaries and projecting these awarenesses into my art."

"Nature is the art of God. "
Ralph Waldo Emerson

GHOSTS

Gravestone Petals, photograph, 1989, 30 x 40 in. (above)

Dogwood Walkway, photograph, 1976, 11 x 14 in. (left)

Sonfist created each of these works to be as ephemeral and transient as a mist. They were left to pass away, their elements reclaimed by nature like a body decaying into earth. Each work is a reflection of the natural processes of birth, death and rebirth.

As John Muir has said, "Let children walk with Nature, let them see the beautiful blendings and communions of death and life, their joyous inseparable unity, as taught in woods and meadows, plains and mountains and streams of our blessed star, and they will learn that death is stingless indeed, and as beautiful as life."

These artworks no longer exist in their original state. Only their photographs survive. The secret languages of the forest and the city are exposed through these photographic essays, collected over time. Each photo landscape selects a fragile moment, which will disappear as quickly as it is photographed.

Aging Leaves, photographic series, 1971, 8 x 30 in.

"Walking through the forest, feeling the texture of the newly blown leaves in relationship to the leaves from yesterday. Photographing micro-change. Each experience of the forest became a clearer understanding of myself."

Tree Cradling Leaf, photograph, 1979, 36 x 48 in.(above)

Forest Micro/Macrocosm, photocollage, 1970, 20 x 8 in. (left)

"Looking at the smallest details of the forest, I would see the universe."

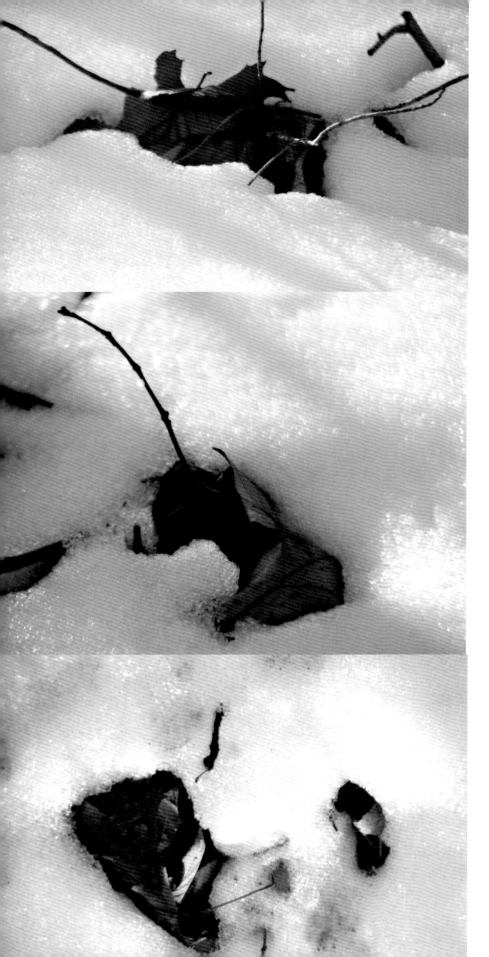

Finds In Snow, photographic series, 1977, 11 x 28 in.

"As the sun rose, the leaves would curl up into themselves. Following the conversation between the sun and the leaf over a period of time."

"I believe a leaf of grass is no less than
the journey-work of the stars."
Walt Whitman

*Three Views of Light, photograpic series, 1970, 10 x
24 in.*

*"As a child I would continually view Monet's Haystacks
and his use of the variability of light and nature."*

Book of Rock Sequence, photographic series, 1971, 8 x 50 in.

"As it takes millions of years for mountains to erode, I participated in the process by opening its secrets."

Universe of Rocks, photographic series, 1971, 24 x 30 in., (detail)

"As the universe is constantly evolving, so does every grain of sand."

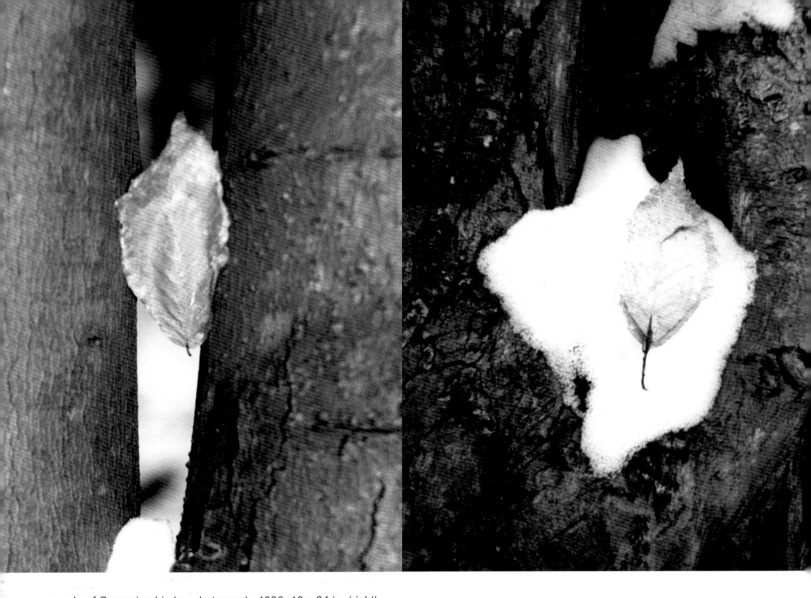

Leaf Caressing Limbs, photograph, 1990, 16 x 24 in. (right)

Snow Cradle, photograph, 1989, 16 x 20 in. (left)

Mother Tree, photograph, 1989, 24 x 36 in. (opposite page)

"To see a World in a Grain of Sand
And a Heaven in a Wild Flower,
Hold Infinity in the palm of your hand
And Eternity in an hour."
William Blake

*Leaves Reflecting the
Milky Way, photograph,
1981, 36 x 48 in. (top)*

*Double Yellow Moss,
photograph, 1975
11 x 14 in. (bottom)*

Nature's Hand, photographic series, 1969, 22 x 14 in.

Bark/Steel, photograph,
1976, 11 x 14 in.

"Visualizing nature and
technology interacting."

Nature/Culture Markings,
photograph, 1971,
11 x 14 in.

Leaves and Their Shadows, Two Views, photographs, 1974, 16 x 20 in.

Book of Leaves, photograph, 1974, 11 x 14 in. (above)

Dancing Leaves, photograph, 1979, 11 x 14 in.

Nature's Crosses, photographic series, 1971, 33 x 42 in. (following spread)

110

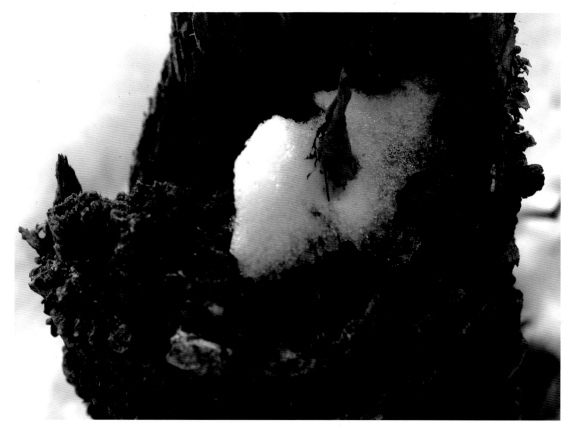

Leaf in Snow Nest, photograph, 1978, 36 x 48 in. (above)

Leaf Caressing Limb, photograph, 1978, 36 x 48 in. (below)

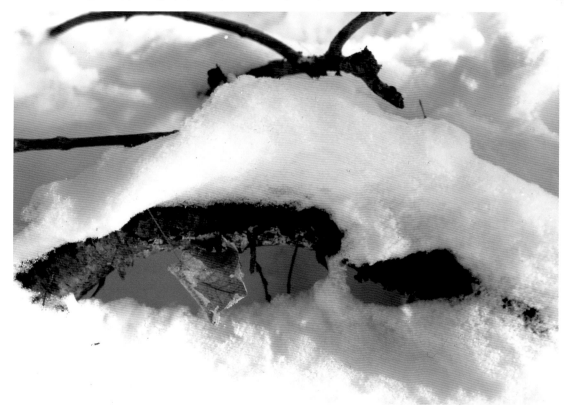

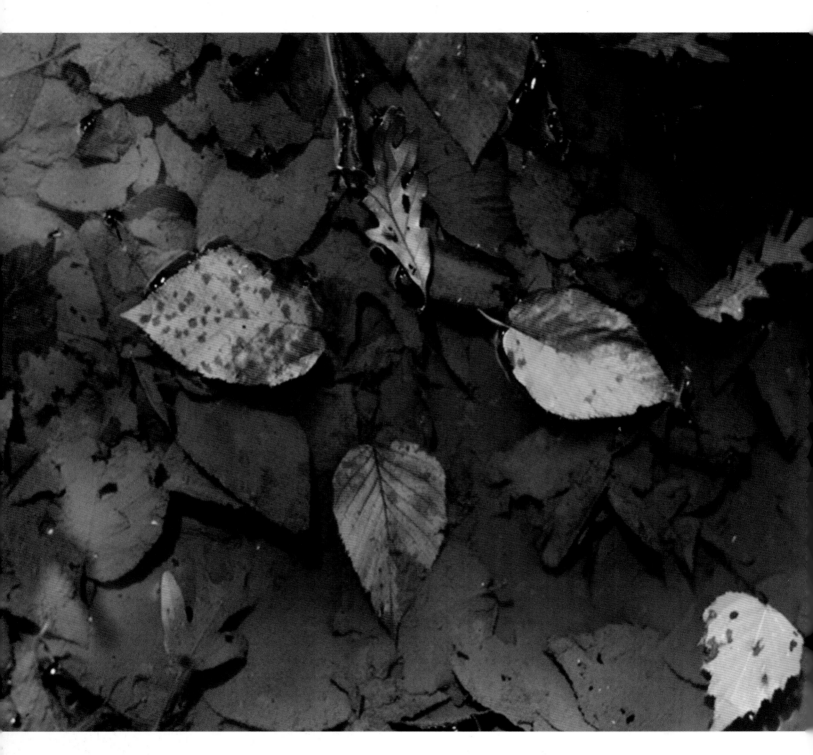

Leaf Cross, photograph, 1971, 24 x 36 in. (above)

Branch Reflecting Itself, photocollage, 1970, 22 x 28 in. (right)

114

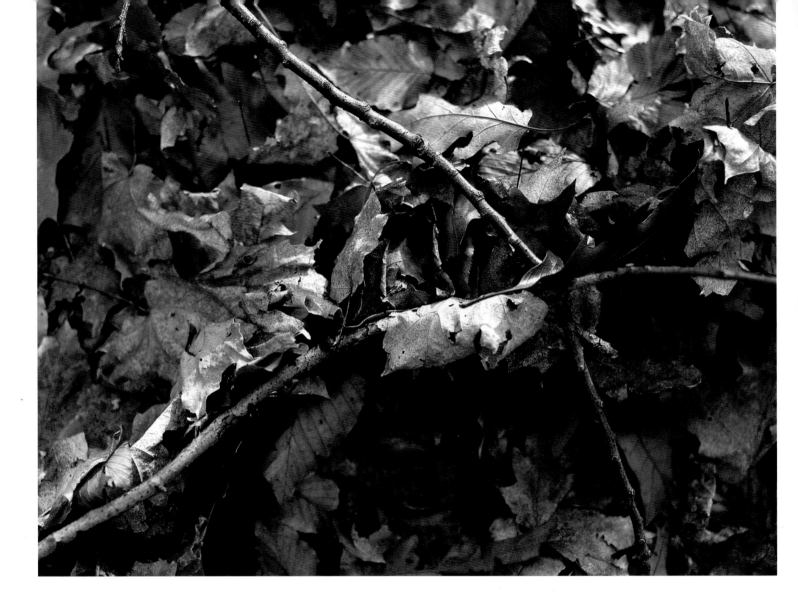

Nature's Cross, photograph, 1971, 24 x 30 in. (above)

Concrete Cross, photograph, 2001, 24 x 36 in. (right)

"As I looked for geometry in nature, I would find the same geometry in urban centers."

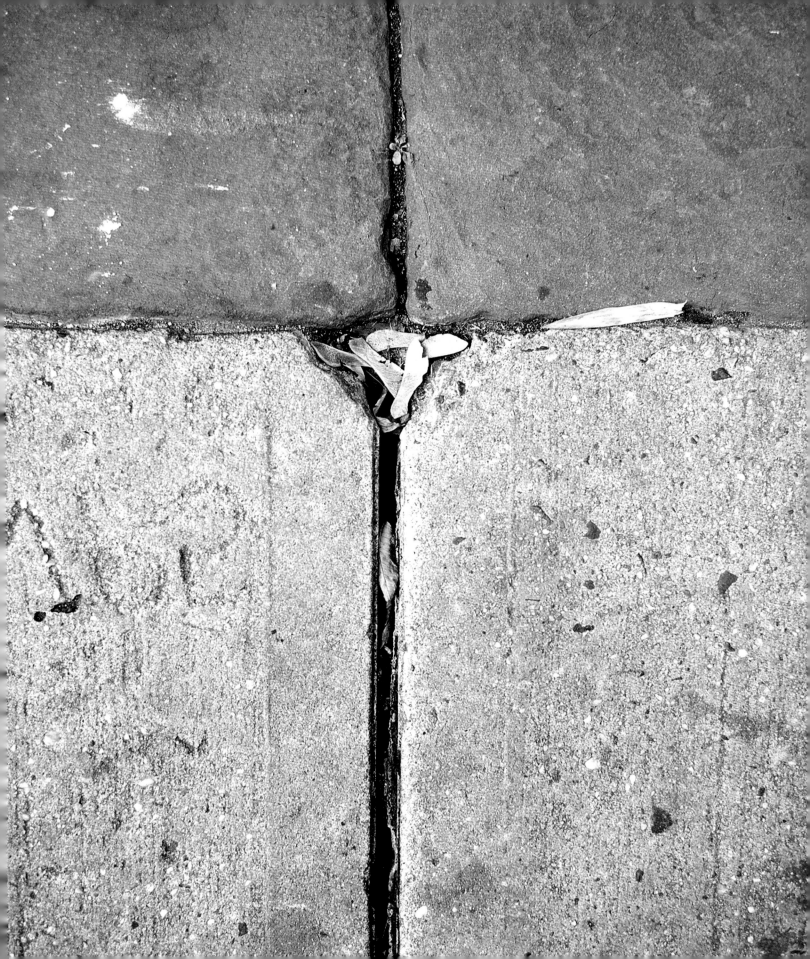

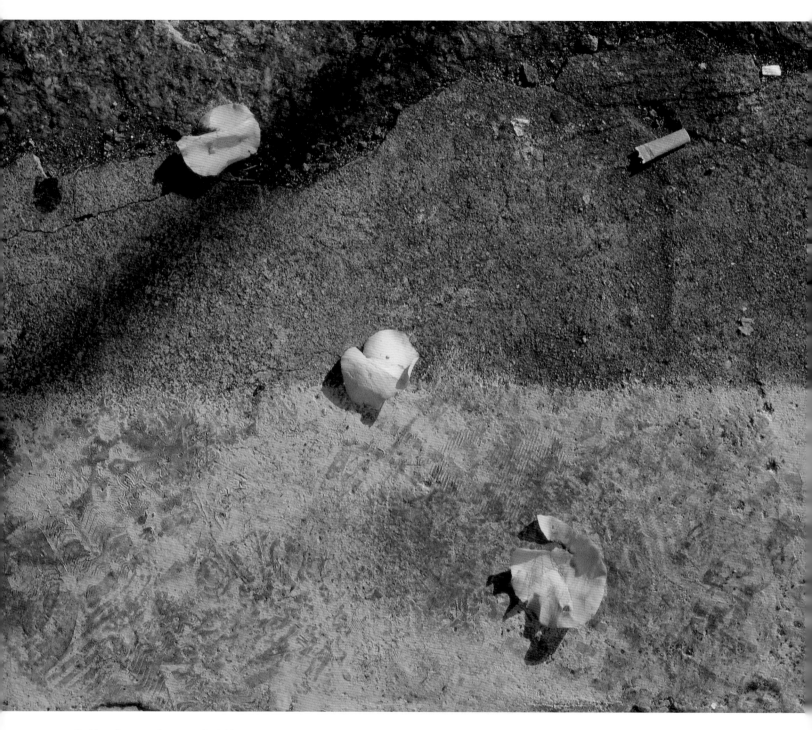

Golden Cross, photograph, 2001, 30 x 40 in.

"Flowers... are a proud assertion that a ray of beauty outvalues all the utilities of the world. "
 Lord Byron

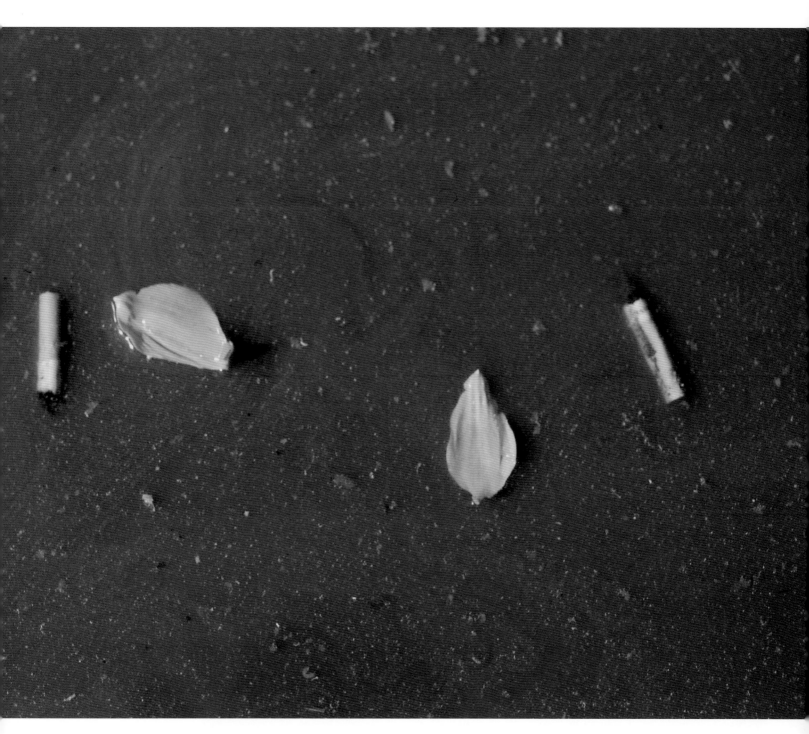

Yellow Line, photograph, 2001, 30 x 40 in.

Nature Culture Maple Pyramid, photograph, 1999, 24 x 36 in. (above)

Nature Culture Rose Pyramid, photograph, 1999, 24 x 36 in. (below)

Nature Culture Mirage, photograph, 2000, 24 x 30 in. (right)

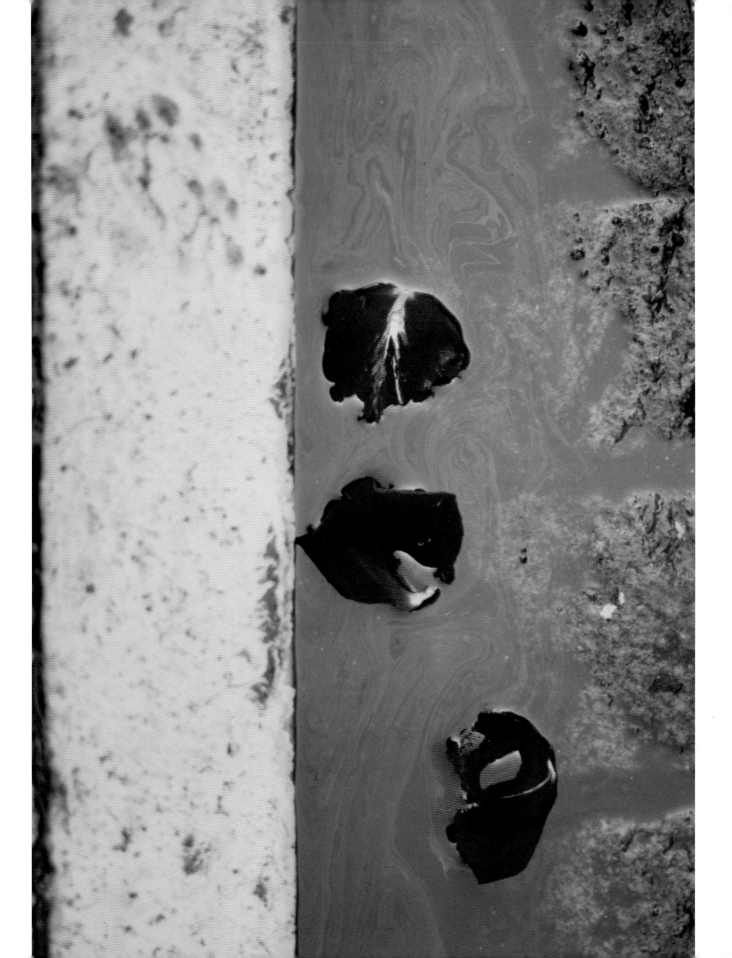

Nature's Time Rock, photograph, 1977, 11 x 14 in.
(right)

"Exposing the unseen."

Nature's Time Sidewalk, 1977, photograph, 11 x 14 in.
(left)

"Exploring the relationship between natural processes and the urban landscape"

Nature/Culture, photograph, 1998, 30 x 40 in.

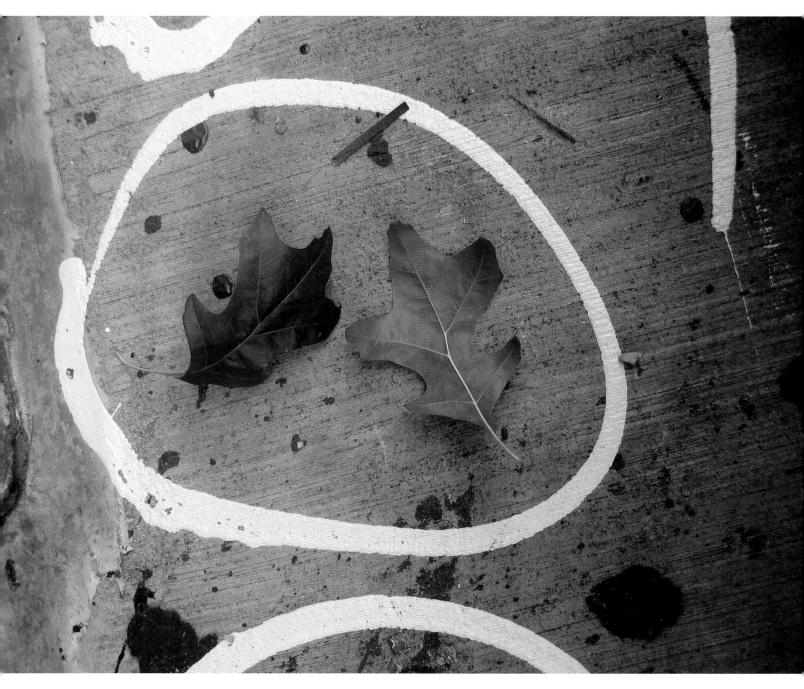

Nature's Dripped Graffiti, photograph, 2001, 30 x 40 in.

"Human subtlety will never devise an invention more beautiful, more simple or more direct than does Nature, because in her inventions, nothing is lacking and nothing is superfluous."
 Ralph Waldo Emerson

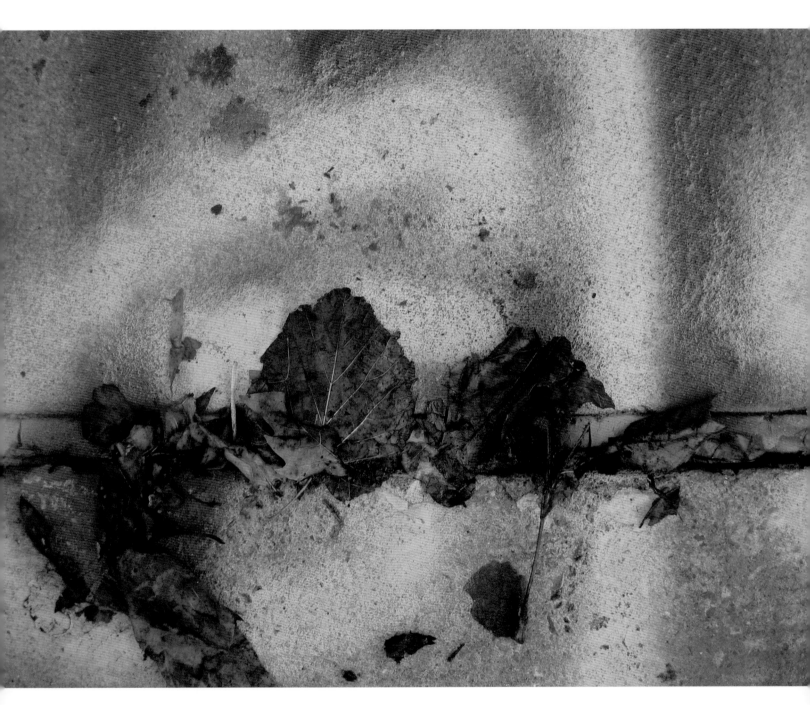

Nature's Sprayed Graffiti, photograph, 2001, 30 x 40 in.

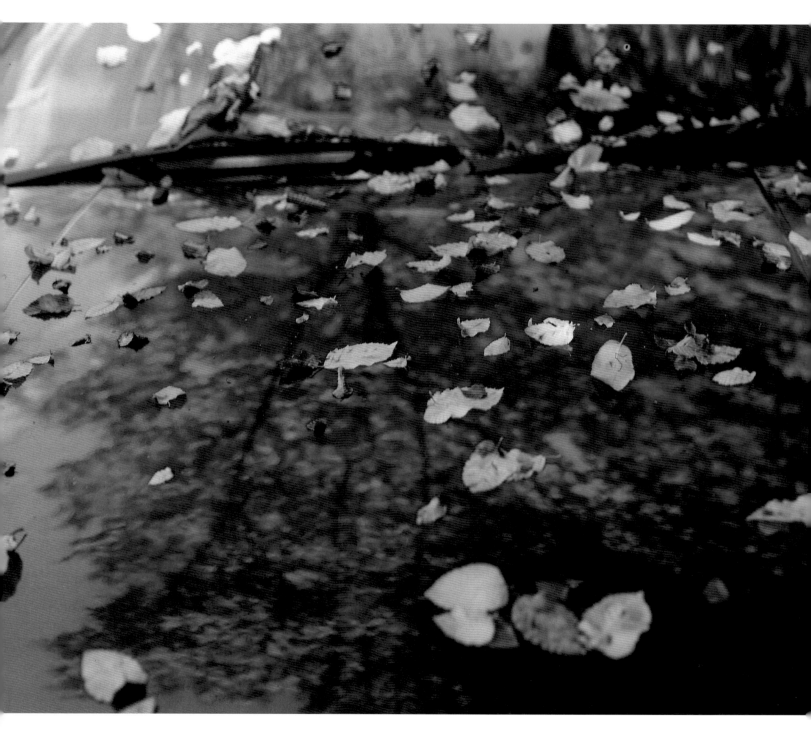

Monet's Landscape, photograph, 2002, 30 x 40 in.

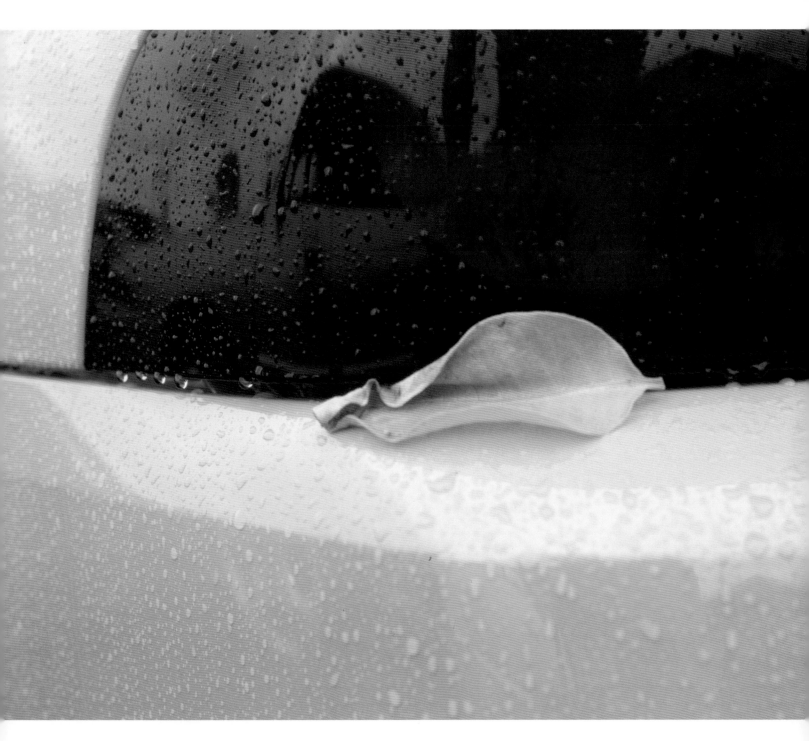

Raining Leaf, photograph, 2002, 30 x 40 in.

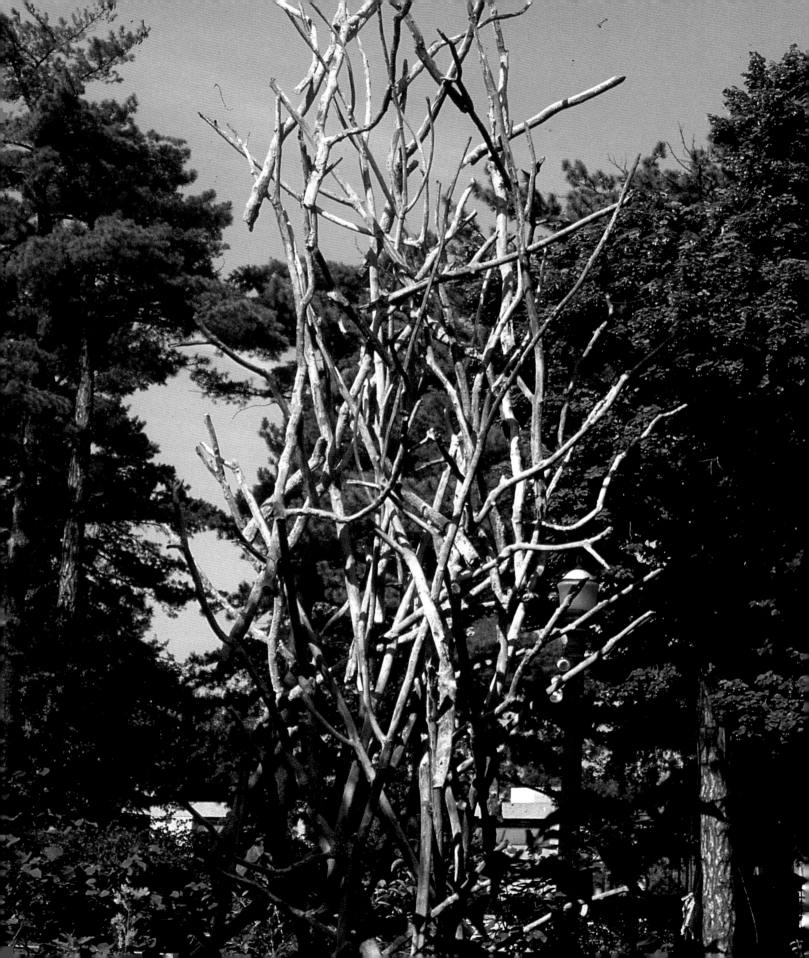

NATURE OVERCOMES MACHINE

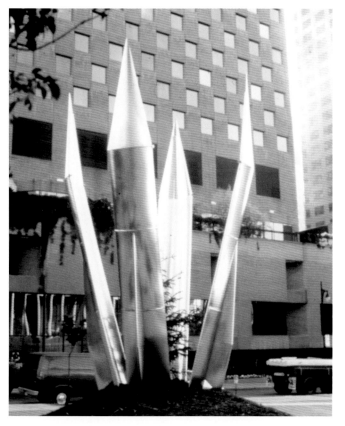

Natures Protector, stainless steel, tree and earth, 1990, 25 x 15 ft. Museum of Contemporary Art, Montreal, Canada (above)

The stainless steel forms represent Soviet Union and U.S. missiles that have been disarmed, giving birth and protection to a forest. CF

Circles of Life, bronze, trees and earth, 1985, Art Institute, Kansas City, MO, 28 x 50 ft. (left)

Sonfist created these artworks from natural materials, then transplanted them into urban environments. We see nature seizing territory back from the city; we have a rare opportunity to witness nature triumphing over technology.

The following artworks juxtapose nature's maternal curves with the rigid angles of human construction. As Walt Whitman has written, "After you have exhausted what there is in business, politics, conviviality, and so on - have found that none of these finally satisfy, or permanently wear - what remains? Nature remains."

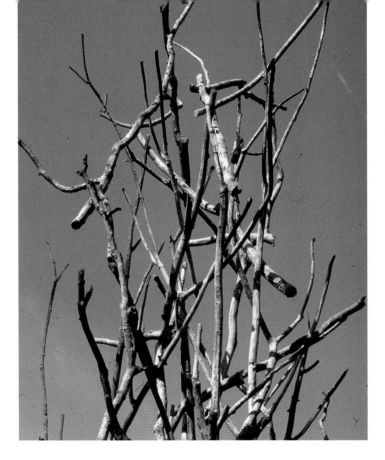

Circles of Life (detail above and first stage below)

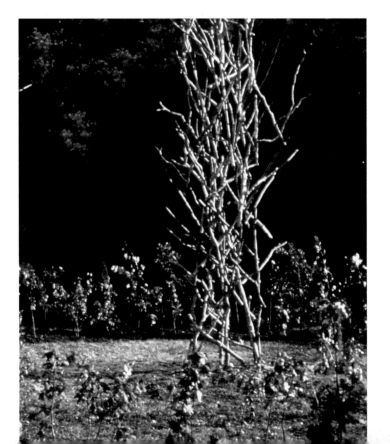

Circles of Life is a bronze sculpture casting of endangered trees surrounded by an indigenous prairie and forest. Eventually the bronze sculpture would integrate with the forest. The sculpture commemorates the trees and prairie at the moment of Kansas City's Centennial. CF (Centennial Commission of Kansas City Art Institute, construction process above and below left and drawing below right)

Natural and Bronze Branches, 1974, 24 x 24 in., Natural: $3,000. Bronze: $3. Purchased together.

"For in the true nature of things, if we rightly consider, every green tree is far more glorious than if it were made of gold and silver."
Martin Luther

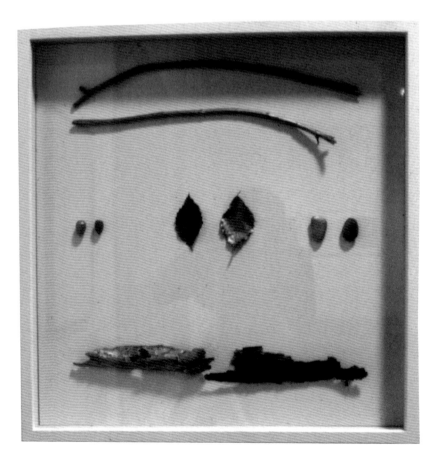

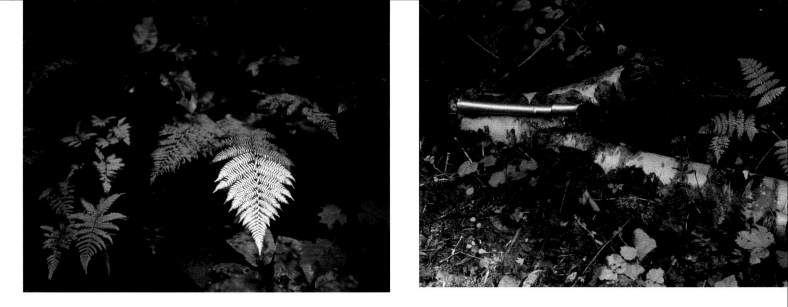

Trail of Gold - Gold Leaf within the Natural Landscape, photographs, 1975, 16 x 20 in.

Natural and Gilded, natural and gilded leaves and twigs, 1974, 24 x 24 in.

Bronze Protectors Entrance, bronze tree limbs, 1983-84, 5 x 5 x 3 ft.,
Florence, Italy (above)

Bronze Protectors, mixed media, 1983-84, 24 x 36 in.
Metropolitan Museum of Art, New York

Bronze Protectors, bronze tree limbs, 1983-84, 4 x 6 x 5 ft.,
Florence, Italy (below)

Bronze Protector, bronze tree limbs, 1983-84, 7 x 5 x 2 ft., Florence, Italy

Bronze relic interacting with its natural reflection. CF

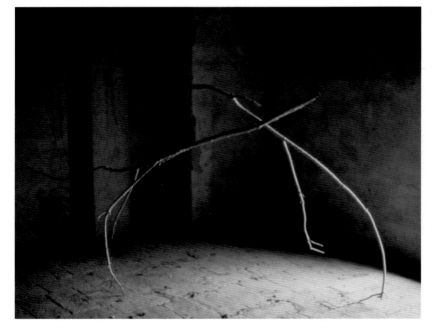

"The tree which moves some to tears of joy is in the eyes of others only a green thing which stands in their way."
William Blake

Bronze Protector, bronze tree limbs, 1983-84, 7 x 6 x 3 ft., Florence, Italy

Each bronze fragment is a relic of an endangered tree. CF

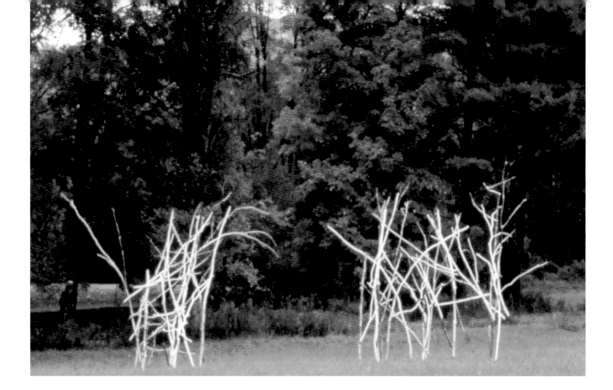

Walking Limbs, bronze, 1986, 16 x 22 x 15 ft., Rye, New York

Representing ancient forests which once stood on this land. CF

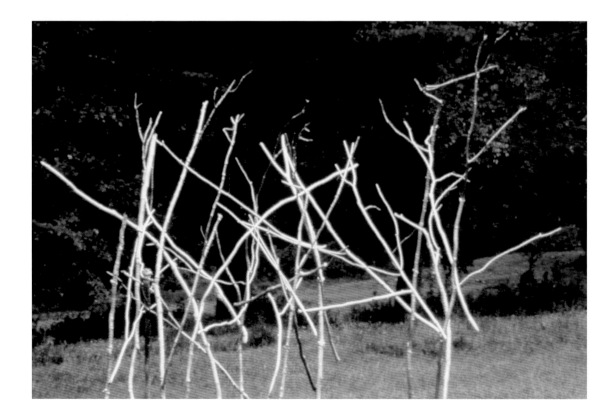

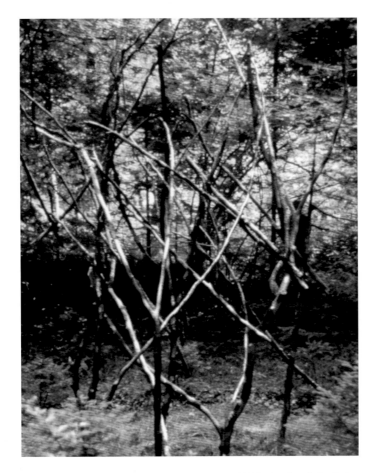

Forest Surrounding Bronze Icon, bronze, 1991, 5 x 8 x 5 ft., Italy

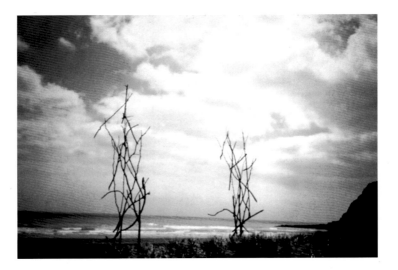

Sculpture of the Wind, bronze, 1984, 16 x 4 x 3.5 ft., New Zealand

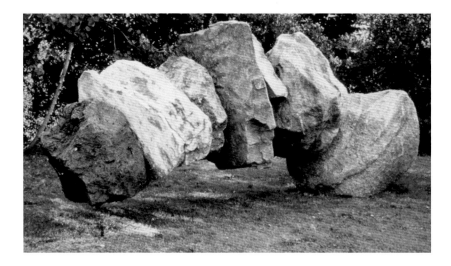

Rocky Mountain Arch, stone, 1991, 16 x 6 x 5 ft., Aspen, Colorado

The Rocky Mountain Arch is the spine of the Rocky Mountains, each rock representing the sites geological history. CF

Rocky Mountain Arch, drawing, 1991, 22 x 30 in., Aspen, Colorado

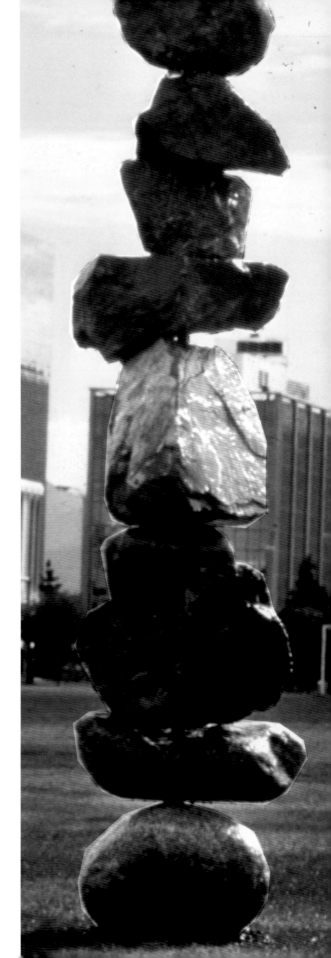

Time Totem, rock, 1987, 18 x 4 x 4 ft., Anchorage, Alaska (two views)

The totem represents tension between rocks coming from the east meeting the tectonic plates coming from the west, causing the Alaskan fault lines. The totem is a record of the millions of years of tension in geological history. CF

Drawing of Rock Monument for High Museum of Art, Atlanta, Georgia, 1979

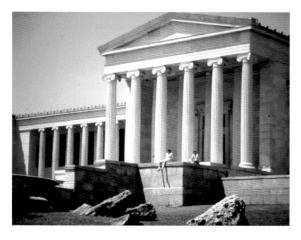
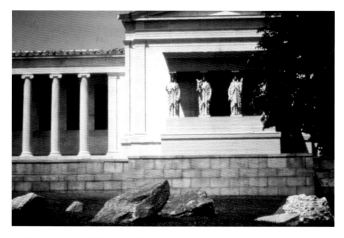

Rock Monument of Buffalo, rocks, 1977-79, 7 x 24 x 24 ft., Albright Knox Museum, Buffalo, New York

Each rock in the rock monument shows a unique moment in the geological history of the region around Buffalo, NY. CF

Earth Monument of Köln, stone, 1984, 12 x 14 ft., Ludwig Museum, Germany (right)

A geological book of rocks, drilled from 0 to 100 feet, visualizes the history of Köln. Commissioned by the Ludwig Museum for the opening of their new museum in Köln. CF

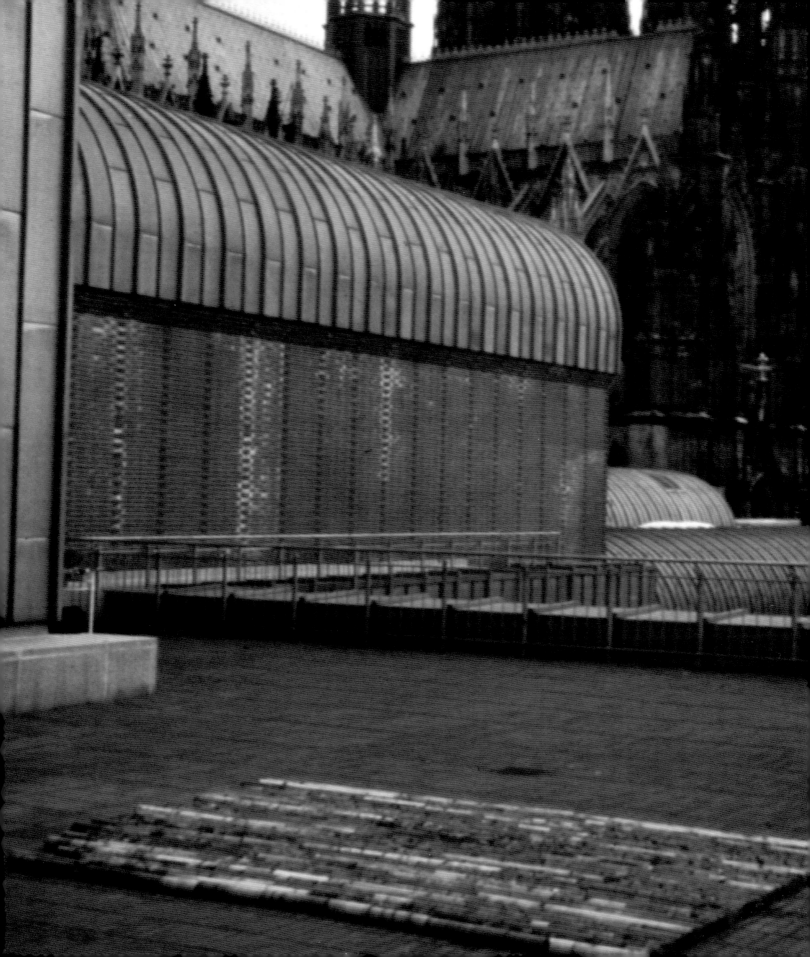

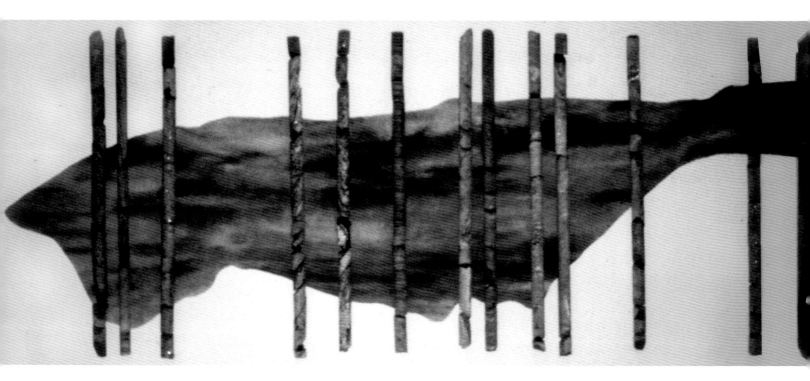

Manhattan Cross Section, rock drillings from 0-100 ft. below the city, 1971, 20 ft. x 4 ft. x 2 in.

"It is a great mortification to the vanity of man that his utmost art and industry can never equal the meanest of nature's productions, either for beauty or value."
David Hume

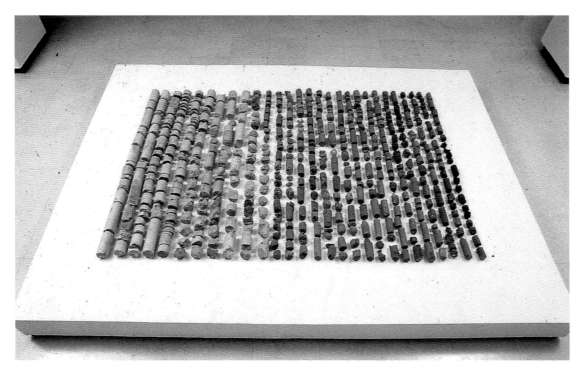

Rock Monument of Chicago, rock drillings from 0-150 ft. below the Museum of Contemporary Art, 1980, 10 ft.x 10 ft. x 3 in.

"You will find something far greater in the woods than you will find in books. Stones and trees will teach you that you will never learn from masters."
 Saint Bernard

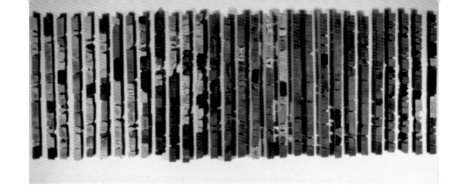

Rock Monument of Dallas, rock drillings from 0-120 ft. below the Dallas Museum of Fine Art, 1981, 5 ft. x 20 ft. x 3 in. (above)

Rock Monument of NYC, rock drillings from 0-125 ft. below the Museum of Modern Art, 1979, 6 ft. x 4 ft. x 3 in. (right)

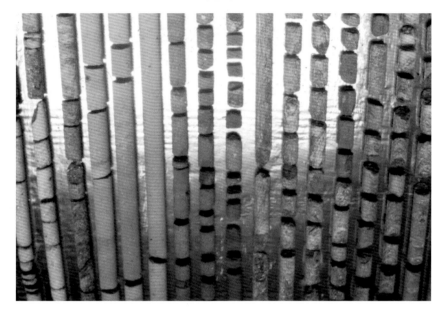

Rock Monument of Akron, rock drillings from 25-150 ft. below Akron, Ohio, 1971-2, 10 ft. x 15 ft. x 3 in. (above)

Rock Monument of Niagara Falls #1, rock drillings from 0-175 ft. below the Albright Knox Museum, 1983, 10 ft. x 12 ft. x 3 in. (below)

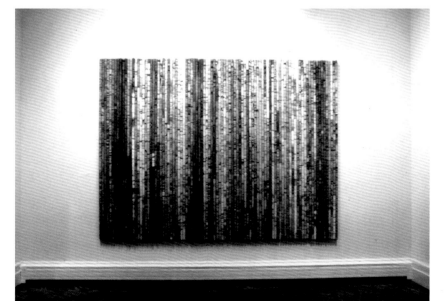

144

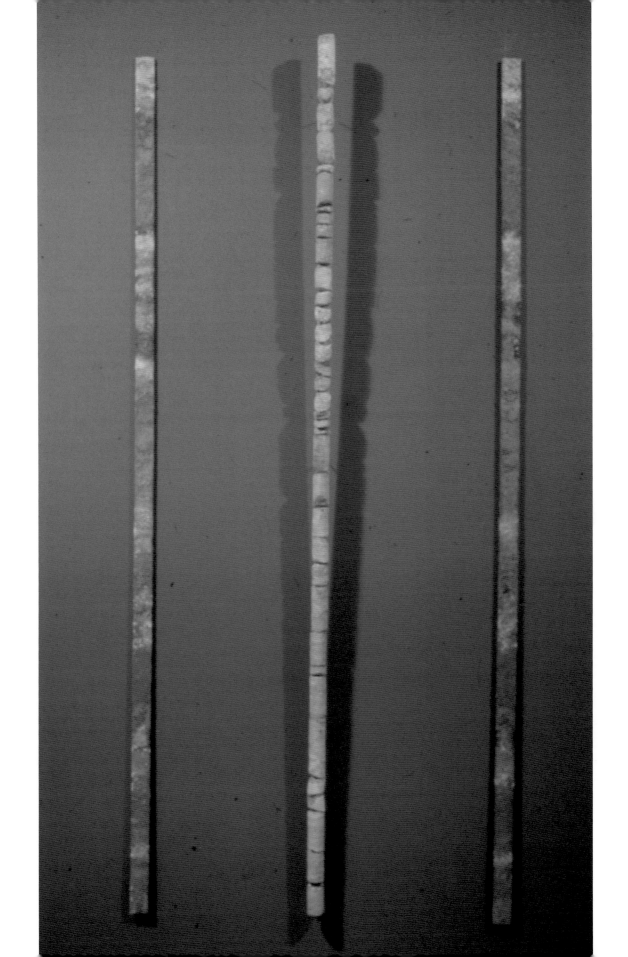

Earth Prints of New York City, earth sound (seismographic) prints, 1969, 11 x 14 in.

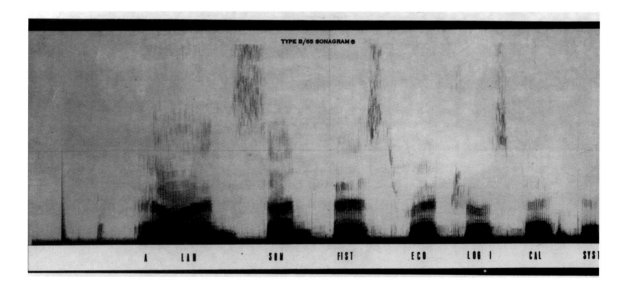

Retrospective Voice Print, 1969, 11 x 14 in.

"My first exhibition was a reflection of my past. The invitation was a print of my own voice."

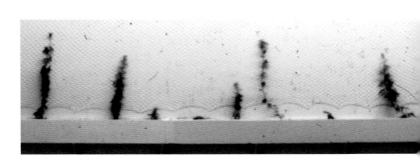

Nature Climbing the Grid, plants and netting, 1971, 8 ft. x 6 ft. x 6 in.

Nature would create its own organic patterns in relation to the man-made object. CF

Heat Water Vapor, steel and water, 1968, 3 x 8 x 3 ft. (left)

The transformation of a material through the different states of matter. CF

Nature Breaking through the Grid detail, sacks of potatoes, 1971, 8 x 2 x 8 ft. (right)

New York City Air, air, glass vials, printed charts, pencil notations, 1970, 2 x 5 ft.

Statistical analysis of New York City's air from upper Manhattan to lower Manhattan, visualizing where there are highly toxic zones of air. CF

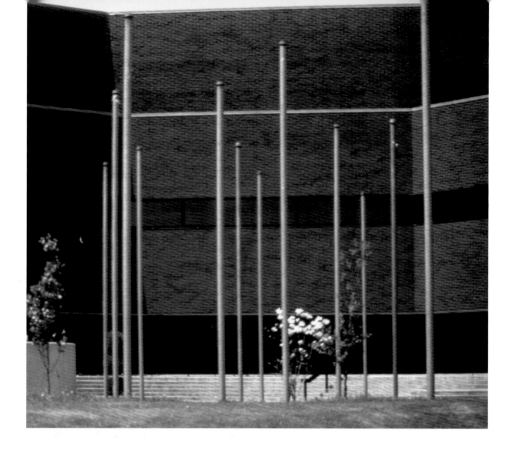

Tower of Growth, trees and stainless steel columns, 1981, 21 ft. cubic area, Louisville, Kentucky, J.B. Speed Art Museum (model below)

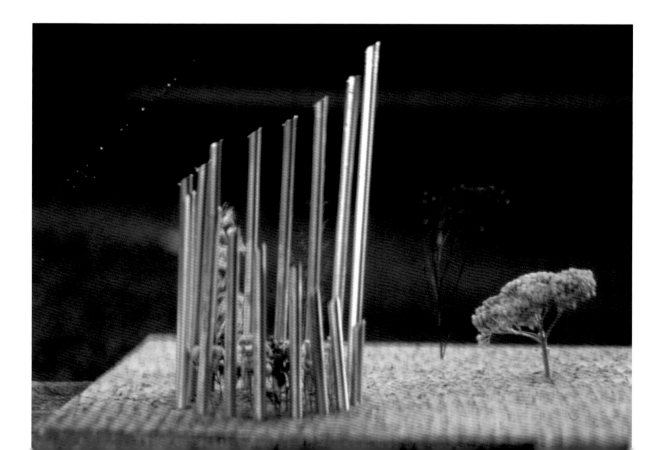

Natural/Cultural Landscape of Aachen, rock, plants and earth, 1999, 30 ft. diameter (detail above)
Aachen, Germany

The stone wall is representational of a fortification that Charlemagne made around Aachen.
Within the fortification is a Celtic fortification, with vegetation from the corresponding time period. As the walls once protected humans, it is now necessary for them to protect the vegetation. CF

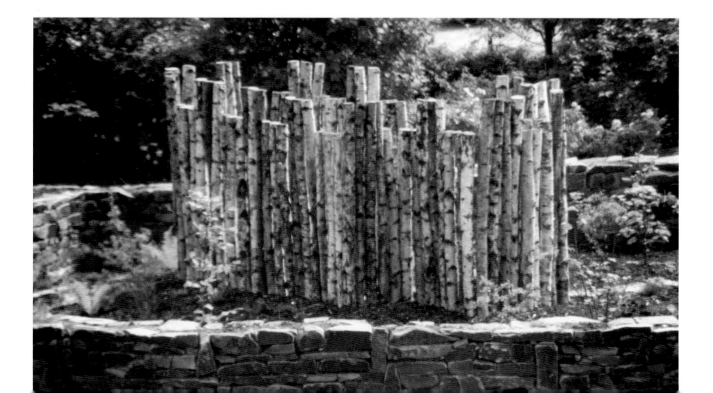

Running Dead Animal, animal, plaster and wood, 1973, 4 x 6 x 2 ft.

Within these plaster blocks are entombed animals, found dead on the side of the road. Their essence is imprinted on the surface. The base is an indicator of the changing internal structure of the plaster block. CF

Nesting Finds, photograph, 1976, 12 x 12 in.

This photographic series explores how animals have adapted themselves to urban life, using both man-made and natural materials. CF

Abandoned Animal Hole, plaster, 1974,
3 x 22 x 8 ft., Elizabeth, New Jersey. (con-
struction below, finished at right)

Sonfist excavated an abandoned animal
hole, exposing the damage caused by
pollution. By exposing the abandoned
home, he visualizes the unique structure
that the animal had created. CF

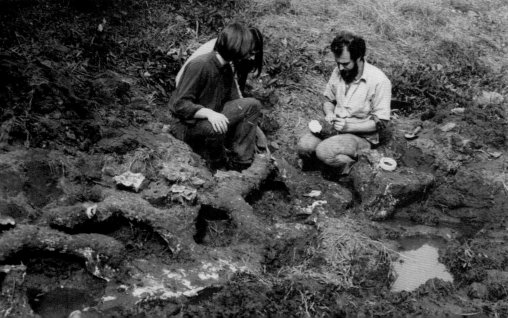

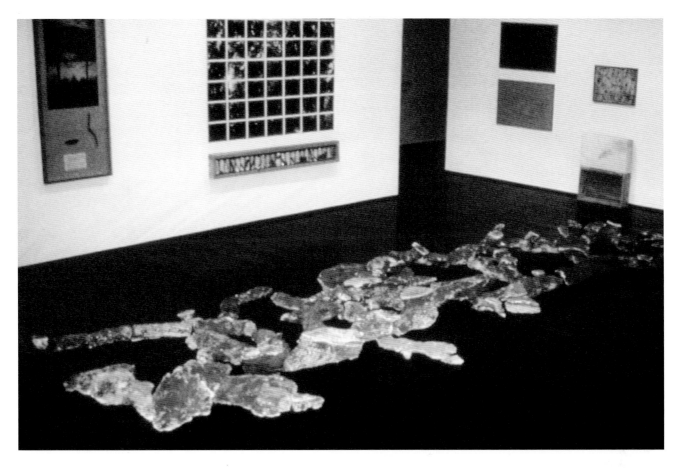

Exhibition at the Boston Museum of Fine Arts, 1977. Clockwise from bottom: Abandoned Animal Hole, plaster, 1974, 3 x 22 x 8 ft., Autobiography of Hemlock Forest, 1975, 4 x 2 ft., Gene Bank, 1975, 56 x 72 in., Earth Paintings, 1970, 24 x 36 in., Micro Landscape, 1968, 16 x 24 in., Running Dead Animal, animal, plaster and wood, 1973, 4 x 6 x 2 ft.

Earth Runoff Casting, plaster, 1975, 4 ft. x 3 ft. x 6 in.

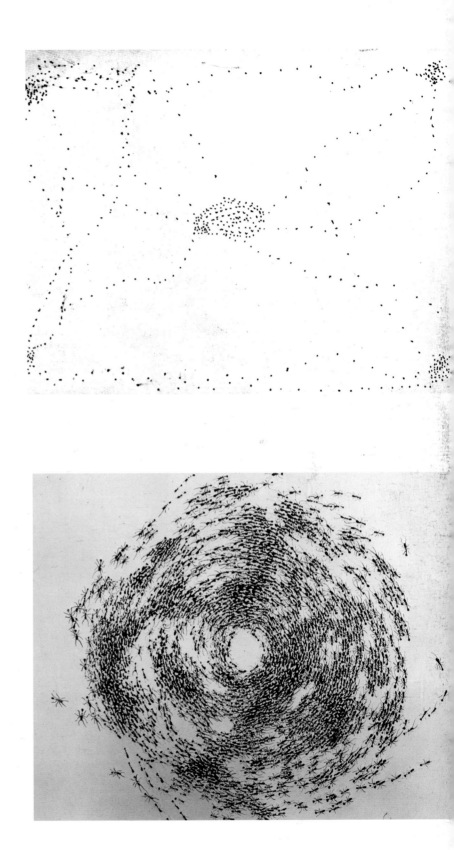

Tracking 100 Viewers of the Whitney Museum, drawing of museums floor plan, 1969, 8 x 10 in. (1 of 100 photographs and drawings at left)

Army Ant Movements, drawings, 1972-73, 24 x 30 in., from Army Ant Exhibition sponsored by the Architectural League of New York.(right)

"While collecting a colony of army ants in Central America, Sonfist suffered a treacherous fall from the side of a cliff. Despite the injury (which landed him unconscious in a Panamanian hospital for many days), upon awakening, he insisted on finishing the exhibition. The ants were introduced to a gallery space called the Automation House, in New York; it was arranged so that the people had to follow a linear pattern, similar to the paths of the army ants themselves. A film of the ants' movements was juxtaposed with people's movement in the city."

 Jonathan Carpenter

A visualization of army ants movements in relationship to human movements of the city. CF

Army Ants: Patterns and Structure, Installation View, wood, army ants, food, 1972, 20 x 30 ft., (detail below)

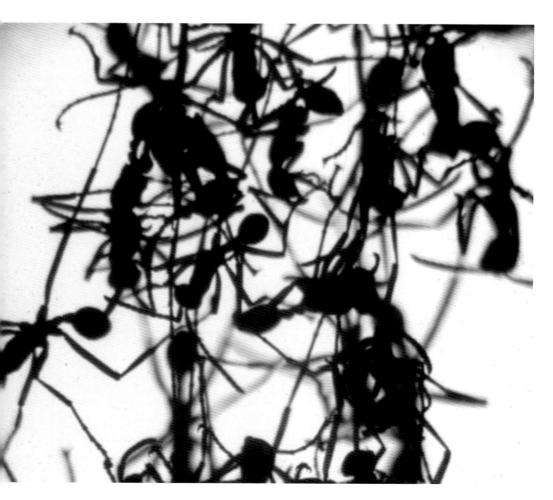

Army Ants: Patterns and Structures, photographs, 1972, 11 x 14 in., (detail below)

As found in nature. CF

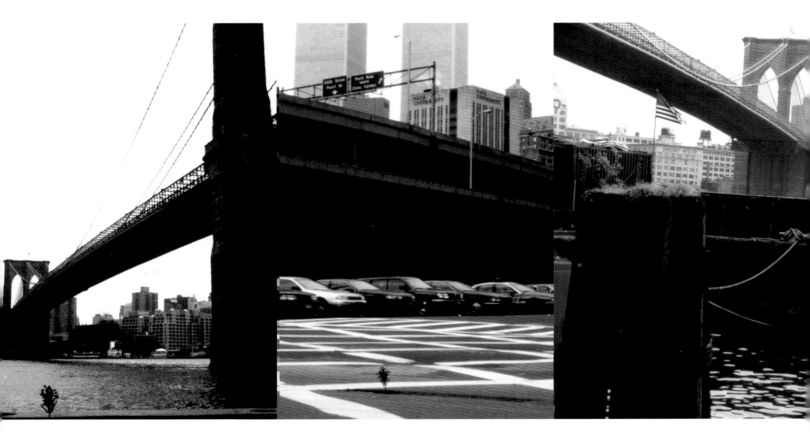

Nature Breaking Through the City, photographic series, 1979, 14 x 33 in., New York City (above)

Nature/Culture, photographic series, 1979, 10 x 24 in., Munich, Germany (right)

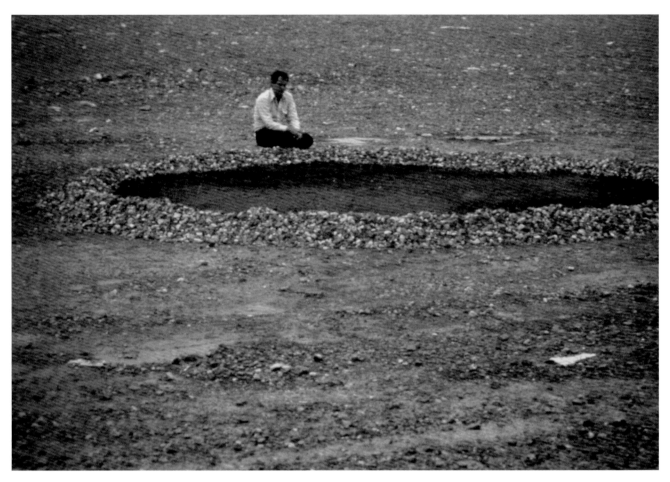

Pool of Virgin Earth, 50 ft. diameter on chemical dump, 1975, Lewiston, New York (right, during 1976)

By sealing the earth into a crater, the site was returned to its predestruction state. CF

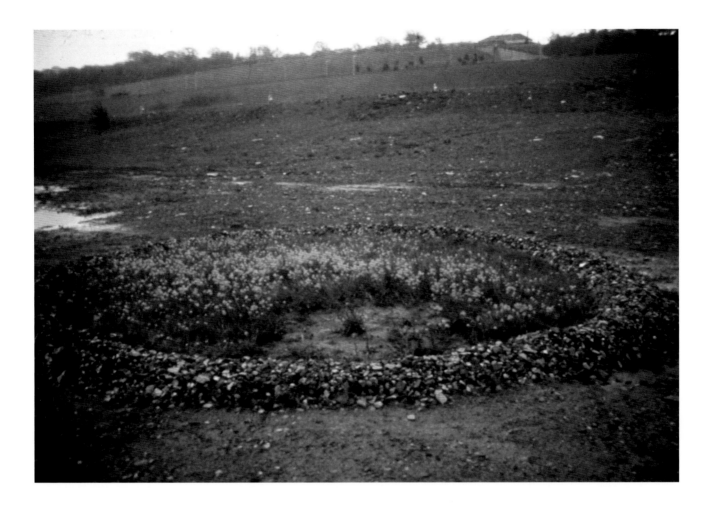

"Salvation lies in nature."
Camille Pissarro

NATURE MIME

Nature/Culture: Scarecrow, mixed media, 1994, 8 x 15 ft. (above)

Myself Becoming the Tree, photograph, 1970, 8 x 10 in. (left)

Sonfist demonstrates nature's relationship to man through visual analogy. Like the Taoist masters of the past, he believes humankind to be deeply rooted in nature. Man doesn't dominate nature; he's a part of it. Man finds happiness when he tunes into nature's rhythms. Even in an age replete with technology, nature and man are indivisible; the two are entwined like vines on a branch.

"Look deep into nature, and then you will understand everything better."
　　　　Albert Einstein

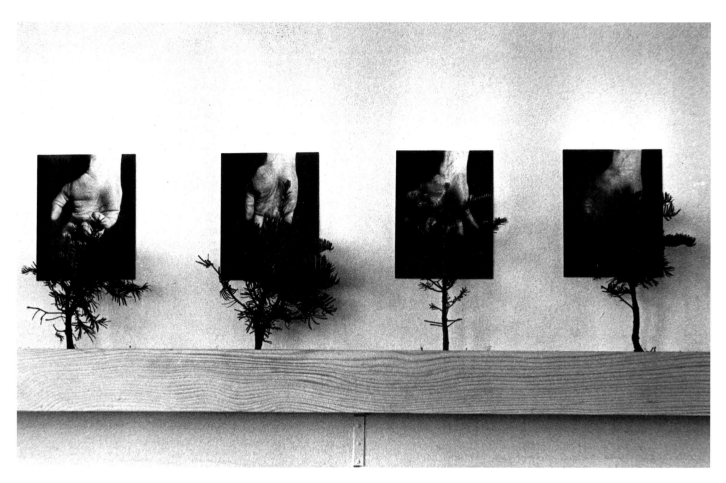

Hand Interacting with Tree, photographs and live trees, 1971, 8 x 2 ft.

As in the Scarecrow, Hand Interacting with Tree becomes a juxtaposition of nature and culture and how they interact with each other. The hand becomes the human force upon nature. CF

"When we show our respect for other living things, they respond with respect for us."
Arapaho Proverb

Human Nature - Veins Leaf, photocollage, 1968, 11 x 14 in.

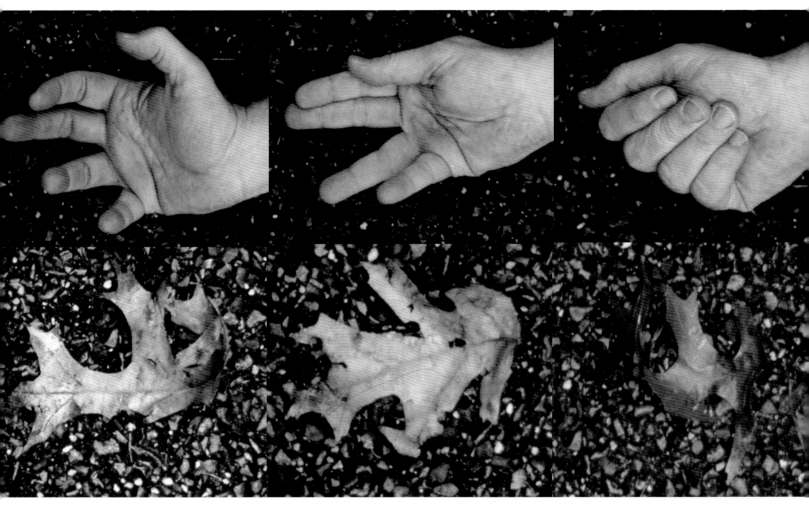

Hand and Leaf, photographic series, 1970, 22 x 92 in.

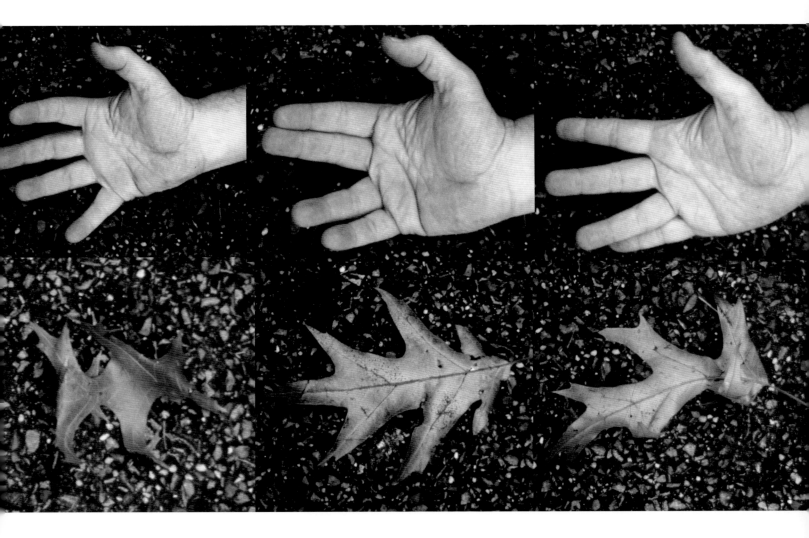

"Great things are done when men and mountains meet."
William Blake

Christ Becomes the Forest, photocollage, 2002, 30 x 40 in. (above)

Skin Becomes Bark, photographic series, 1969, 30 x 40 in. (left)

*"The sunspot traced my steps to my past as I cover my hands
with the fallen bark of my white oak."*

Myself Becoming a Rock, photographs, 1971, 22 x 14 in.

Myself Becoming a Branch, photographs, 1971, 22 x 14 in.

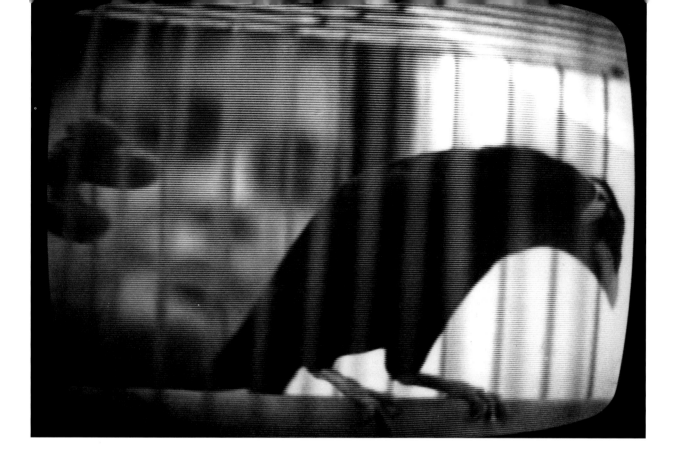

Animal Mimicking Human/Human Mimicking Animal, video/photographic series, 1971, 11 x 14 in.

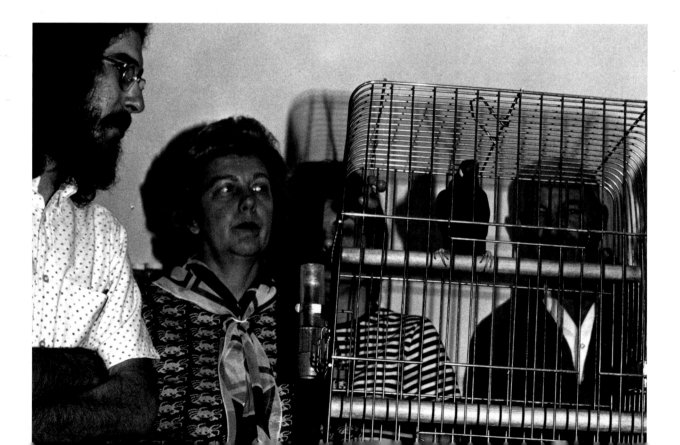

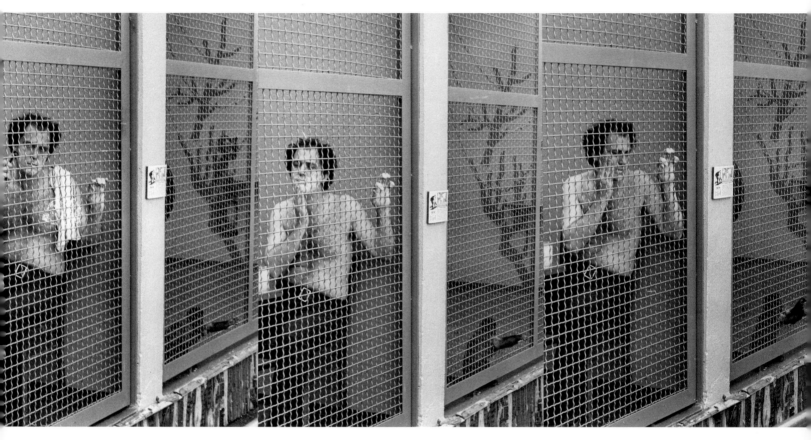

Homo Sapiens, photographic documentation of performance, 1976-77, 11 x 14 in.

Alan Sonfist lived in a cage at the zoo for a week. CF

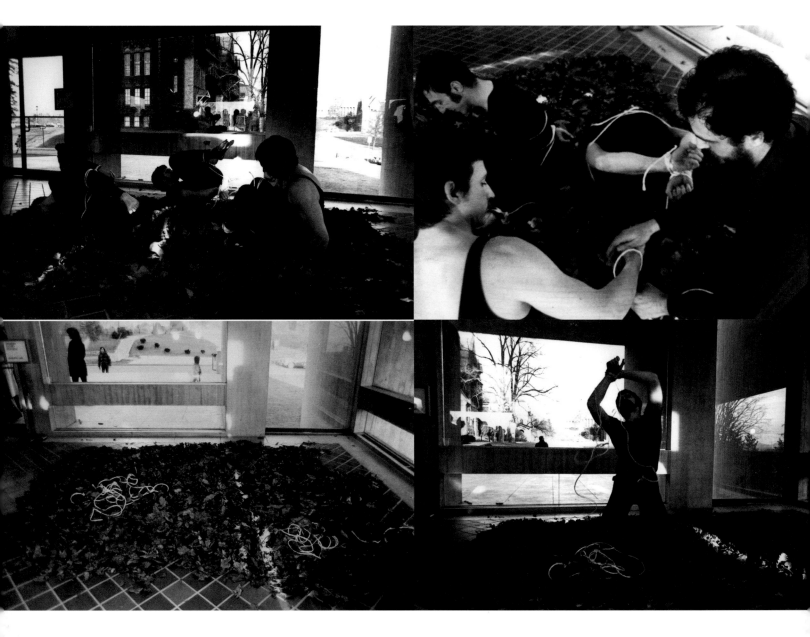

Wounded Animal Performance, photographic documentation of performance, 1975, 11 x 14 in.

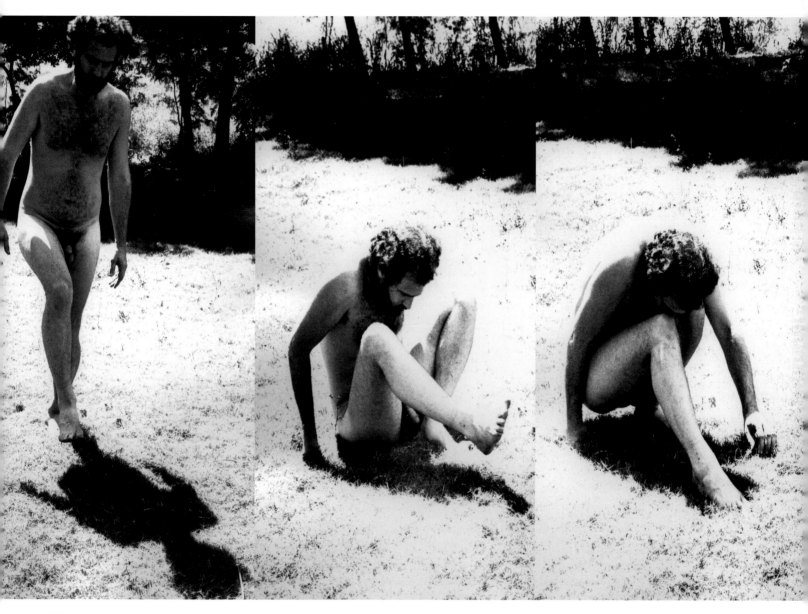

Walking into Myself, photographic series, 1974, 44 x 14 in.

"As a child I wanted to become my shadow."

Leaf Painting, paint on canvas, 1968, 8 x 30 in. (above in progress, right completed)

Sonfist placed a canvas within the leaves. He painted the canvas to match the leaves. CF

Twigs Becomes Photograph, mixed media, 1971, 24 x 36 in.

Twigs Becomes Photograph, mixed media, 1971, 24 x 36 in.

"Joy in looking and comprehending is nature's most beautiful gift."
 Albert Einstein

Portholes of Ancient Rivers of New York, 100 photographs, 1999-2000, 2 miles Sponsored by the Thomas Sprengel Foundation

"The portholes are a metaphorical shadow of the city's natural history."

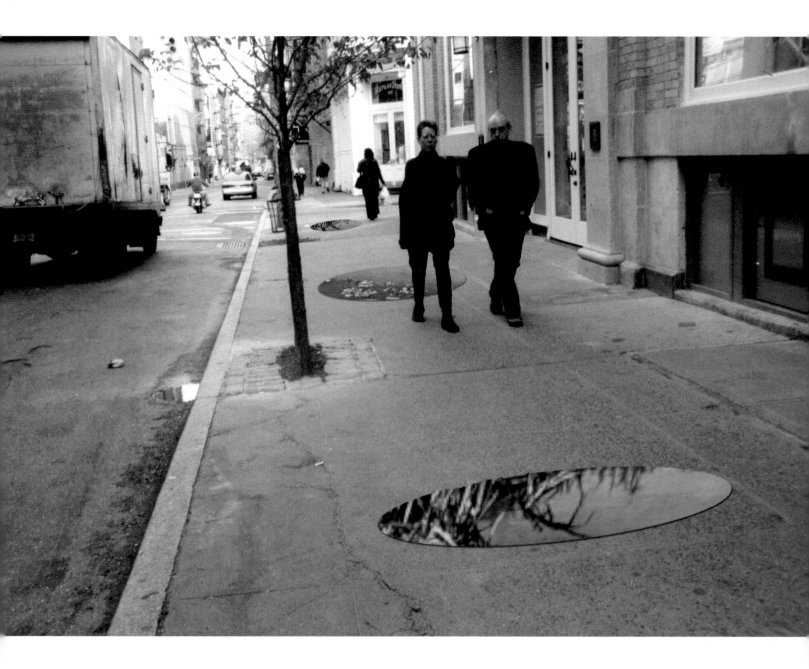

Portholes of Ancient Rivers of New York, photograph, 1999-2000, 24 in. diameter (above and right)

"I don't work after nature, but before nature and with her."
Pablo Picasso

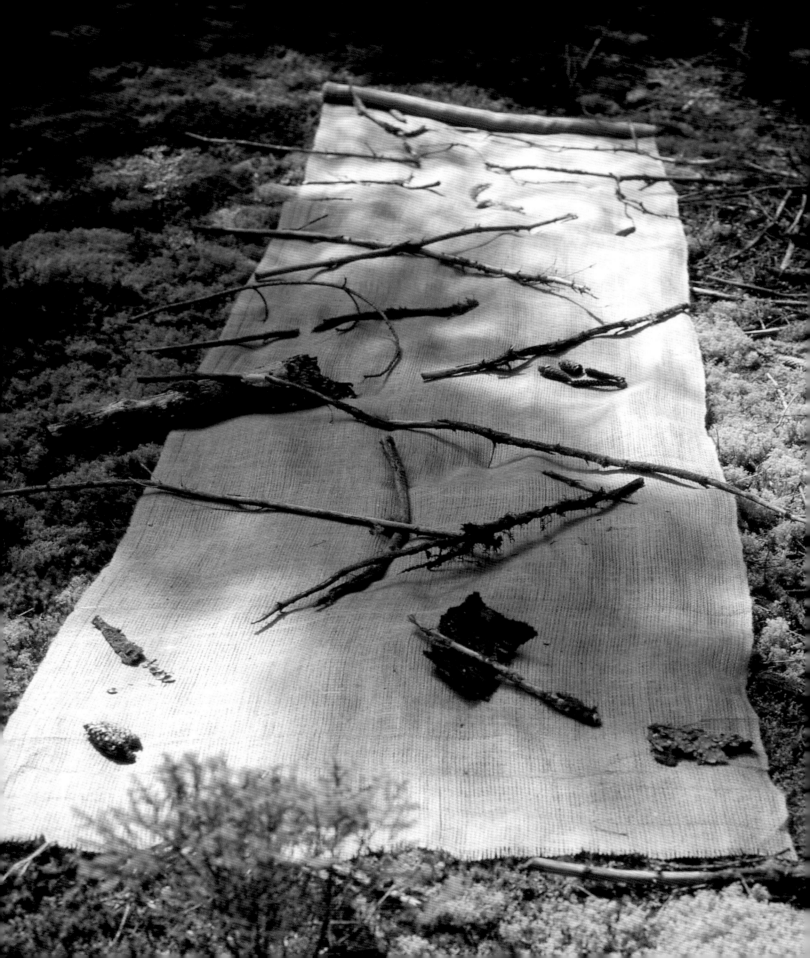

THE ELEMENTALS

Element Selection, mixed media, 1974, 3 ft. x 3 ft. x 6 in. Köln, Germany (above)

"The forest becomes a mixture of human and natural elements."

Element Selection, mixed media, 1969, 6 x 20 ft, Adirondack Mountains, New York (left)

"The earth talked and the leaves and branches came forward."

The works in this section mirror nature's asymmetry. The elements appear as if they've fallen together, like leaves forming patterns as they tumble from the trees. Instead of imposing a mechanical human structure on them, Sonfist allows them to flow together, positioning elements as a river deposits rocks, silt and branches.

"Let us permit nature to have her way. She understands her business better than we do."
 Michel de Montaigne

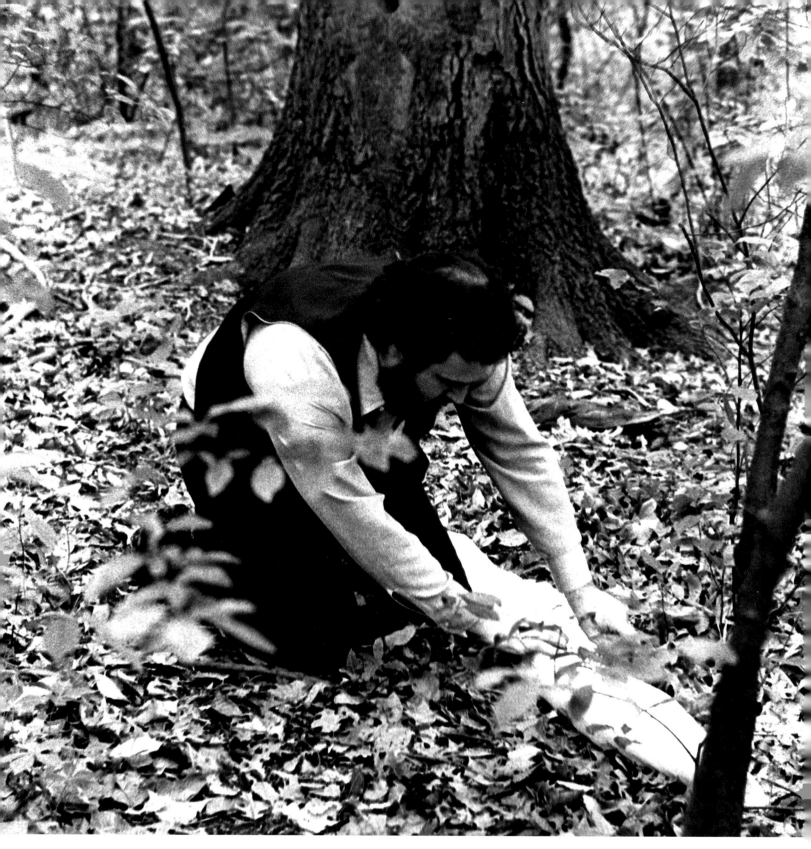

Element Selection Living Museum, mixed media, 1970, 6 x 12 ft., The Catskills, New York

"As I unrolled the canvas, the rocks, twigs and leaves talked and I placed them on the canvas as I found them. The canvas was left in the woods as a museum of the moment."

"The canvas decayed and became part of the earth."

Element Selection, mixed media, 1971, 6 x 12 ft., Terrytown, New York

187

Element Selection Living Museum, mixed media, 1974, 6 x 12 ft., Köln, Germany

Element Selection, relics of natural fragments displayed exactly as they were found within the Köln forest, 1974, 6 x 12 ft., Köln, Germany

"Art is a science and the true–born daughter of nature. But in order to speak we may call it the grandchild of nature."
Leonardo da Vinci

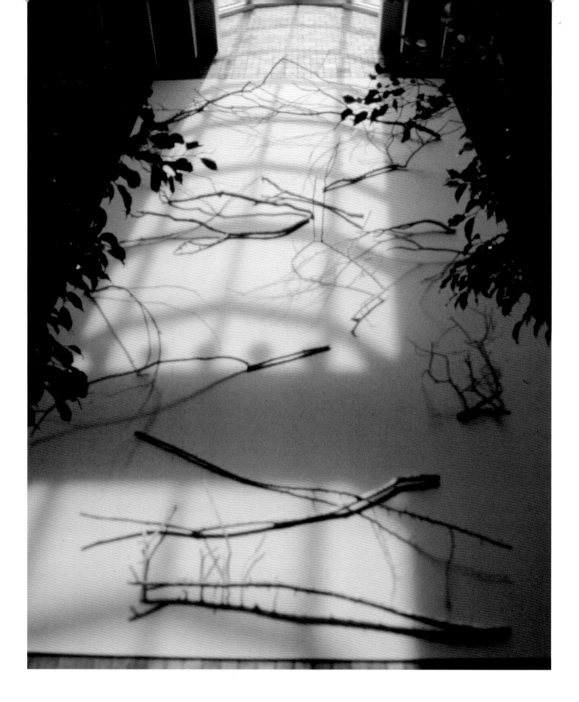

Element Selection, mixed media, 1983, 15 x 30 ft., Arco Corporation, Houston, Texas

Mapping of the earth before the building was constructed on the site. The elements are natural and gilded contrasting the values that we place on nature. CF

Element Selection - Mapping of the Forest Floor, mixed media, 1971, 6 x 12 ft., Sleepy Hollow, New York (overview)

Element Selection, Sleepy Hollow, New York, details (gallery site, above - natural site, below)

The gallery site reflects the natural site. CF

Finds in Snow, leaves and twigs, 1974, 12 x 12 x 6 in.

"Archaeological finds of nature
Sun openings: creates snow finds"

"As I walked through the forest, the snow opened revealing the
leaves caressing their twigs."

"Art is constitutive…The artist determines beauty.
He does not take it over."
Johanne von Goethe

Finds in Snow, 1974, 1 x 8 in.

Finds in Snow, 1974,
3 x 1 ft.

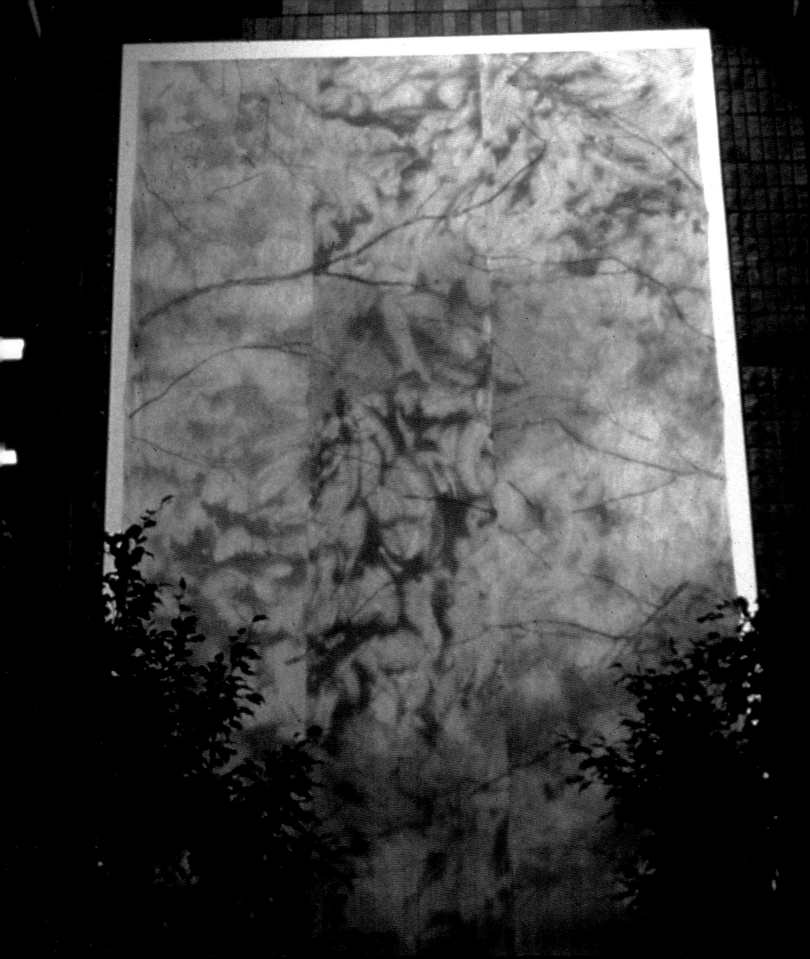

Frottage of the Hemlock Forest, mixed media, 1969, 6 x 8 ft. (above)

Impression of Dry River Bed, mixed media, 1983, 15 x 30 ft. (left)

Element Selection, photograph and drawing, 1971, 11 x 28 in.

Talking Twig, Talking Rock, 1968, 8 x 1 ft. (overview above, detail below)

A dialogue between the rock and the twig. Using the visual similarities of their elements, Sonfist creates a painting. CF

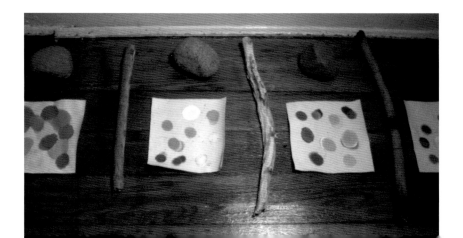

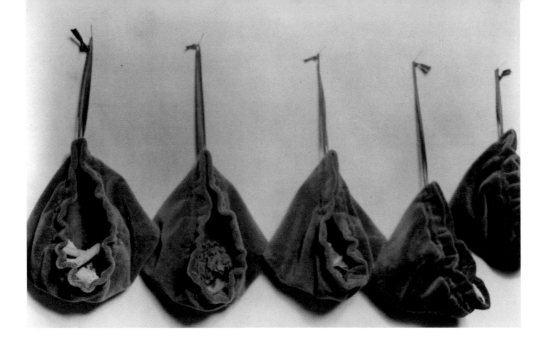

Collections, mixed media, 1971, 1 x 8 ft.

"I would walk through the woods and select fragments. Each velvet bag became a landscape within itself."

Element Selection, photograph and twigs, 1970, 22 x 14 in.

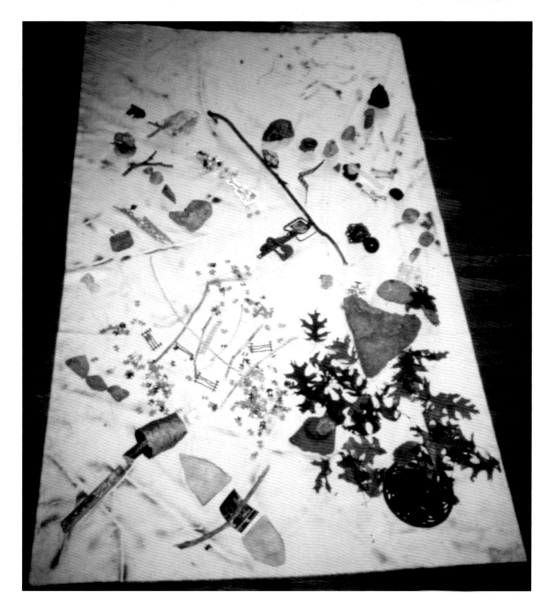

Natural/Cultural Element Selection of New York, mixed media, 1981, 6 x 15 ft.
(overview above, detail below)

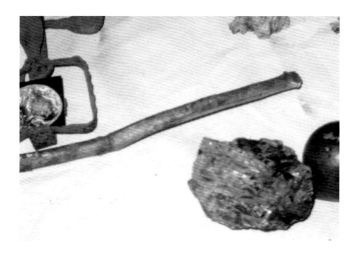

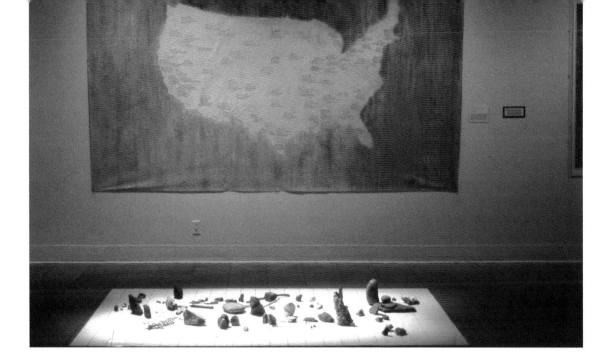

USA Element Selection: Natural Toxic, mixed media, 1988, 6 x 10 ft. (above)

A travel map of toxic sites throughout the United States, juxtaposed with our National Natural Heritage Sites. CF

Natural Toxic Elements, mixed media, 1988, 6 x 10 ft. (below)

The natural elements and the toxic elements that have been selected all over the United States. CF

"As I wandered through America seeking its beauty, I found its toxic reflection."

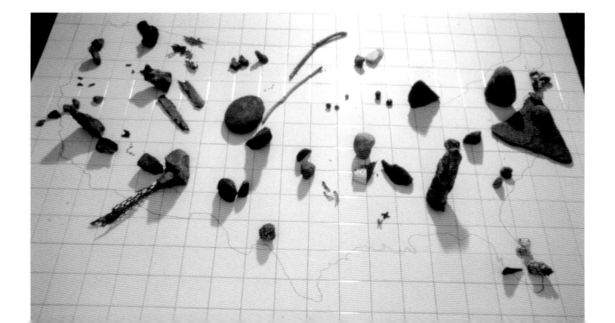

Stations of the Cross: From Real to Plastic, Forest Fire, mixed media, 3 x 6 ft. (detail above)

Stations of the Cross: From Real to Plastic, Matchbooks, mixed media, 3 x 6 ft. (detail right)

The Stations of the Cross visualizes the transformation of a tree to its artificial element. CF

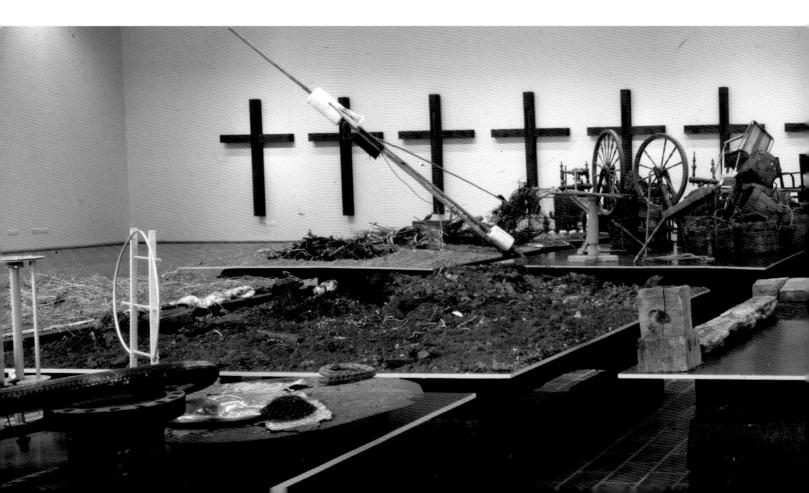

Element Selection, Installation at Pori Museum, Finland, mixed media, 1994, 50 x 75 ft. (below)

The city of Pori has been divided up, each portion corresponding to a natural or cultural section. The installation is a natural/cultural grid of the city. CF

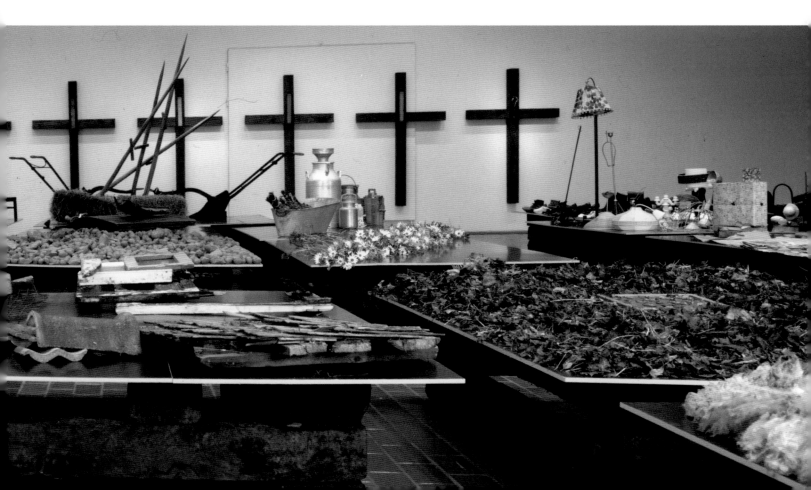

" Time and Nature in Sonfist's Work"

Excerpt from an essay by Lawrence Alloway

"My body is my museum, it's my history"
Alan Sonfist

An expansion of the concept of autobiography is central to Alan Sonfist's work. The term is stretched from the person of the artist to include the works of art themselves.

As an example, here is a part of the Autobiography of Tracings:

1957	Summer rock turning. Seeds and snakes.
1962-65	Joined my subconscious under self-induced hypnosis. Became one with Oak.
1963	Sun paintings reflecting the earth.
1964	Made sound of animals and trees.
1965	Verbal to visual translation.

In every work there is a compost of memories and identifications based on the idea that an artist is an artist all the time and that therefore art is not a special discipline or condition. This is in opposition to formalist criticism, which defines art as a specialized craft. By charting labyrinth continuities, of which the work is one episode, Sonfist assumes the compatibility of the terms life and art. He looks for an interactive relation between the natural and the artificial: the natural includes autobiography and landscape, the artificial includes autobiography and art. The autobiography is the means of unifying world and art.

Sonfist has written that "any form is one stage in a continuum shaped by other factors, often invisible." This point is made, for instance, in his element selections, in which he spreads loose canvas on an outdoor site and deposits twigs, leaves, and stones from the ground beneath. Nature is treated as an unbounded field, the found parts of which, details, are ordered by the act of selection. However, they are placed in positions that correspond to their original location on the earth. Samples of the outside world are turned into trophies of personal experience, but without being themselves altered.The customary procedure is to leave the canvases in place, so that they enter the cycle of "decay and growth" that Sonfist has briefly interrupted. Other works that consist of objects removed from the limitless world are taken to the studio in collection bags, soft stringed containers made to hold objects from the forest floor.

(Incidentally, the twigs are only picked up, never broken off growing trees.) These finds are sometimes accompanied by texts:

> I could feel the lines of my skin
> The cold wind passed
> The twigs formed their own lines
> Moving back and forth from the rock.

There is a kind of serious nonchalance, as if the pieces meant too much to change after the crucial acts of removal and storage. Placing the twigs, the stones, the feathers in a row or next to a bag is an act of preservation rather than of design. Perhaps we can call the bits of nature used in this way trophies. It is Sonfist's intention to reveal nature but not to transform it. He uses original elements from nature, recontextualized in his art, but in ways that preserve their physical nature. A classical trophy was an accumulation of captured arms and other spoils, often bunched together; the objects were recontextualized but not otherwise changed. Sonfist changes the context but honors the individual shape and material of each piece.

Nature as field, an unbounded domain, underlies the series of element selections and the collection bags. This method of working is a powerful subversion of the compactness of the work of art. When Sonfist takes nature as a field he presents the bits with what I would call situational immediacy, as concretely as possible. When he takes nature as process we have physical immediacy while the work changes in time. The canvas mold pieces for example, grew after Sonfist initiated the chemical process: though he could anticipate the direction of events he could not control or predict the actual configurations on the canvas. To quote the artist: "The growth of the work is characterized by patterns of indeterminacy, since a multiplicity of natural variables creates unforeseen occurrences." In other works he studied the aesthetic possibilities of tropism. His crystal enclosures are vacuum-sealed columns or spheres that present a changing display as the crystals inside respond to ambient conditions such as light or heat differences, and pass from solid to vaporous states. The spectator's role is to initiate change, contributing body heat or shadow to the cycle. In another piece Sonfist used a school of fish that changed position when approached by spectators.

The variety of Sonfist's ideas is revealed by comparing his use of fish to his use of snails. In the latter, the tracks of the creatures' excrement acted as a physically real graph of their movements. Time sequences are built into both works, but there is no tropism involved in the snail piece. It is, in fact, an example of Sonfist's interest in traffic pattern, of which the most spectacular demonstration is the *Colony of Army Ants*. The form displayed here was that of a society engaged in food collecting, as the ants streamed along changing routes in search of food that Sonfist placed in changing locations. This was followed by a study of the flow of visitors to an exhibition at the Whitney Museum: the ants were their own signs, but the results of the Whitney piece were abstracted into a numerical graph. Another use of traffic pattern, this time in memorial form, is the *Abandoned Animal Hole*, the positive cast of a muskrat warren, in which buried habitat becomes declarative structure.It is like an underground tree, a monument to the morphology of branching structure. Sonfist's approaches to traffic flow, taken with his study of movement in time in terms of chemical change, seasonal decay, and animate response, show the range of his organicism.

Sonfist has pointed out that "public monuments traditionally have celebrated events in human history, acts or humans of importance to the whole community," and he argues for an enlargement of the definition of community "to include non-human elements....natural phenomena." Instead of institutional monuments, he proposes monuments to aspects of the biosphere. The *Time Landscape* had its origin in his life, including memories of trees, but it has been carried to a large public scale. Also there are proposals for rock monuments: in one form, rocks collected throughout a state would be assembled at a site; in another, a core sample of the specific site would be displayed, perhaps in a narrow transport chamber, like a geological totem pole. In either case, the earth is literally the subject of the sculpture. To quote the artist again: "The

concept of what is a public monument, then, is subject to reevaluation and redefinition in light of our greatly expanded perception of what constitutes community." In line with this, he draws attention to the need for some changes in what constitutes news: for example, "the migrations of birds and animals should be recorded as public events. At present the Center for Short-Lived Phenomena at the Smithsonian Institution records events such as the birth of islands and mails notices to subscribers. This information should be broadcast internationally." Sonfist's intention is to make a public sculpture and to define public information in ways that would sensitize spectators and readers to the cycle of ecology. Such monuments would be implicit resistance on behalf of the world that we are neglecting and destroying.

Sonfist's works are characterized visually by internal mobility, non-hierarchic scatter, or the display of literal materials. His art is environmental as it involves the spectator, extends into space, or accepts the transfer of unprocessed objects. A group of works since 1973, however, seems to depart from this cluster. It is a series of boxes measuring 23.5 x 23.5 inches, with a depth of 5.5 inches. They are closed and there is no way of opening them except for violating their neat geometry. The boxes are made of light maple and birch, hard woods selected by Sonfist for their minimal grain and texture. They are unusually inert objects to come from him. In conversation he has remarked on his acceptance of the fact that to live in the city is to live in a set of arbitrary containers. He points out that the plot for *Time Landscape* is rectangular. The reference to nature, outwardly excluded, is concealed within boxes; their contents are taken from the web of contacts and dates assembled in the autobiographies, like samples of the attic in safe-deposit boxes.

In fact these closed, not to say impervious, objects are another step in Sonfist's practice of non-compact, non-self-evident form of art. They are accompanied by autobiographies and there are also schematic drawings of the different compartments that divide each box. The typescripts and plans are like satellites in orbit around the boxes. Thus the presentation constitutes a structure of different levels of information with varying degrees of accessibility. Sonfist has taken an aspect of Minimal sculpture, geometric form with a closed surface but the implication of a hollow interior, and revivified its semantic potential by the accompanying verbal lists and the hidden elements. The strict containment of boxes becomes another feature of autobiography: what we have here is a spectacle of secrets.

Some events recur in several autobiographies, some not. The cumulative effect, however, is to spread the notion of art as the product of a single potent cause over the whole life of the artist. The only analogy that I can think of to this historical layering of the work becoming the form of the work is René Char's *Arriére-Histoire Du Pôeme Pulvérisé,* in which the poet's annotation of a copy of his book became a book added to the original. Char recorded his hesitation about regarding the later notes on equal terms with the poems, but he was wrong to feel he had to defend the primacy of the poems. What we get from the notes is a sense of relationship, the connections between poetry and what Char calls "the awkward and untenable world that served in its making. Each poem is accompanied by its confidential marginalia like a whispering stream."

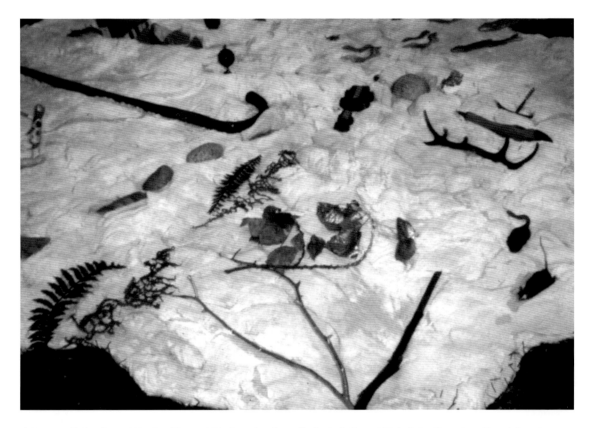

Element Selection of Berlin: Natural Toxic, mixed media installation, 1991, 6 ft. diameter, Kunst Academy Museum, Berlin

Wedding celebration cake made of natural and toxic elements of West Berlin. CF

SEEDS OF THE UNIVERSE

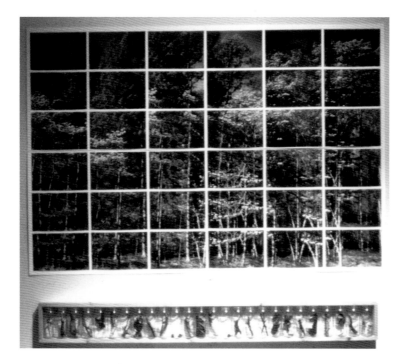

Gene Bank of New York, mixed media, 1974, 6 x 8 ft., (above)

Relics of the forest of the world, photographed from 180 to 360 degrees. Included are genetic element selections that represent the entire forest for future generations to recreate the forest. CF

Earth Painting of Houston, earth and canvas, 1983, 15 x 30 ft., (left, lobby of Arco)

Earth was taken from all sections of Houston, Texas. Each section represents a charting of the earth's surface in the city. CF

"The blade of grass contains the elephant," reads an ancient Buddhist text. This inscription elegantly captures the idea of the biggest within the smallest, the microcosm within the macrocosm. The following works are some of Sonfist's most magnificent, because they capture nature's infinite cycle.

"The sun, with all those planets revolving around it and dependent on it, can still ripen a bunch of grapes as if it had nothing else in the universe to do."
 Galileo

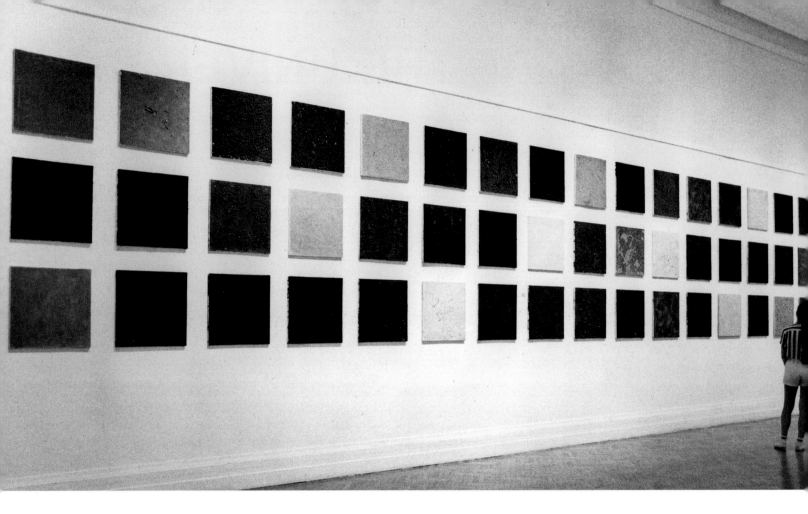

Earth Paintings, USA, Installation View, earth and canvas, earth collected from all over the United States, 1970, 2 x 2 ft., Corcoran Art Gallery, Washington, D.C.

"Nature is an infinite sphere of which the center is everywhere and the circumference is nowhere."
Pascal

Earth Paintings, USA: East Hampton, earth and canvas, 1970, 2 x 2 ft., Corcoran Art Gallery

Oak Tree Looking at its Future, Installation View, 1991, 4 x 4 x 6 ft.

Exhibition View, Museum of Art, Iowa, 1995, 25 x 100 ft. (above)

Gene Bank of Westchester, photocollage, 1977, 66 x 84 in. (following spread)

Aging Leaves of Köln, leaves and paper, 1971, 24 x 36 in. (above)

Aging Leaves of New York, leaves and paper, 1970, 24 x 36 in. (below)

Lifting segments of leaves directly from the forest floor, observing the decaying leaves in one moment of time. CF

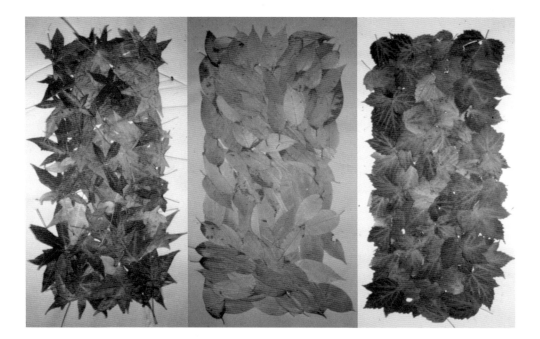

Fall Leaves Series, leaves and paper, 1970, 24 x 36 in.

Each collection of leaves represents a moment of time. The leaves were collected daily, visualizing the changing colors and textures. CF

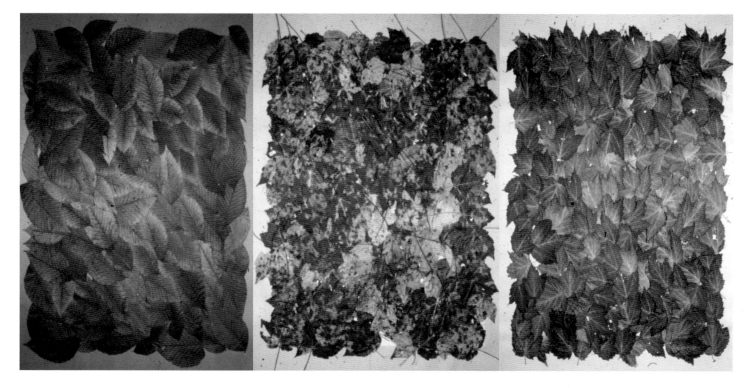

Leaves Frozen in Time, encaustic and leaves, 1968, 48 x 48 in.

Fall Leaves Westchester, leaves and paper, 1970, 18 x 36 in.

Aging Earth, earth and canvas, 1970, 12 x 36 in.

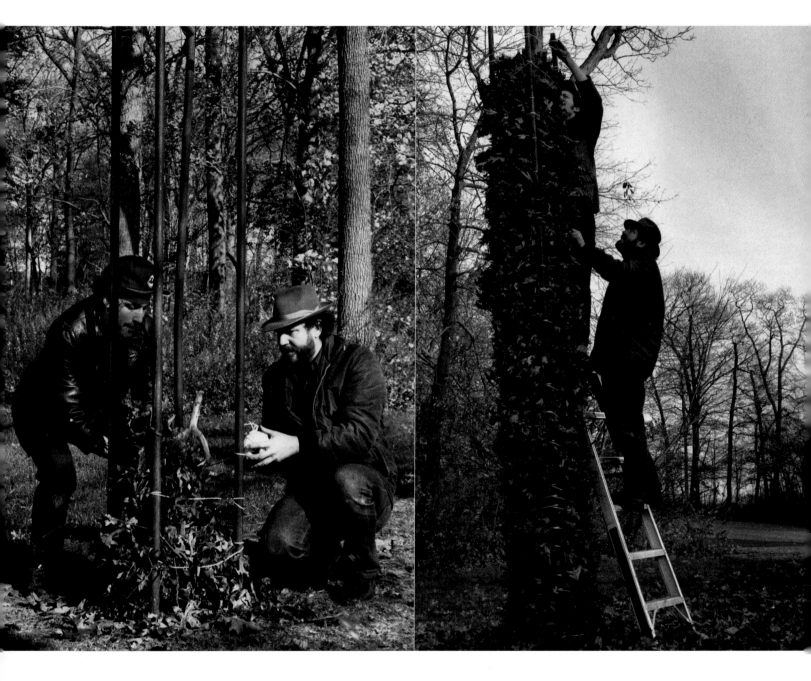

Leaves Become Earth Column, Outdoor Installation, leaves and steel, 1974, 2 x 12 x 2 ft., Long Island, New York

216

Excerpt from interview with Sonfist

Michael Danoff

DANOFF: So, you made art as a child.

SONFIST: Well, there was no beginning. It was part of my childhood. Growing up next to the primeval forests of the Bronx was a very rare treat. I started to do drawings of my favorite childhood tree and taking photographic landscapes including my white oak with the family Kodak point-and-shoot camera when I was four. It was my father's ritual to take me for a walk through the forest early Sunday mornings.

D: It's hard to imagine a forest in the Bronx. What was it doing there?

S: It was a ravine leading down to the Bronx River that the urban developers overlooked. In the rest of my neighborhood, there wasn't a single tree on the street. It was a desert of concrete. So I would go into the forest and collect seeds, leaves, rocks. Everything I found was a treasure of the forest. I remember seeing foxes and deer, and we roamed the forest together.

D: So you were doing drawings, too?

S: Yes, I have vivid memories of a particular oak tree, early on. I played with it and did hundreds of drawings of it. My mother saved all my artworks, for which I'm very fortunate. It reaffirms my spiritual connection to the environment. We also unearthed some photographs I took of the forest when I was a little bit older. My parents kept telling me that they wanted me to take pictures of the family. I considered the animals and the woods to be part of my family.

D: At some point, did this start to turn into a consciousness of yourself as an artist? Did you begin thinking about studying art?

S: There was no tradition in my family of creating art. My parents actively enjoyed the natural environment and went to museums. I don't think my parents realized that they had set up a foundation for me to pursue my art.

D: What about that transition? When did you think that you would spend your life dedicated to art? So there wasn't some art teacher who said to you, "you have to go to college and get a degree in art"? You could have kept it as a hobby and become a tax accountant.

S: From an early age, art was magical. In high school, there were some art courses that were required and the art chairman liked my work, and felt I was talented. But when it came time to decide what to do next, I started going to school in the Midwest to study agriculture.

D: Who else from the South Bronx went there to study agriculture?

S: (laughs) No one! I was the only one on the farm at that time from the East. There was a co-op program where people worked a farm. But it was people who were from the Midwest with an agricultural background, and me. It made me realize quickly that farming was nothing like my romantic image of farming. Out there, it was "Agri-business".

I continued doing my art, especially photographs and drawings, and collecting. Collecting is part of human nature. For me, at least, it was a way of getting close to what I was drawing and taking pictures of. Those were always equally important to my work. I didn't label them as art, but I kept them around.

When I was at the college, the professors asked me, "What does this have to do with art?" I replied, "What does this not have to do with art?" It was kind of a funny dilemma during that time period. They didn't have an answer, and I didn't have an answer.

D: What did you do after college?

(continued on page 223)

Seeds Within the Cracks of the City, Installation View, mixed media, 1994, each section: 6 x 12 in. (above, and detail below)

Each section on the photograph corresponds to a section on the floor-piece. Seeds taken from the land in the photograph were planted in the corresponding floor-piece. Then it was observed what grew - ancient and contemporary plants that had reintegrated themselves into the city. CF

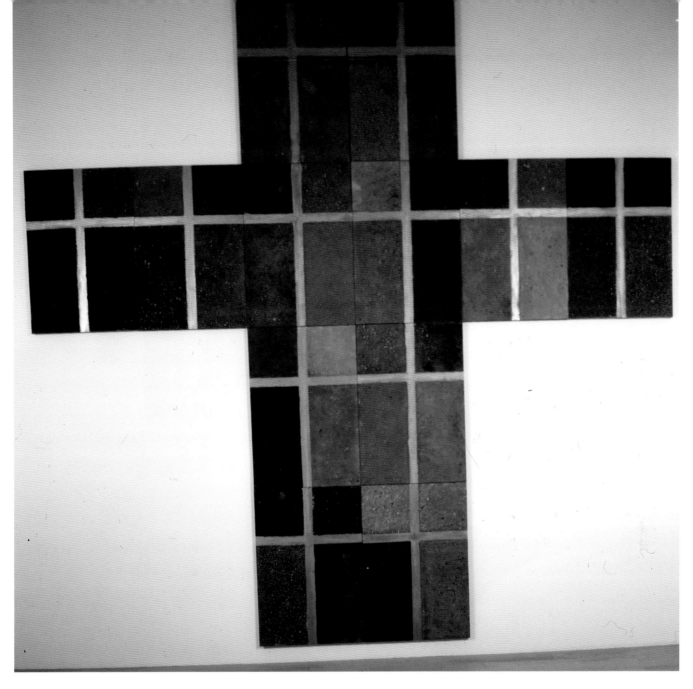

Icon of Texas, earth, gold leaf and canvas, 1991, each section: 2 x 3 ft., Commissioned by the Museum of Contemporary Art for the International Monetary Conference, Houston, Texas

Crystal Monument, minerals, 1968, 4 x 12 x 1 ft.

The crystal monument is constantly changing with the environment. The crystals are transforming from solid to gas to solid, changing with the natural conditions that surround them. CF

Crystal Monument, minerals, 1967, 6 x 36 in.

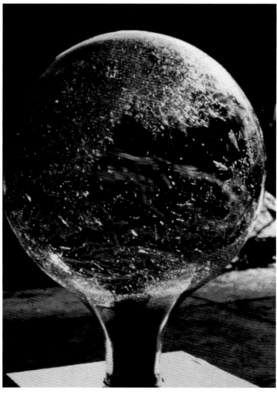

"The art itself is nature."
Polixenes

Crystal Monument, minerals, 1968, 36 in. diameter

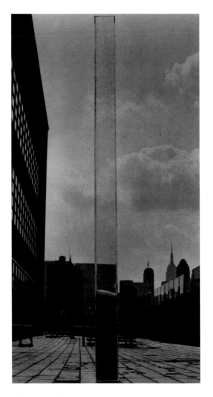

Crystal Monument, minerals,
1968, 1 x 8 x 1 ft.

Crystal Monument, minerals,
1968, 1 x 8 x 1 ft. (detail)

Crystal Monument, minerals, 1969, 36 in. diameter (below)

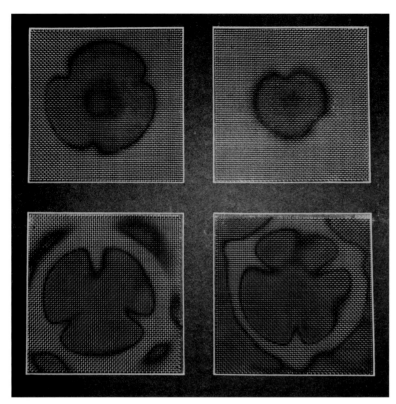

Heat Print, nickel, 1968, 36 x 36 in.

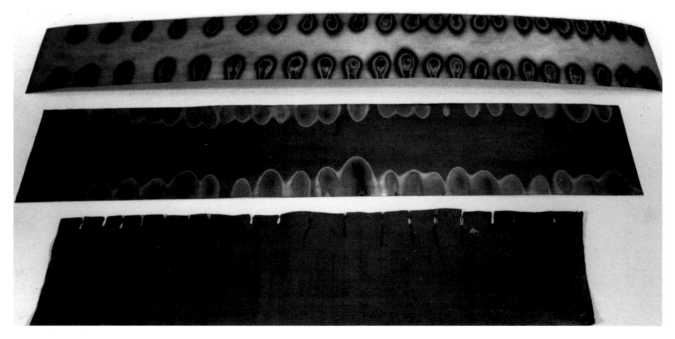

Heat Print, copper, stainless steel and lead, 1968, 2 x 4 ft.

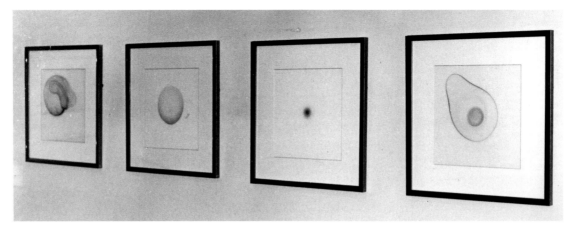

Black Spectrum, Installation View, ink and paper, 1974, 12 x 12 in., Museum of Modern Art, New York City

Black is a natural pigment of the earth, a visualization of black's internal structure. CF

S: I panicked. After being in the Midwest, I knew I didn't want to go back to the South Bronx. My parents were still living there, and at that time, it was still a very violent area. At that time, the area of the Bronx where I spent my childhood was burning. Whole properties were being burned down. There was some kind of informal deforestation going on, and all the forests were burning.

D: Burning?! Was this some kind of vandalism?

S: I imagine so. Some kind of a hostility toward the environment. I think when people don't understand something, they tend to try to destroy it. That goes for art, and unfortunately this day and age, nature, too.

D: Recently you have been spending a bit more time making paintings that incorporate photographs. One of the things that interests me about your development is that the institutions where you exhibited were very much part of the contemporary art world, but your development had to do with your own theory about where art was that gave way to a new kind of art, which grew out of your early childhood experiences with that forest in the South Bronx. Perhaps that has something to do with the more traditional forms of beauty in Western Art continuing through your work. Whether it's the touch of a painter, or consideration of attractive texture or composition or line or whatever else certainly comes out in these works of combined painting and photography. Maybe you don't want to go there, in terms of "Traditional Beauty," but I do think it's a part of your work.

S: Before photography, we judged reality though a painting. Now we see reality in a photograph or film.

D: You see the landscape in two ways, which are somehow amalgamated, because there's a painting component and a photograph component?

S: The combining of paint and photographs enhances our vision of reality. I also created a sequence of cubist time collages and they were connected through the reality of a fragment of nature that existed within the photographs.

D: What I found so extraordinary about them is there are sections that clearly are painterly, and then areas which are photographs, and then somehow it all visually coheres. That's very difficult to achieve. You would think that as two distinctive media, they would, if not visually clash, at least be uncomfortable bed partners. But it does work.

The photographs and paintings give us a metaphorical view of our realities and at the same time gives us a clearer vision of our world. The work is so diverse, but by focusing on some of them, we can get some idea of the depth and consistency of what you've been doing for decades.

S: Yes, my artwork is autobiographical, but it becomes a metaphor of the community, the world, and the universe.

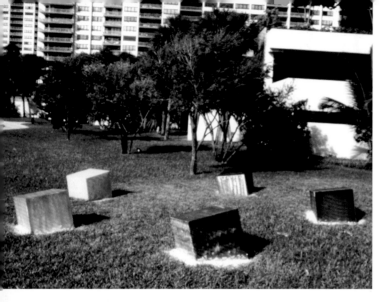

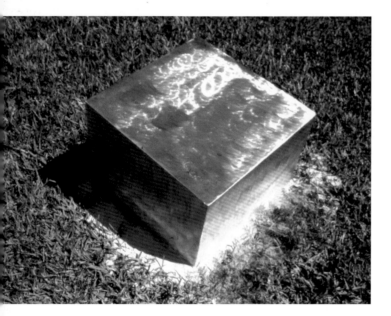

Time Enclosures of Miami, Outdoor Installation, seeds of a forest and metal (copper, brass, stainless steel, aluminum, cortan steel), 1979, each enclosure: 24 x 24 x 24 in.

Each enclosure contains a complete forest of seeds. The enclosures age, and release the forest according to the rate of the metal's decay . CF

Time Enclosures of New York, Outdoor Installation, seeds of a forest and metal, 1990, each enclosure: 2 x 10 x 2 ft., sponsored by the Public Art Fund New York City (above)

Time Enclosures of West Palm Beach, Outdoor Installation, seeds of a forest and metal, 1983, each enclosure: 24 x 24 x 24 in. (below)

Earth Frottage, earth and wax, 1971, 6 x 11 ft. (finished above, detail of impression below)

Aging Canvas of New York, mold and fungus, 1967, 6 x 6 ft.

Aging Canvas of the Catskills, mold and fungus, 1968, 6 x 6 ft.

Snail Habitat, snails, algae, and water, 1970, 24 x 24 x 24 in., Institute of Contemporary Art London

Frozen Fish Released, fish in ice, 1973, 6 x 6 x 12 in.

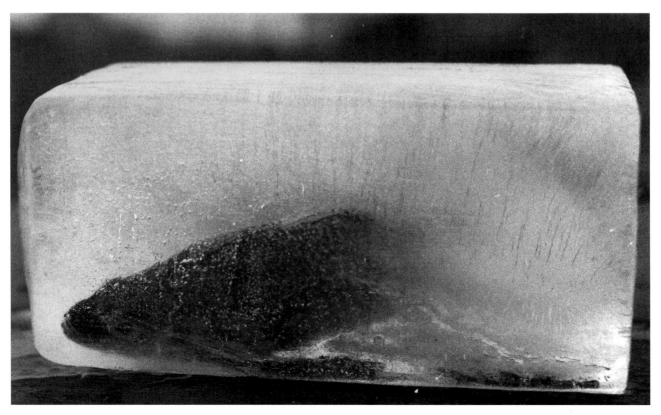

"All plants are our brothers and sisters. They talk to us, and if we listen carefully, we can hear them."
 Arapaho Belief

Aging Doors Protecting Forest, doors, trees and earth, 1993, 8 x 7 x 8 ft.

Through the cracks in this door one can see a landscape. CF

"I believe in God, only I spell it Nature."
 John Muir

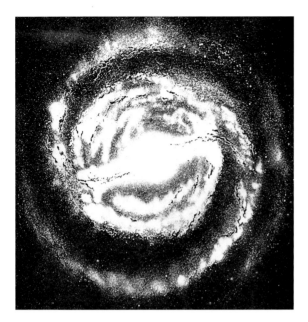

Looking at the Milky Way Through a Seed, lithograph, 1974, 24 x 24 in.

A seed is placed in the Milky Way, visualizing the beginning of the universe. CF

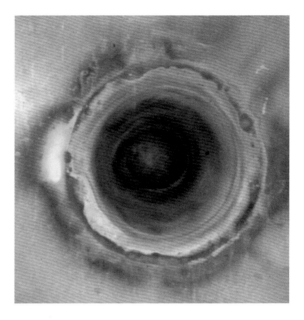

Heat Print, silver, 1974, 24 x 24 in.

The visualization of the internal structure of the metal. CF

Micro Landscape, photograph painting, 1975, 48 x 48 in.

Seed of the Universe - Supernova, photograph painting, 1974, 48 x 48 in.

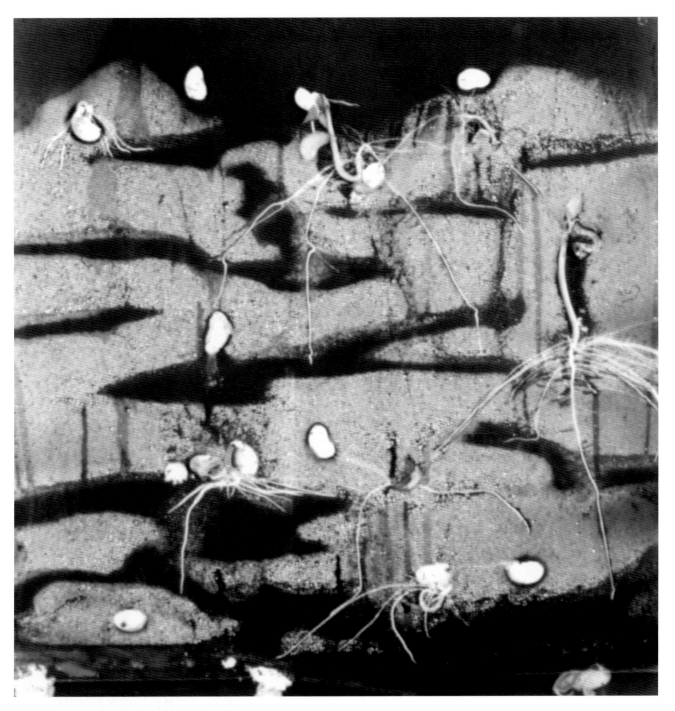

Seeds>Water>Plant>Seeds>Painting, 1971, 24 x 24 x 2 in.

This is the complete cycle of the seed in the form of a painting. CF

"It is art that nature makes."
 William Shakespeare

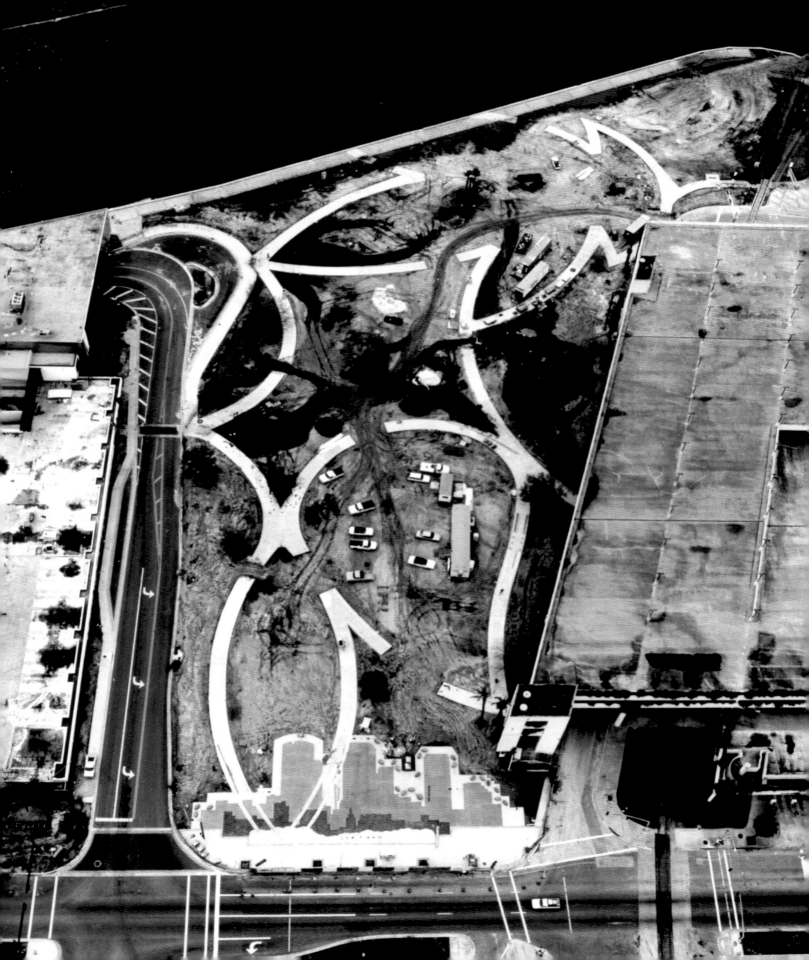

NATURAL/CULTURAL[™] LANDSCAPES

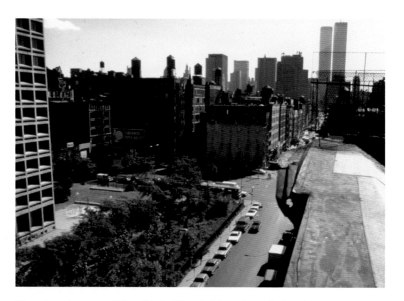

Time Landscape of New York City, Outdoor Installation,1965-present, 45 x 400 ft. (above)

Natural/Cultural Landscape of Tampa, Florida, Outdoor Installation, 1994-present, 7 acres (left)

In Sonfist's landscapes, vast seas of time are compacted into tiny spaces. These projects are often re-creations of the environment as it existed before man's interference. For example, with his Time Landscape in downtown Manhattan, Sonfist replanted the kind of forest which once blanketed all of New York City. Man had long since obliterated nature in favor of skyscrapers and concrete. Sonfist claimed a section of land and returned it to its primal state.

"In the vaunted works of Art, the master stroke is Nature's part."
Ralph Waldo Emerson

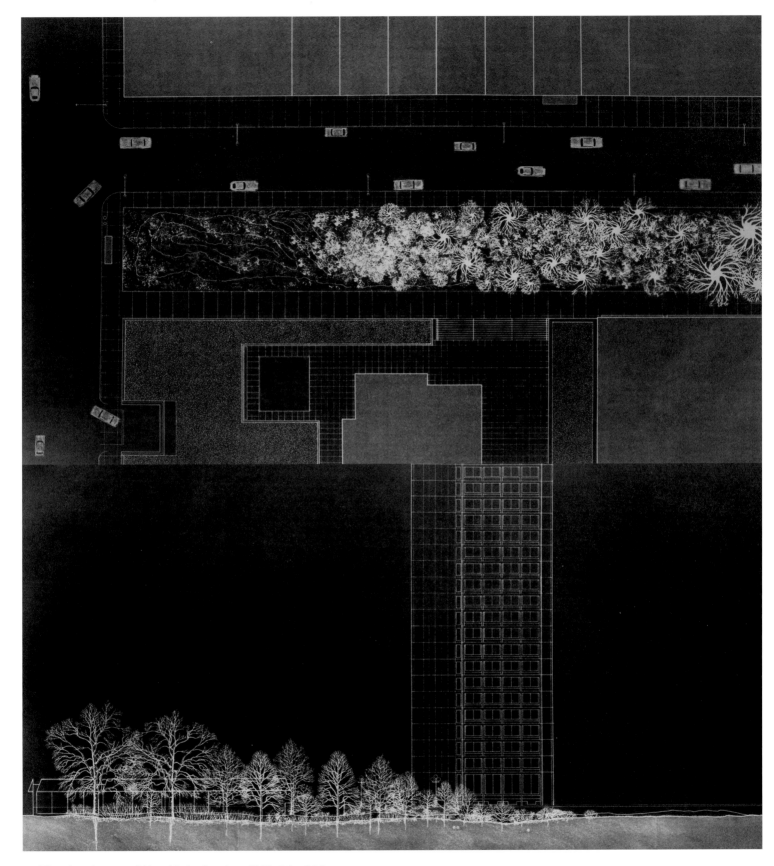

Time Landscape of New York, drawing, 1969, 24 x 36 in.

Time Landscape of New York, 12 lithographs of future forests, streams and wildflower areas throughout the city, 1978, 22 x 30 in.

Time Landscape of New York, watercolor, 1965, 18 x 24 in.

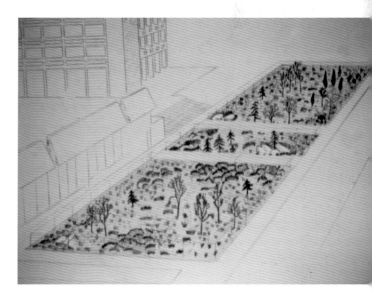

Time Landscape of New York, drawing, 1969, 24 x 36 in.

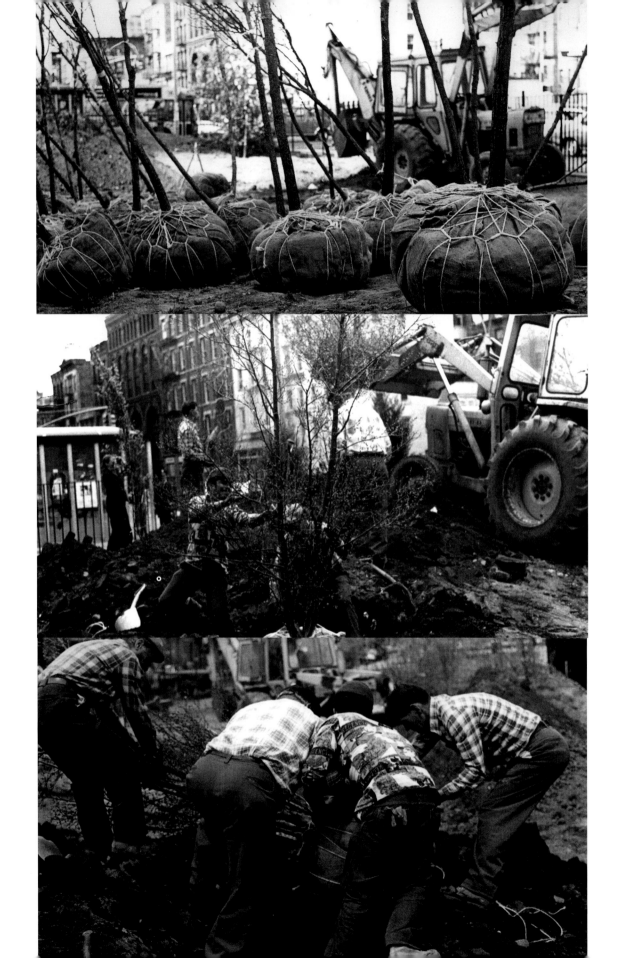

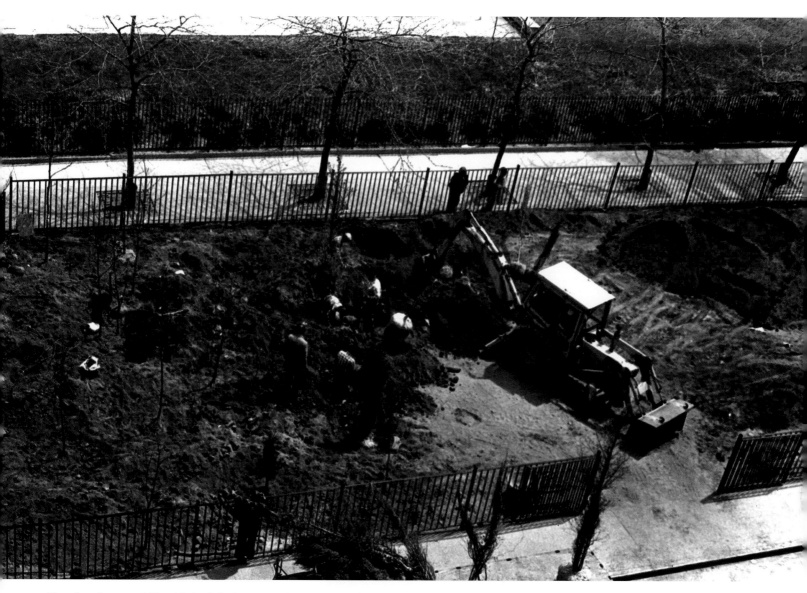

Time Landscape of New York, (left, above and following page)

"1999 was the year that one of Sonfist's oldest (and most cherished) works garnered sanction by the New York political system. The Commissioner of New York City Parks, Henry Stern, granted landmark status to the Time Landscape on the corner of La Guardia Place and Houston Street. At that time, the city announced their endorsement of additional Time Landscapes; a promise was made to restore the area of the Bronx River where Sonfist grew up and that promise has begun to become a reality."

Jonathan Carpenter

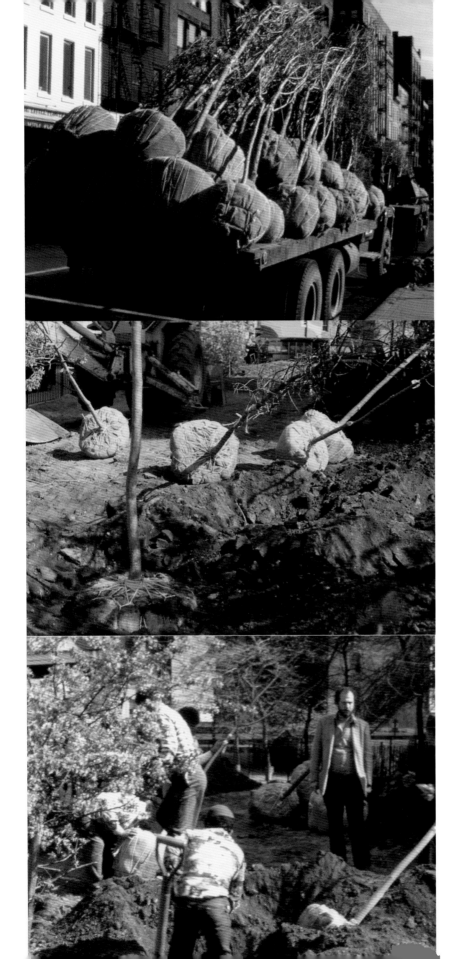

Alan Sonfist`s Time Landscape

John K. Grande

The view that nature in a city is something irrelevant, a decorative aspect of the daily hustle and bustle of progress as we know it, is something that Alan Sonfist has challenged, since the 1960s. Not only with his *Time Landscape* (Jardin de Temps) but equally with his drill samplings of major urban centers in Europe and North America (Aachen, New York, Toronto, and elsewhere). Nature fulfills a psychological, ecological, and aesthetic function in daily life, reducing stress, encouraging reflection and relaxation.

It has largely been forgotten that early land artists such as Smithson, Heizer, and Alan Sonfist generated this movement to get out of the commercial galleries, to move art into a new context, one that is part of the North American landscape. Hence to find artists now seizing the land art aesthetic and regressing purely into a design and objective vision of the landscape is not encouraging. The reason that writers and people in the cultural sector are beginning to question this aesthetic is that it does nothing to further the understanding that art is a living phenomenon. As I write in my book, *Balance: Art and Nature*, NATURE IS THE ART OF WHICH WE ARE A PART.

Increasingly nature has been challenged by postmodernists as largely a nostalgic concept, one generated by Romantics to create idealized pastoral scenes like those of Turner and Constable. The truth is that nature is a volatile and powerful force that is part of our lives and affects us enormously. The recent forest fires across North America have cost the economy many millions of dollars, for instance. Indeed the fires were in part the result of not allowing nature`s processes including fires to occur regularly, thus reducing deadwood in North America`s forests. Alan Sonfist`s *Time Landscape* was the first environmental sculpture to have truly raised questions about our urban environment. *Time Landscape* reawakened the public`s sense of natural history in the same way Gordon Matta-Clark`s cutaway architectural pieces or Sewer video made us reconsider the urban context from an aesthetic as opposed to a pragmatic perspective.

Alan Sonfist`s *Time Landscape* exists as a monument to nature within the urban context. I mention the word context because many artists have lost any sense of a continuity of place, of the tactile and physical reality of life. Some recent nature projects manipulate nature to engender a sense of well being. Trees, plants, entire landscapes are reconfigured to create a tranquil scenario which is ideal, but the actual plants and trees used do not relate to the actual site, nor is there any consideration of their permanence in the site. They serve a temporary aesthetic function, instead of reawakening our sense of the holistic character of life itself. This disconnected form of real life actually works against nature, even against civilization in the long run. We have to realize that ecology plays a role even in sophisticated economies such as those of North America and Europe. Nature has a memory. We should too.

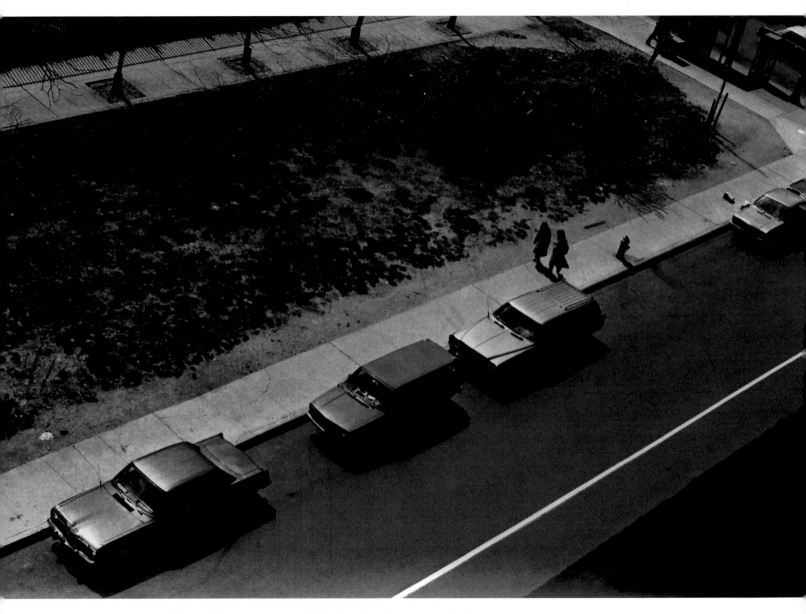

Time Landscape of New York, progression, 1965 (above) to the present.(right)

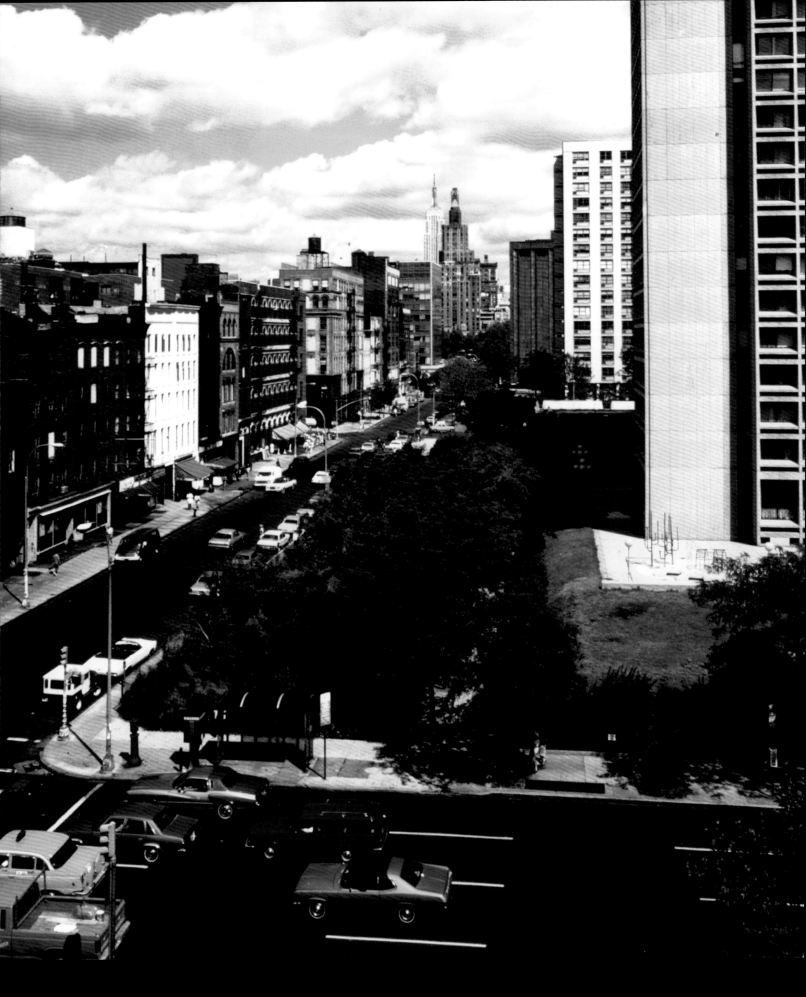

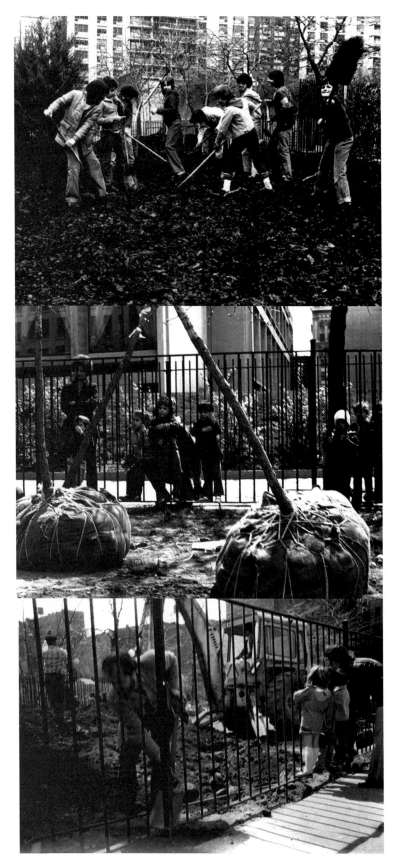

Time Landscape, Nature Culture Educational Program

City of New York
Parks & Recreation

The Arsenal
Central Park
New York, New York 10021

Adrian Benepe
Commissioner

October 30, 2003

To Whom It May Concern:

I am pleased to write a letter of reference for Alan Sonfist. Mr. Sonfist has shown his significant talent as a landscape architect in New York City and has developed wonderfully innovative ways of bringing the city's natural history to life through art.

Mr. Sonfist's work in New York City includes *Time Landscape*, a living monument in Greenwich Village to the forest that once blanketed Manhattan Island. In 1965 he first proposed the project and started on the planting in 1978 at the 25' x 40' rectangular plot. His design, which included a palette of native trees, shrubs, wild grasses, flowers, plants, and rocks, was derived from his extensive research on New York's botany, geology, and history. The result of this efforts was a developing forest that represents the Manhattan landscape inhabited by Native Americans and encountered by Dutch settlers in the early 17th century.

Though the design draws on an era gone by, the park fits seamlessly into the 21st century streetscape of Manhattan. Its dedicated volunteers who assist in keeping the park clean and the plants healthy are evidence of the strong sentiments the neighborhood feels for this space. Through its appealing design and heavy use, it has been a great educational park for people of all ages.

I encourage you to review and consider strongly Mr. Sonfist's work. I would expect that if he were selected in whatever project you propose, you would be as pleased as we are with his work.

Sincerely,

Adrian Benepe

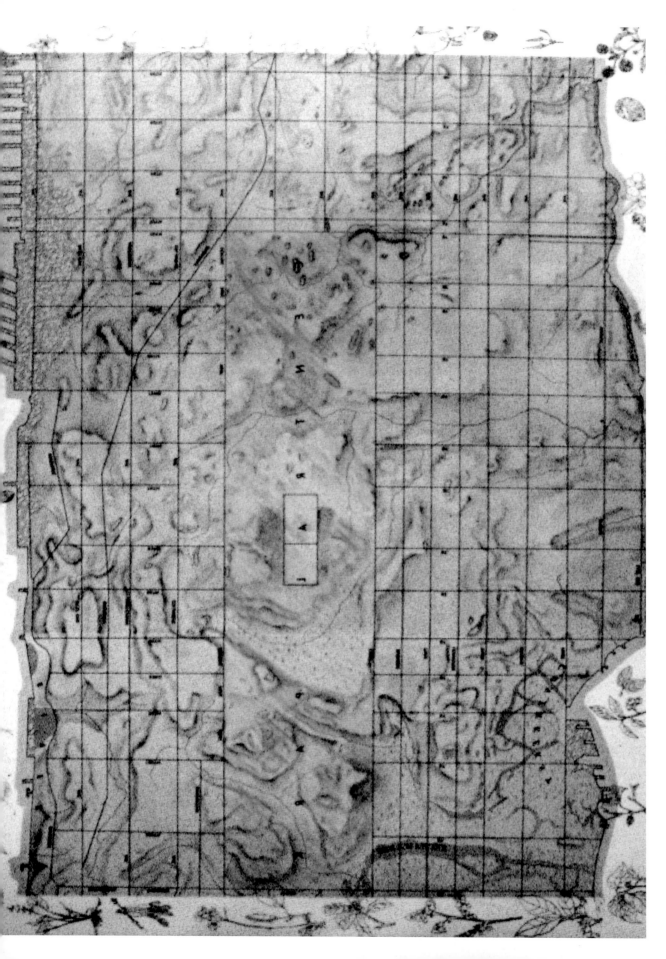

Hidden Landscape of New York, drawing, 1979, 22 x 30 in. (detail)

A contemporary land-scape overlays the historical landscape.

Time Landscape of the Bronx, trompe l'oeil mural and planting, 1978-79, 1 acre, Public Art Fund Commission (mural detail above)

The Hemlock forest trompe l'oeil became the representation of America in Alain Renais's movie My American Uncle. CF

Time Landscape of Brooklyn, tromp l'oeil mural and planting, 1978-79, 1/2 acre

Time Landscape, Socrates Sculpture Park, 1991, 25 x 200 ft., Long Island City

Natural/Cultural Landscape of Dallas: Plants and Animals, watercolor, 1979-80, 22 x 30 in.

Natural/Cultural Landscape of Trinity River, Dallas: Regional Terrain and Water System, photocollage, 1979-80, 2 x 4 ft. (detail)

Natural/Cultural Landscape of Trinity River, Dallas: Regional Terrain and Water System, photocollage, 1979-80, 2 x 4 ft.

The New York Times — Editorial

OAKS AND CATBIRDS, FOREVER

Permanence does not seem to last all that long in big cities, but a piece of woodland in downtown Manhattan now has a good chance of achieving it. A 200-by-45-foot community park at the corner of Houston Street and La Guardia is being transferred to the Parks Department. This, as much as anything can, will insure it against intrusion or destruction.

Technically it is not a park but an outdoor sculpture, with oak trees, hickories, junipers, maples and sassafrases artfully crowded into a little space. A "Time Landscape," it is called by its designer, Alan Sonfist, who put it together a decade ago to recreate the look of Manhattan's terrain before the white settlers came.

The trees, shrubs and grasses all grow as they did four centuries ago, and along with natural history offer some reminders of social history. The settlers used oak for their ships, hickory for their wheel spokes, and sassafras root as medicine for everything from aching joints to ailing livers.

The little woods today seems remarkably at home in the modern world. A catbird scruffs in the litter on the shaded floor; a pair of squawking jays chase through the branches.

These two belong in the ancient landscape, for their ancestors were here before Peter Minuit struck his big bargain. The oaks may look more majestic and enduring; but the weeds and the songbirds, though they seem only a passing part of nature, are also part of nature's permanence.

The Villager — Editorial

THE FOREST FOR THE TREES

"Midway in the journey of our life I found myself in a dark wood for the straight way was lost," Dante Aligieri wrote in the opening lines of his ageless classic, "The Inferno." The story tells how he wandered through the woods and forests, gaining knowledge, experience and wisdom to move from Hell to Purgatory until he reached Heaven upon finding his way out of the woods. Here in New York, we find ourselves in a forest of concrete and steel and many of our residents never have the chance to hear the message in the murmuring of pines and the hemlocks. It is for this reason we are delighted that artist Alan Sonfist's proposal to create a "forest" in a 200-foot by 45-foot strip of land along La Guardia Place between Bleecker and Houston Streets, is about to finally become a reality. That it will be filled with the types of trees and vegetation that existed here before the area was colonized 300 years ago is a great idea, especially to show those of our number who seldom see or hear a forest, that New York was not always concrete and steel.

In a time when our children believe that firewood comes from a market on Sixth Avenue and Village residents seem to be willing to do almost anything to preserve and create open space, it is heartening to see that Alan Sonfist is giving us guidance in our wandering through the urban forest, and bringing us out to the open through his plan to bring nature into the city.

Nature Theater, drawing, 1999, 22 x 30 in., Goethe Park, University of Bauhaus, Germany

Nature Theater is a Roman - style ampitheater where people are able to witness nature's performance of continual change. Text engraved into a ring of metal surrounds the theater, recording the past, present, and future events of the local environment. CF

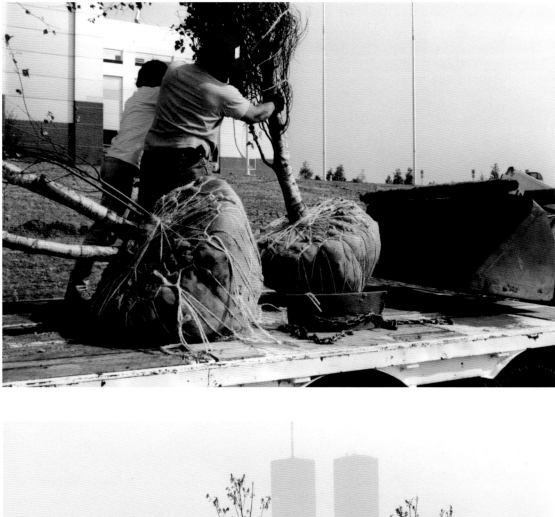

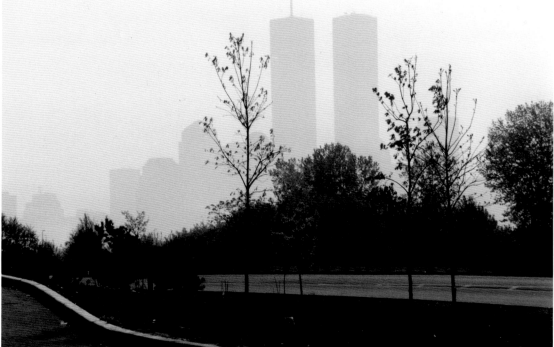

*Natural/Cultural Landscape of Jersey City, 1994, 5 acres, Liberty
Science Center, New Jersey (construction).*

Natural/Cultural Landscape of Indianapolis, 1991-92, 50 x 400 ft., (complete above, detail of wild flowers at right)

Pathway represents the White River underneath the site. CF

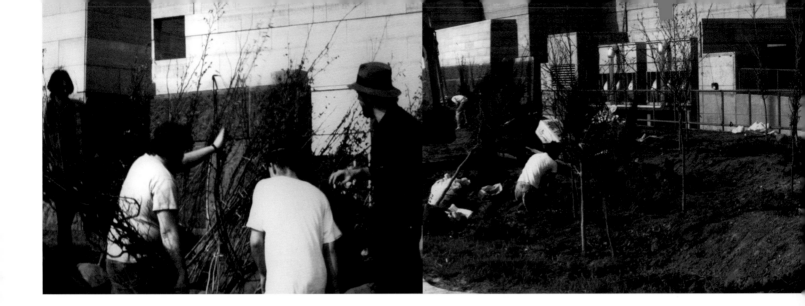

Natural/Cultural Landscape of Indianapolis, 1991-92, 25 x 150 ft.,
Eiteljorg Museum, Indiana (construction)

Plan for Natural/Cultural Landscape of Paris, drawing, 1991, 2 x 15 ft., commissioned by EPAD

Paris La Defence is a restoration to create a series of parks representing the great monuments of Paris. Each monument is sited for its unique historical vegetation. For example, Notre Dame Cathedral, whose shape would be used as the footprint in the creation of the park. The park would be a marsh existing within the structure next to the Seine River. The water would be filtered through the natural process of the marsh. The parks would give homage to the unique vegetation that has existed historically on these significant grounds. The illustration shows parks connected by hedges, representing French military tactics. CF

252

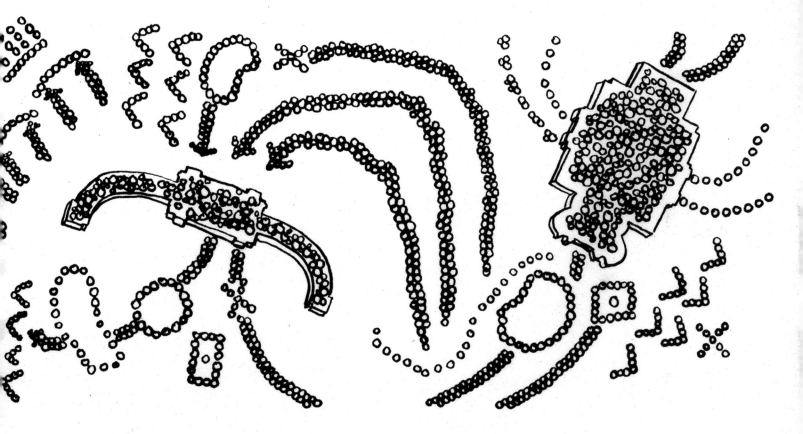

La Defense choisit ses<<jardiniers>>
Alan Sonfist se compte parmi des artistes qui ont toujours eu une longueur d'avance sur leur temps et le siecle
epouse generalement leurs idees avec trente ou quarante ans de retard.
 Alice Sedat et Francis Rambert, LE FIGARO

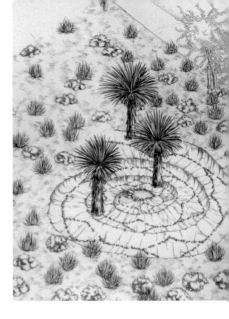

Natural/Cultural Landscape of LaQuinta: Oasis, drawing, 1992, 22 x 30 in.

LaQuinta Nature Trail is a three and half mile walk visualizing the history of the land from an oasis to the future (zero-) landscaping. The walk is a living museum of the region. The path shows how humans intervene with the land agriculturally (with a grid of palm trees shading a citrus tree in the center), colonially (with flowering bushes from the time of the Spanish), and contempraneously (with the formal clipped hedges of suburban estates). The trail ends with a snake unfolding itself made of native flowers that require almost zero watering. The trail was commissioned by the Department of Waterworks CF.

"Now [outside my window] there's an oasis of beauty that reflects our own history." John West, resident of LaQuinta

Natural/Cultural Landscape of LaQuinta, California, 1992

Zero Natural/Cultural Landscape: 21st Century,
drawing, 1992, 22 x 30 in.

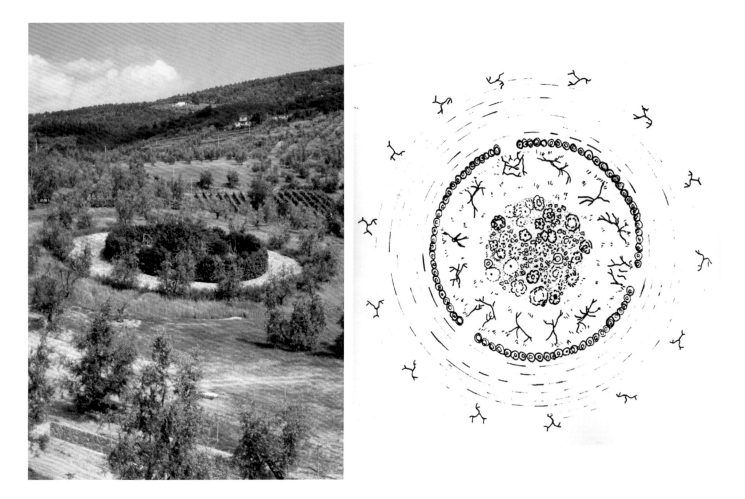

Circles of Time, 1986-89, 3 acres, Villa Celle, Tuscany, Italy (completed above left, drawing above right, and searching for historical relics at right)

A series of ring landscapes represents the history of Tuscany: from the inner core representing a primeval forest; a herbal ring representing the Etruscan use of the land; a bronze ring representing the Greek and Roman gods, a laurel wall representing Greek influence; a geological walk, and the outer ring of olive and wheat representing the contemporary use of the land. CF

"If we begin at once to break the bonds that bind us to nature and to devote ourselves purely to combinations of pure color and independent form, we shall produce works that are mere geometric decorations, resembling something like a necktie."

 Wassily Kandinsky

Circles of Time, Renaissance Geological Walkway, Tuscany

Circles of Time, Laurel Ring with view of Bronze Door

"To achieve progress, nature alone counts, and the eye is trained through contact with her."
 Paul Cezanne

Circles of Time, detail of door within Laurel Ring leading to the Renaissance Geological Walkway

Circles of Time, detail

"As I viewed the Milky Way the circles of time became clear with the movement of the stars as a drop of water ripples in a pond."

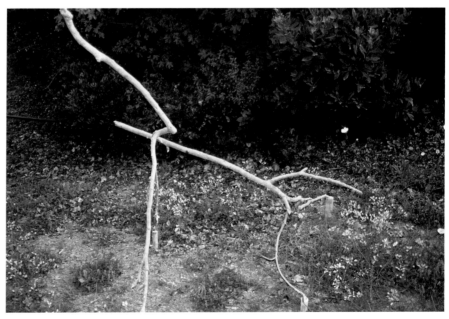

Circles of Time, Bronze Guardian within Etruscan Garden

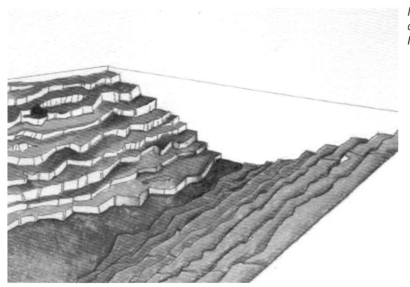

Natural/Cultural Landscape of the Great South Bay, drawing, 1995, 22 x 30 in. (water fountain for Richard Meier's court house) Islip, Long Island

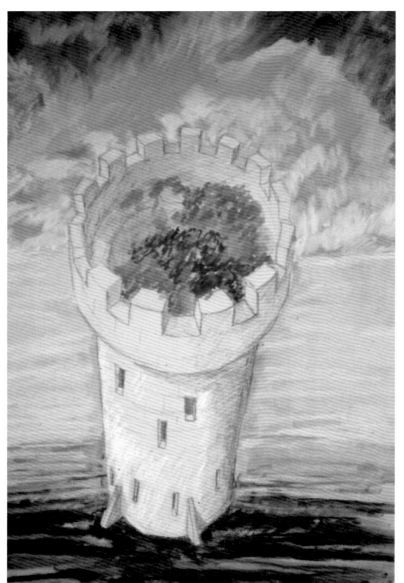

Natural/Cultural Landscape of Graz, Austria, drawing, 1987, 22 x 30 in. (castle protecting forest)

*Natural/Cultural Landscape of Kennedy Center,
drawing, 1987, 22 x 30 in. (narrative walk)
Cambridge, Massachusetts*

*Natural/Cultural Landscape
of Hamden, drawing, 1990-
91, 22 x 30 in. (leaf park)
Hamden, Connecticut*

Natural/Cultural Landscape of Tampa, Florida, 1993-95, 7 acres.

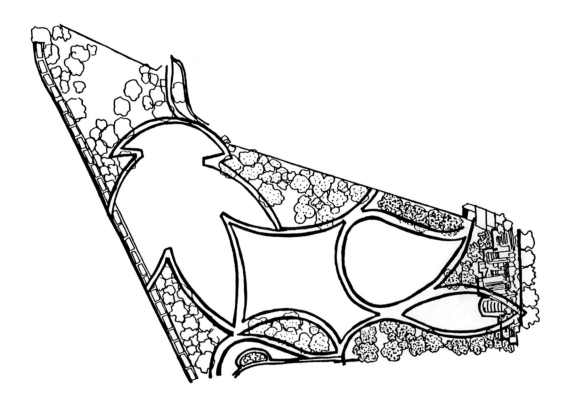

Natural/Cultural Landscape of Tampa, Florida (plan)

"Although Sonfist's Time Landscapes have begun to flourish outside the United States, there remains something essentially American about the concept. Harold Rosenberg once remarked, "Americans dream of taking home hunks of raw nature." The belief in the healing power of nature which runs through American art and literature is embodied in Sonfist's recreation of historical forests in all particularity."

Eleanor Heartney, *History and the Landscape*, The University of Iowa Museum of Art

Natural/Cultural Landscape of Tampa, Florida (construction)

Natural/Cultural Landscape of Tampa, Florida

Natural/Cultural Landscape of Tampa, Florida (above, columns growing indigenous plants - below, mural of nature, warehouses and skyscrapers)

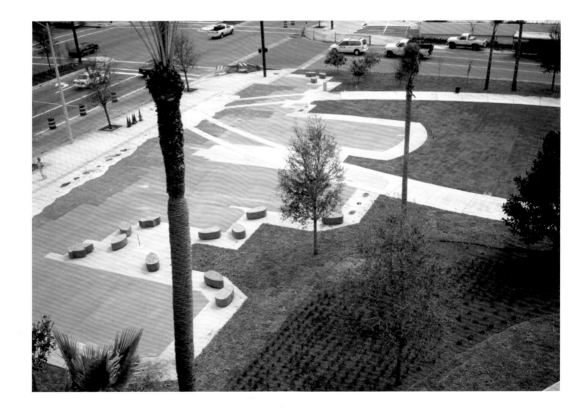

Natural/Cultural Landscape of Tampa, Florida (leaf shaped sitting areas)

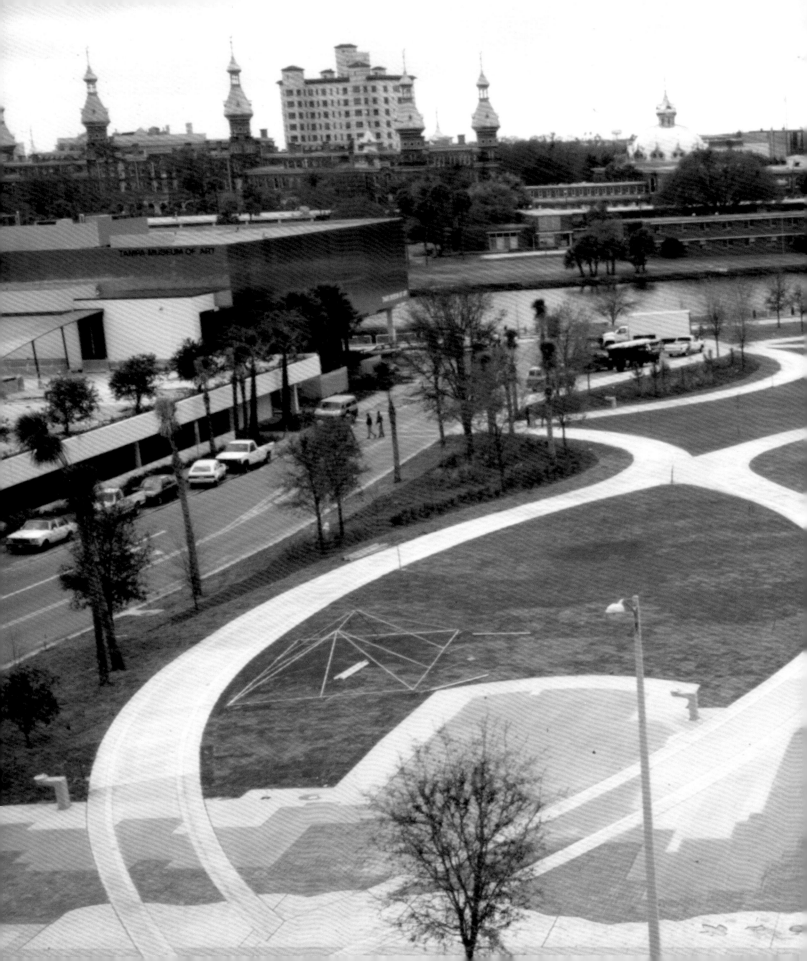

Royal Victorian Hospital, Interior/Exterior Healing Trail, drawings, 2004, 22 x 30 in.

The Royal Victoria Hospital Healing Trail visualizes the natural and cultural history of the community. The trail begins with the indigenous landscape and visualizes the stages of human interaction. The pathway encourages contemplation and healing for the patients as well as for the community. CF

"The Royal Victorian Hospital seeks to create an external environment that promotes health and tranquility and the education of people regarding natural remedies. We seek to address both the physical and spiritual well being of those in need. We envision people visiting RVH not simply to address physical ailments but to seek solace in its environment – a place to walk about and enjoy the natural healing that arises from the natural landscapes of Alan Sonfist's Healing Trail."

Eric Laycock, Senior Vice President, Royal Victorian Hospital

Lost Falcon of Westphalia, Neolithic Forest and Celtic Mounds, 2004, 44 x 28 meters

The human and natural history of the land in the form of a falcon. CF

Lost Falcon of Westphalia

Dr. Uwe Rüth

As part of the Woodland Sculpture Trail in the Rothaar Mountains in Germany between the towns Bad Berleburg in the area of Wittgenstein and Schmallenberg in the Sauerland region, Alan Sonfist has situated in the midst of the forest his work "The Monument of The Lost Falcon." The fourth sculpture on the Woodland Sculpture Trail was completed in 2003.

On the ground of the forest there is the shadow of a large falcon as if hovering in the air. The shadow has a wingspan of 44 meters and is 28 meters from head to tail. Its contours are drawn by means of a 1 meter high earthen wall on which 750 European larch seedlings are planted. In the interior of the shadow - protected by the wall - there are 350 different native seedlings naturally growing in this region, among them the fir, the snowball tree, the elderberry bush, the pine tree, the beech tree, the oak tree, and the hazel tree. Today they are no longer naturally found. Following the wish of the artist, the interior is planted according to a naturally wild pattern to reforest the natural flora. Outside the earthen wall a two meter wide space covered with grey slate gravel leads around the silhouette of the falcon. Against the forest, the sculpture is secured by a two meter high wooden fence. The result will be that after a first phase of growth the earthwork will look like a naturally wild island in the middle of a forestry district.

In his work the artist speaks of the lost natural and cultural resources of the past. The interior of the shadow of the falcon will become a forest of memory, because the naturally wild flora of this region will be growing again undisturbed.

274

Sonfist establishes the earthen wall, which formerly gave man protection, to protect the revitalization of the primeval forest in the shadow of the falcon. Around this wall the rustic and complete fence defends the undisturbed development of nature against man and animal.

The total outline of the falcon is only visible from a bird's perspective.

The wandering falcon may recognize the shape and maybe remain. The man who is flying over will be surprised by this image that comes out of the forest as a gigantic shadow of the bird.

Sonfist also points to the very old cultural models of the first drawings in Nazca Peru (around 700 BC), the Giant of Cerne Abbas in England (around the time of Christ's Birth) and the Great Serpent in Adams County, Ohio, USA (around 800 B.C.).

An immediate relationship is also drawn to the works of Herbert Bayer, Isamu Noguchi, and to works that follow them – land art works in the Southwest of the United States in the 1970s by Michael Heizer, Robert Smithson, and, of course, to Sonfist's own earlier works.

Looking at all the natural and cultural historical relationships, found in this work by Alan Sonfist, you realize the entirety of human relationships to the complexity of our world. As the most recent humans in world history, we are totally responsible for what we destroy or rebuild. Alan Sonfist demonstrates this in an imaginative and natural language in the mountains of highly civilized Central Europe.

Selected
PRIVATE AND PUBLIC COMMISSIONS

Celtic Fortification Landscape, Aachen, Germany
Nature Theater, University of Goethe, Germany
Geological Timeline, Duisburg, Germany
Narrative Mural of Urban Nature, Merrick, NY
Labrynth Of SouthBend, South Bend, IN
Natures Protectors, Montreal, Canada
Healing Trail, Berrie, Canada
Four Seasons Sculpture, Temple University, PA
Time Landscape ™, Greenwich Village, NY
5 Time Enclosures with Forest Seeds, Boca Raton, FL
Rock Monument of Buffalo, Buffalo, NY
Circle of Life Centennial, Kansas City, MO
Natural/Cultural Landscape™ of Swanee, Swanee, TN
Geological Landscape Mural, Houston, TX
Rising Earth Washington Monument, Washington, DC
Theatre of Nature, University of Bauhaus, Germany
Time Landscape™ of Trinity River, Dallas, TX
Stream Trace Hospital Landscape, Pistoia, Italy
Sculpture Natural/Cultural Landscape, La Quinta, CA
Natural/Cultural Landscape™ of Indianapolis, Indianapolis, IN
Natural/Cultural Landscape™ of Tampa, Tampa, FL
The Lost Falcon, Bad Berleburg, Germany
Natural/Cultural Landscape™ of Pori, Pori, Finland
Geological Landscape, Toronto, Canada
Natural/Cultural Landscape™ of La Quinta, La Quinta, CA
1001 Oaks in a Stone Ship, Langeland, Denmark
Natural/Cultural Time Enclosure™, Portland, ME

Selected
SOLO EXHIBITIONS

Natural Disasters, Paul Rodgers/9W Gallery, NYC
Burning Forest, Santa Fe Art Institute, Santa Fe, NM
Reflections of the Milky Way, Maison des Gouverneurs, Sorel, Quebec, Canada
Hidden & Natural Secrets of New York, Goethe Institute, NYC
Retrospective: A History of the Land, Museum of Art, University of Iowa, Iowa City, IA
Natural/Cultural Landscapes, Tampa Art Museum; Tampa, FL
Drawings of La Defence, Parks of PARIS, EPAD Museum of Contemporary, Paris, France
Gauguin's Landscape Commission, Port-au-France, Martinique
Natures Reflections, Max Protetch Gallery, NYC

Environmental Landscape of Indianapolis, Eiteljorg Museum, Indianapolis, IN

Public Sculptures of the Site, Pennsylvania State University, Pittsburgh, PA

Trinity River Proposal, Dallas Museum of Art, Dallas, TX

Earth USA, Corcoran Museum, Washington, DC

Tree Growth, J.B. Speed Art Museum, Louisville, KY

Nature/Culture Landscapes, Marian Goodman Gallery, NYC

Rock Monument of Buffalo, Albright-Knox Museum, Buffalo, NY

Monument of Atlanta, High Museum of Art, Atlanta, GA

Environmental Public Sculptures, Neuberger Museum (SUNY), Purchase, NY

Photo Landscapes, Leo Castelli Gallery; NYC

Autobiography of Sonfist's landscapes, Smithsonian Institution, National Collection of Fine Arts, D.C.

Nature of Germany, Neue Galerie Museum, Sammlung Ludwig, Aachen, Germany

Autobiography of a Hemlock Forest, Galerie Valsecchi, Milan, Italy

Nature's Value, Gallery Cavallino, Venice, Italy

Parks of New York City, Centre Cultural Americain, Paris, France

Running Dead Animal, Stefanotty Gallery, NYC

Time Landscapes, Photos, Drawings, Model, Finch Collage Museum of Art, NYC

Photographs & Nature Direct, Palley and Lowe Gallery; NYC

Animals, Minerals and Vegetables, I.C.A., London, England

Army Ants, Automation House (sponsor: Architectural League), NYC

Nature of Akron, Akron Institute (video catalog), Akron, OH

The Nature of Things, Harcus-Krakow Gallery, Boston, MA

Star Charting, Dezon-Zaks Gallery, Chicago, IL

Outdoor Crystal Sculpture, Finch College Museum of Art, NYC

Nature's Reflections, Reese Palley Gallery, NYC

Earth Day, Union Square Park (natural and artificial landscape), NYC

Selected
GROUP EXHIBITIONS

Trilogi: Kunst, Natur, Vindeskab, Kunsthallen Brandts, Klaedefabrik, Denmark

Differentes Natures, Prado Museum, Prado, Spain

Creative Solutions to Ecological Issues, Dallas Museum of Natural History, Dallas, TX

Fragile Ecologies, Center for Fine Arts, Miami, FL

Opening Exhibition for Environmental Art Museum, Langeland, Denmark

Fragile Ecologies, Queens Museum, Queens, NYC

Revered Earth, Center for Contemporary Arts, Santa Fe, NM

Sticks and Stones: Nature, Katonah Museum of Art, Katonah, NY

Spirit of the Earth, Santa Fe Contemporary Art Center, Santa Fe, NM

The Endangered Earth, Pasadena Art Center, Pasadena, CA

Sculpture Arch of the Rockies, Aspen 1990, Aspen Art Museum, Aspen, CO

Revered Earth, Museum of Contemporary Arts, Houston, TX

Nature as Art, Kunst Academia; Berlin, Germany

Crystal Landscapes,World's Fair, Osaka, Japan

The Artist as Social Designer, Los Angeles County Museum, Los Angeles, CA

Der Baum, Heidelberger Kunstverein, Heidelberger, Germany

Chance and Change, Auckland City Art Gallery; Auckland, New Zealand

Metmanhattan, Whitney Museum of American Art; NYC

Common Ground, Ringling Museum of Art, Sarasota, FL

Artists Parks and Gardens, Museum of Contemporary Art; Chicago, IL

Response to the Elements, Contemporary Art Center; Toronto, Canada

Reasoned Space: The Arizona, Center for Creative Photography; Tucson, AZ

Views of America, Museum of Modern Art; NYC

Hudson River Artists, Vassar College Museum of Art; Poughkeepsie, NY

Interactions with the Environment, Whitney Museum of American Art; NYC

Photographs as Art Documenta, Kassel, Germany

Italian Nature: Venice Biennale, Video Section, Venice, Italy

Nature of the Body: Biennale de Paris, Paris, France

A Response to the Environment, Rutgers University Art Gallery, New Brunswick, NJ

Body Art; Museum of Contemporary Art, Chicago, IL

Living Ritual, Museum of Contemporary Art, Graz, Austria

Project 74, Walraf-Richartz Museum, Koln, Germany

Materials and Manipulation, Whitney Museum of American Art, NYC

Trees of Manhattan: Acquisition Exhibition, Finch College of Museum Art

Landscape on the Sixth Floor, Museum of Modern Art, NYC

Elements - Earth, Air, Fire, Water, Museum of Fine Arts, Boston, MA

Lucht-Kunst, Stedelijk Museum, Amsterdam, Holland

Crystal Monument, Museum of Natural History NYC

Selected
KEYNOTE SPEAKER

Art Ecology Conference: Berlin, Germany

Public Art of the Park: University of Lund, Sweden

Nature of the City: Midwest Art College Association: Memphis, TN

Public Art: National Museum Art Conference, Pittsburgh, PA

Australian Nature Environmental Sculpture for National Museum

Southern Landscape Conference, Miami, FL

Rhode Island School of Design Landscape Conference

Selected
MUSEUM COLLECTIONS

Akron Art Institute, Akron, OH

Albright-Knox Museum, Buffalo, NY

Allen Art Museum, Oberlin, OH

Art Gallery of Ontario, Toronto, Canada

Art Institute of Chicago, Chicago, IL

Auckland Museum of Contemporary Art; Auckland, New Zealand

Berkeley Museum of Art, Berkeley, CA

Boston Museum of Fine Art, Boston, MA

Brooklyn Museum of Art, Brooklyn, NYC

Celle Art Sculpture Park, Pistoia, Italy

Center for Creative Photography; Tucson, AZ

Contemporary Art Museum, Los Angeles, CA

Dallas Museum of Art, Dallas, TX

Fresno Art Museum, Fresno, CA

Houston Museum of Fine Art, Houston, TX

Johnson Museum, Ithaca, NY

Los Angeles Country Museum, CA

Lowe Art Museum, Coral Gables, FL

Ludwig Museum, Koln, Germany

Metropolitan Museum of Art, NYC

Musee d'art Contemporain de Montreal, Montreal, Canada

Museum of Contemporary Art, Chicago, IL

Museum of Modern Art, NYC

Museum of Modern Art, Paris, France

National Gallery of Art, Australia

Neue Museum, Sammlung Ludwig, Germany

Newport Harbor Museum, CA

Power Gallery of Contemporary Art, Australia

Princeton University Museum, NJ

Wadsworth Antheneum Museum, CT

Whitney Museum of American Art, NYC

Wilhelm Lehmbruck Museum, Duisburg, Germany

Selected
SYMPOSIUMS AND VISITING PROFESSORSHIPS

Boston Museum of Fine Arts, "Earth, Air, and Fire." Boston

Dade County Art Conference, "Public Art and the Environment." FL

Environmental Art, Cooper Union, NYC

Massachusetts Institute of Technology, International Conference. Cambridge, MA

Metropolitan Museum of Art, "Artist Series:Nature as Public Monument." New York

Midwest College Conference, "Public Art:Nature within the City." Memphis, TN.

Penn State University, "Urban and Suburban Environmental Art.", PA

"Southern Sculpture Conference, "Art of the Land." San Antonio, TX

Research Fellowship - MIT, Cambridge, MA